FOTO CLUBE BANDEIRANTE — FICHA DE SÓCIO

E
INSCRIÇÃO N.o 170
CONTRIBUINTE
Fone 5-4210
Fone 3-4121
to 19 / 12 / 1899
rado
ADO EM 4/6/43, SOB N.o 41

NOME: POLACOW – Jacob
INSCRIÇÃO N.o 264
CONTRIBUINTE
Admitido em 25 / Novembro / 1943
Residência Rua TRAIPU
Categoria Contribuinte
n.º 1075 (Cidade) Fone 51-994
Trabalha á Rua... n.º 36 Fone 32.000
Nacionalidade Brasileira
Data do nascimento 25 / 67 / 1912
Estado Civil Casado
Profissão: Engenheiro-agrónomo
CARTEIRA de ... n.º 3.466-D-OREA
Deve ser procurado
OBSERVAÇÕES: CARTÃO DA POLICIA SOB n.o 121 em 10-1-44
Em 1-9-60 – Pediu demissão.
Em 5-9-60 – Demissão concedida.

FOTO CLUBE BANDEIRANTE — FICHA DE SÓCIO
NOME: IACOBE – Carlos
INSCRIÇÃO N.o 316

D1132973
OBSERVAÇÕES: Em 9/11/59 – Excluido por falta de pagamento.

NOME: TOSHIDA
OBSERVAÇÕES:

MENSALIDADES

Ano	Mensalidade	Janeiro	Fevereiro	Março	Abril	Maio	Junho	Julho	Agosto	Setembro	Outubro	Novembro	Dezembro
									Outubro	Novembro	Dezembro		
		PAGO	PAGO	PAGO									
		PAGO	PAGO	PAGO									
1946	124	PAGO	PAGO	PAGO	PAGO	PAGO	PAGO	PAGO	PAGO	PAGO	PAGO	PAGO	
1947	108	PAGO	PAGO	PAGO	PAGO	PAGO	PAGO	PAGO	PAGO	PAGO	PAGO	PAGO	
1946	161	PAGO	PAGO	PAGO	PAGO	PAGO	PAGO	PAGO	PAGO	PAGO	PAGO	PAGO	
1947	184	PAGO	PAGO	PAGO	PAGO	PAGO	PAGO	PAGO	PAGO	PAGO	PAGO	PAGO	
1946	166	PA											
1947	139	PA											

FOTO CINE CLUBE BANDEIRANTE — FICHA DE SÓCIO

994-1404
O
...RREIRA DA SILVA
INSCRIÇÃO N.o 437
Admitido em 30 de Janeiro de 1947 Categoria: Contribuinte
Residência ... Fone:
Trabalha á Rua Marconi 71 9º s/91 cep.01047 Fone:
Cidade São Paulo Estado SP
Bras. Data do Nascimento 3 / 3 / 11
Civil: casado Profissão: industrial
Correspondência Na Residência onde trabalha Deve ser cobrado Na Residência
REMIDO Palseio em / /1986-

FOTO-CINE CLUBE BANDEIRANTE — FICHA DE SÓCIO
NOME: AGOSTINELLI – José Julio
INSCRIÇÃO N.o 438
Admitido em 30 / Janeiro / 1947 Categoria: Contribuinte
Residência Rua Mbu-Guassú, 218 – Aeroporto Fone: 61-6959
Trabalha á Fone:
Cidade Estado
Nacionalidade Brasileira Data do nascimento: 6 / 5 / 1919
Estado Civil: Casado Profissão: Industrial
CARTEIRA de ... n.º 601.582
Correspondência Na Residência onde trabalha
Deve ser cobrado Na Residência
OBSERVAÇÕES: ELIMINADO Eliminado
Em 30/9/66

SERGIO D
FOTO CINE CLUBE BA — FICHA DE SÓC
NOME: SERGIO DOMINGOS TREVELLIN
Admitido em 28 de Maio de 1947
Residência R.
Trabalha á Rua Julio Conceição 737 cep
Cidade São Paulo
Nacionalidade Bras.
Estado Civil Solteiro
Correspondência Na Residência onde trabalha
OBSERVAÇÕES:

FOTO-CINE CLUBE BANDEIRANTE — FICHA DE SÓCIO

NTE
INSCRIÇÃO N.o 563
CONTRIBUINTE 9-45
(Cidade) Fone:
Fone:
nascimento 6 / 4 / 25
Biologista
procurado
ELIMINADO
EM 33/11/64
de 64

NOME: FEER – Oswaldo Willy
INSCRIÇÃO N.o 5936
Admitido em 18 / Janeiro / 1949 Categoria: CONTRIBUINTE
Residência Rua Zacarias de Góes, 393 – Apt. 6 Fone 6-3248
Trabalha á n.º CEP13200 Fone:
Cidade JUNDIAÍ Estado São Paulo
Nacionalidade Brasileira Data do nascimento: 29 / 11 / 1911
Estado Civil: Casado Profissão: Comerciante
CARTEIRA de ... n.º 499.322
Correspondência na residência onde trabalha
Deve ser cobrado na residência onde trabalha
OBSERVAÇÕES:

NOME: KAWAHARA – Kazuo
INSCRIÇÃO N.o 607
Admitido em 25 / março / 1949 Categoria: CONTRIBUINTE
Residência n.º () Fone:
Trabalha á Largo do Pires, 36 -12 - s.6 n.º () Fone: 32-374
Cidade SÃO PAULO Estado São Paulo
Nacionalidade Japoneza Data do nascimento: 18 / 11 / 1905
Estado Civil: Casado Profissão: Comerciante
CARTEIRA de ... n.º 532.914
Correspondência na residência onde trabalha
Deve ser cobrado DEMITIDO
OBSERVAÇÕES: Vejo minha demissão
Em 11/21/65

GATO
NOME: EIJIR
OBSERVAÇÕES

FOTO-CINE CLUBE BANDEIRANTE — FICHA DE SÓCIO

...CINE CLUBE BANDEIRANTE
...Marques da Silva
INSCRIÇÃO N.o 811
9 / novembro / 1950 Categoria CONTRIBUINTE
n.º 123 4º PB. 41 Fone 8-342
Rua Maria Antonia n.º 204 Fone 3-1783
CAPITAL Estado
Brasileira Data do nascimento: 25 / 2 / 1922
Casado Profissão: Funcionário Público
n.º 463.123 DEMITIDO
Em 5 / 5 / 66

NOME: CARNEIRO – André
INSCRIÇÃO N.o 846
Admitido em 20 / março / 1951 Categoria
Residência Rua... n.º 5 () Fone: 17
Trabalha á n.º () Fone:
Cidade ATIBAIA Estado S. Paulo
Nacionalidade Brasileiro Data do nascimento: 9 / 5 / 1922
Estado Civil: Solteiro Profissão: Jornalista
CARTEIRA de ... n.º 62995
Correspondência na residência onde trabalha
Deve ser cobrado na residência onde trabalha
OBSERVAÇÕES: ELIMINADO
Em 11/3/65

NOME: CARNEIRO – Dulce G.
Admitido em 20 / março / 1951 Categoria
Residência Rua Albuquerque Lins, 661-4º-Ap.42 n.º ()
Trabalha á n.º
Cidade ATIBAIA São Paulo Estado S. Pa
Nacionalidade Brasileira Data do nascimento
Estado Civil: Solteira Profissão: Jorn
CARTEIRA de ... n.º
Correspondência
Deve ser cobrado
OBSERVAÇÕES: Demitida a

FOTO-CINE CLUBE BANDEIRANTE — FICHA DE SÓCIO

...NDEIRANTE
INSCRIÇÃO N.o 1037
Categoria: CONTRIBUINTE
n.º () Fone: 92-4...
n.º 1-H Fone: 9-3713
Estado SÃO PAULO
Data do nascimento: 4 / 3 / 916
Profissão: INDUSTRIAL
Correspondência Cx.postal, 10119
Deve ser cobrado na residência

FOTO-CINE CLUBE BANDEIRANTE — FICHA DE SÓCIO
NOME: HIDE – Paulo Susuki
INSCRIÇÃO N.o 1165
Admitido em 9 / dezembro / 1954 Categoria: contribuinte
Residência Rua Japurá n.º 286 Fone: 35-8069
Trabalha á Senador Feijó na SÉ, 243-1º-s.26 Fone: 37-116
Cidade São Paulo Estado
Nacionalidade Japoneza Data do nascimento: 15 / 3 / 925
Estado Civil: solteiro Profissão: eletricista
CARTEIRA de Estrangeiro Reservista n.º
Correspondência onde trabalha
Deve ser cobrado onde trabalha ELIMINADO
Em 6/1/63
OBSERVAÇÕES: Em 13-2-57 – Pediu licença por um ano, para tratamento de saúde. Em 27-2-57 – Foi atendido (Fevereiro 1957 a Janeiro 1958).

JOÃO B

FOTO CINE CLUBE BANDEIRANTE — FICHA DE SÓCIO
NOME: JOÃO BIZARRO DA NAVE FILHO
INSCRIÇÃO N.o 1.450
Admitido em 17 de junho de 1958 Categoria: Contribuinte
Residência Rua Rio de Janeiro, 212 / 7º Cep 01240 Fone: 67-9845
Trabalha á Rua Cantagalo, 76 Fone:
Cidade São Paulo Estado SP
Nacionalidade Português Data do Nascimento 14 / 05 / 1908
Estado Civil: Casado Profissão: Industrial
Correspondência Na Residência
Deve ser cobrado Na Residência
OBSERVA

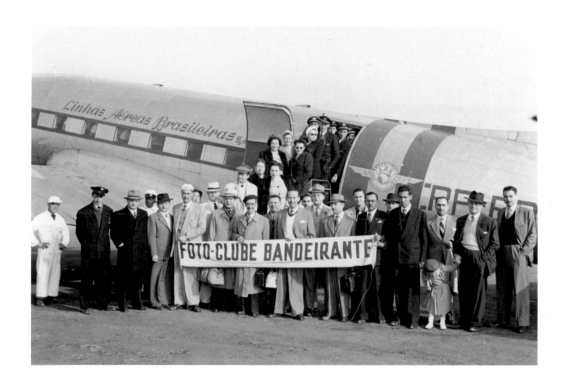

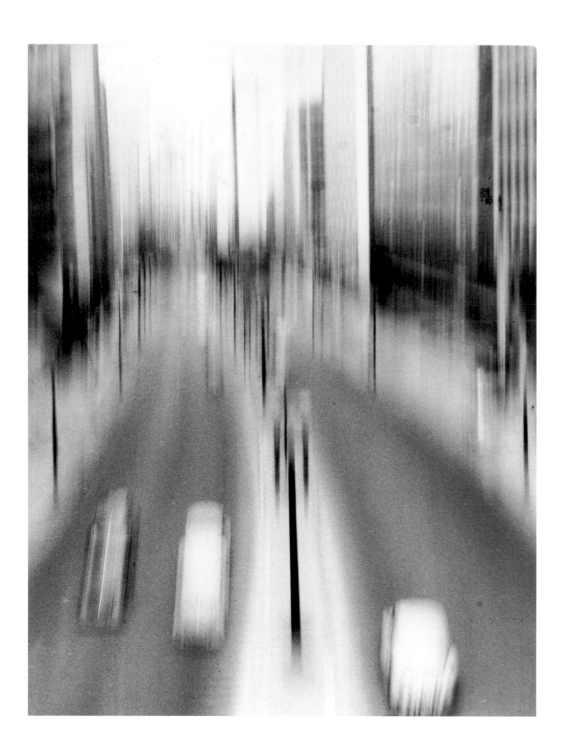

FOTOCLUBISMO

**Brazilian Modernist Photography
and the Foto-Cine Clube Bandeirante
1946-1964**

Sarah Hermanson Meister

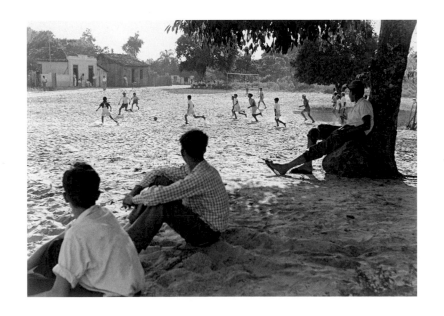

The Museum of Modern Art, New York

CONTENTS

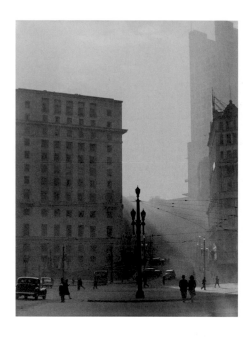

6 FOREWORD
 Glenn D. Lowry

8 ACKNOWLEDGMENTS

10 EXCELENTE, BOM, SOFRÍVEL, POBRE:
 JUDGING POSTWAR PHOTOGRAPHY IN BRAZIL
 Sarah Hermanson Meister

PLATES
The thematic groupings in the plate section are distilled from assigned
subjects for Foto-Cine Clube Bandeirante's monthly photo contests,
which are listed on the first page of each section.

40 I.
 Architecture
 José Yalenti
 Abstractions from Nature

66 II.
 Solitude
 Gertrudes Altschul
 Shadows

88 III.
 Daily Life
 Thomaz Farkas
 Nocturnes

104 IV.
 Experimental Processes
 Geraldo de Barros
 Texture and Shape

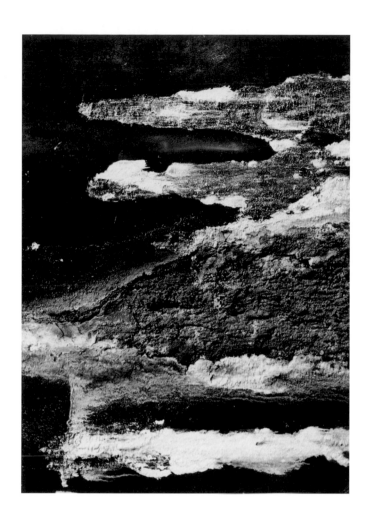

130 **V.**
Rain
German Lorca
Simplicity

148 **VI.**
"Table-Tops"
Marcel Giró
Movement

164 *BOLETIM FOTO-CINE:*
AN ANNOTATED AND ILLUSTRATED CHRONOLOGY
Liz Donato

178 FCCB MEMBERS IN *FOTOCLUBISMO*

184 TRUSTEES OF THE MUSEUM
OF MODERN ART

FOREWORD

Fotoclubismo: Brazilian Modernist Photography and the Foto-Cine Clube Bandeirante, 1946–1964 introduces an important chapter in the history of postwar art to audiences outside Brazil, but the seeds were first planted in late 1948 when Edward Steichen, the newly appointed director of the Museum's Department of Photography, received a visit from a São Paulo–based photographer and filmmaker named Thomaz Farkas. Only twenty-four at the time, Farkas, a founding member of the Foto-Cine Clube Bandeirante, had been experimenting with a camera for more than a decade. Within a year of that momentous encounter, two photographs that Farkas made during his visit to MoMA (below and opposite) would feature in his first solo exhibition at the Museu de Arte Moderna de São Paulo (MAM). In a letter to Steichen in January 1949, Farkas revealed that this new museum of modern art would open before the end of the month. With characteristic humility he wrote, "Somehow they put me on the photography committee," mentioned nothing of the plans for his own exhibition, and proposed

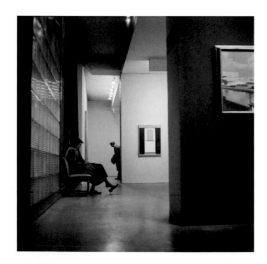

that their two museums could "do some kind of exchange activities," although nothing emerged from this suggestion. Farkas also indicated he was sending, under separate cover, a group of prints in which Steichen had expressed interest; he hoped the curator would find them "technically suitable." Evidently, they were: Steichen included one in his 1951 exhibition *Abstraction in Photography*, and it was exhibited again and formally accessioned in 1959—making it the first photograph by a Brazilian artist to enter the Museum Collection. The six other prints remained in storage, largely untouched, until 2014, when an inquiry from the Farkas family coincided with the beginning of the research that led, eventually, to *Fotoclubismo*.

The Museum's engagement with art from Latin America, while imperfect and prone to lapses (such as the one involving Farkas), is deep and longstanding. The Mexican muralist Diego Rivera was the subject of a one-person exhibition in 1931, as was the Brazilian painter Candido Portinari in 1940. By January 1942 the building of the collection was sufficiently robust as to warrant an exhibition of recent acquisitions by Latin American artists (the highlight of which was a sculpture by the Brazilian Maria Martins), and in 1943 the Museum presented *Brazil Builds*, a survey of four centuries of Brazilian architecture. MoMA's commitment to the region has been amplified in more recent decades in three distinct but interrelated ways: curatorial focus, acquisitions, and exhibitions. In 1999 the Museum welcomed Paulo Herkenhoff, the institution's first curator of Latin American art. In 2003 Luis Enrique Pérez-Oramas assumed this role, which became permanent when Estrellita Brodsky endowed the position, now held by Beverly Adams. The scope and ambition of the Museum's engagement in this field was transformed in 2018 when Inés Katzenstein became Curator of Latin American Art and the inaugural director of the Patricia Phelps de Cisneros Research Institute for the Study of Art from Latin America; the work of the institute complements C-MAP (Contemporary and Modern Art Perspectives), a cross-departmental research initiative founded at the Museum in 2009 that encourages curators to attend to histories outside of North America and Western Europe. It is under the aegis of C-MAP that Sarah Meister's interest in Brazilian photography clubs was able to take root.

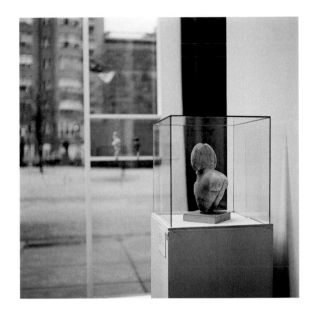

Opposite: Thomaz Farkas. *View of the Museum Collection* (*Vista da coleção do museu*) [The Museum of Modern Art, New York]. 1948. Collection João Farkas and Kiko Farkas

Right: Thomaz Farkas. *View of the exhibition "Timeless Aspects of Modern Art"* (*Vista da exposição "Aspectos atemporais da arte moderna"*) [The Museum of Modern Art, New York]. 1948. Collection João Farkas and Kiko Farkas

The sixty photographs from the Museum Collection featured in this publication and in the exhibition it accompanies came to us thanks to the Committee on Photography, expertly chaired by David Dechman, and to the Latin American and Caribbean Fund, established through the leadership of Patricia Phelps de Cisneros, as well as to the extraordinary generosity of individuals associated with each. I would particularly like to acknowledge the contributions of Ian Cook, David Dechman, Thomas Dunn, Donna Redel, and Richard O. Rieger, and all members of the Committee on Photography, as well as former members John Pritzker, Amie Rath Nuttall, and Lois Zenkel. Additionally, the following members of the Latin American and Caribbean Fund supported these acquisitions above and beyond his or her due: Estrellita Brodsky, Patricia Phelps de Cisneros, Adriana Cisneros de Griffin, Agnes Gund, Marie-Josée and Henry R. Kravis, Ramiro Ortiz, José Olympio da Veiga Pereira, Ernesto Poma, and Alfredo Egydio Setubal. Our ability to introduce visitors to photography from across Latin America in our temporary exhibitions and in our collection galleries has been transformed by these magnanimous contributions.

As our galleries increasingly function as places of encounter with less familiar but vitally important art historical narratives, these acquisitions of the work of amateur photographers active in Brazil in the mid-twentieth century bolster our efforts to celebrate previously marginalized artists and geographies. I would like to thank Sarah Meister, Curator, and Dana Ostrander, Curatorial Assistant, in the Robert B. Menschel Department of Photography, for putting at center stage the extraordinary achievements of a group of photographers whose names you have likely never heard. Sarah has situated this body of work within the dynamic international network that engendered it, and she brings a fresh perspective to amateur practices too often overlooked. Perhaps the greatest contribution of Sarah's show, however, is its challenge to viewers, first to acknowledge, and then to question, the implicit biases we inescapably bring with us when we judge the value of a work of art (or of anything, really). The connection between this important aesthetic labor and the crucial work that lies before us of creating a more just and equitable society will not be lost on many viewers of the show—indeed, we hope it will become apparent to all.

Fotoclubismo would not be possible without key loans from several important São Paulo collections (and one in New York) that, together with MoMA's holdings, offer an unparalleled view of the Brazilian amateur photography scene at midcentury. I wish to thank our lenders—the Museu de Arte de São Paulo (MASP); Itaú Cultural; Fernanda Feitosa and Heitor Martins; João Farkas and Kiko Farkas; Ricardo and Susana Steinbruch; and David Dechman and Michel Mercure—for their collaboration in the midst of unprecedented global adversity. The exhibition accompanying this pioneering publication has been made possible by the exceptional generosity of David Dechman and Michel Mercure—steadfast champions of this project from its origins, and of photography at the Museum in general—and Rose and Alfredo Setubal.

Finally, I would like to thank Clément Chéroux, The Joel and Anne Ehrenkranz Chief Curator of Photography, for his leadership of the Department of Photography in these very challenging times.

Glenn D. Lowry
The David Rockefeller Director
The Museum of Modern Art

ACKNOWLEDGMENTS

It is a joy and a privilege to introduce the work of the Foto-Cine Clube Bandeirante to audiences outside of Brazil. I am all too aware that this project was unachievable without the generosity and support of (literally) hundreds of colleagues and friends, and I profoundly regret I cannot mention everyone by name. (I leave out professional titles here to make room for as many acknowledgments as possible.) The foundational scholarship of Helouise Costa deserves to be much better known outside Brazil, and the work of Heloisa Espada is likewise indispensable. I am deeply indebted to both Helouise and Heloisa for their collegiality and seemingly unending patience with my questions. If I have inadvertently referenced something they wrote in Portuguese but only mentioned in passing in one of our many conversations, I apologize. Even without direct quotations, this work is deeply indebted to them both.

There are a handful of individuals affiliated (or formerly affiliated) with MoMA who have been similarly essential. First, Patricia Phelps de Cisneros has made it possible for this non-Portuguese-speaking curator to develop a respectable expertise in postwar Brazilian photography. Her leadership, through the Latin American and Caribbean Fund and elsewhere, has made possible the acquisition of many of the works featured in *Fotoclubismo*. Patty's efforts are complemented by C-MAP, the research initiative founded by Kathy Halbreich and now overseen by Jay Levenson and our colleagues in MoMA's International Program. I am very grateful for the learning opportunities C-MAP fostered, both on Fifty-Third Street and during multiple trips across Latin America. Luis Pérez-Oramas has been a fellow traveler for many of these, and it was he who first pushed me to grapple with the achievements of an amateur photography club in São Paulo. Luis's absence from MoMA is keenly felt, but much less than it would have been thanks to the arrival of Inés Katzenstein, whose friendship and constructive feedback have profoundly enriched my thinking. There are four other individuals whose contributions deserve more credit than we have space to express. Abigail Lapin Dardashti, a Museum Research Consortium Fellow in 2016–17, laid the groundwork for all that has followed, in part through her flawless orchestration of a major symposium (more on that below). Liz Donato was equally indispensable in the same role in 2017–18; this book's Chronology was just one of the fruits of her labor. We welcomed Tiê Higashi as a 12-Month Intern in September 2018; her creative research and superb organizational skills were invaluable to this project. Last but certainly not least, Dana Ostrander has been instrumental in countless ways and under unprecedentedly challenging circumstances. To these four brilliant collaborators, I offer my sincerest thanks.

Nearly half the plates in *Fotoclubismo* are drawn from MoMA's collection; the rest come from important institutional and private collections. On behalf of everyone at the Museum I want to thank our generous lenders: in New York, David Dechman and Michel Mercure, and in São Paulo, Susana and Ricardo Steinbruch (with Vivian Bernfeld), João Farkas and Kiko Farkas, Fernanda Feitosa and Heitor Martins (with Ana Francisca Salles Barros) and the exceedingly helpful teams at MASP (Adriano Pedrosa, above all, but also Paula Coelho Magalhães de Lima and Cecília Winter) and Itaú Cultural (especially Sofia Fan and Naiade Margonar Gasparini). These lenders have not only made it possible for us to feature their works in our exhibition, they have also warmly welcomed me into their homes and offices, spent their afternoons accompanying me to storage facilities, and offered me meals, coffee, and (when the occasion demanded) wine. They have checked and rechecked data, provided images, and generously shared insight and information regarding works in their care. I cannot wait to share their treasures with our audiences.

One singular highlight of my research has been getting to know German Lorca and benefiting from his astounding recall of the era *Fotoclubismo* explores. Many family members of artists featured here have been endlessly patient and supportive, and I would particularly like to thank Ernst Oscar Altschul, Fabiana de Barros and Michel Favre, João Farkas and Kiko Farkas, Gaspar Gasparian Filho, J. Henrique Lorca and

Frederico Lorca, and Marcio Scavone. We were introduced to many of these families through Pablo Di Giulio and Marcella Brandimarti at Utópica, Isabel Amado (and Renata Baralle), Iatã Cannabrava (and Andressa Cerqueira), Luciana Brito, and Eric Franck; each has facilitated the Museum's acquisitions with exemplary professionalism. I have treasured my conversations with two contemporary artists who bring uniquely valuable perspectives to this work: Vik Muniz and Rosângela Rennó, who curated a major FCCB exhibition at MASP in 2015–16. In addition to those institutions that are lending works from their collections, I would also like to thank four others for their invaluable support: Instituto Moreira Salles (particularly Heloisa Espada, Sergio Burgi, Thyago Noguiera, and Samuel Titan), Museu de Arte Moderna de São Paulo, Pinacoteca do Estado de São Paulo, and above all, the Foto-Cine Clube Bandeirante and its president, José Luiz Pedro.

Many people around the world have kindly helped build context around the FCCB's achievements, and to them I extend my heartfelt thanks: In Mexico City, Aldo Iram Juárez (president of the Club Fotográfico de México) and Patricia and José Antonio Rodríguez; in Buenos Aires, Facundo de Zuviría, Marina Pellegrini at Galería Vasari, and Alicia Sanguinetti (Annemarie Heinrich's daughter); in Paris, Anais Feyeux, and the Société Française de Photographie (Marion Perceval and Vincent Guyot); in Tokyo, Katsuya Ishida at MEM gallery and scholars Ryuichi Kaneko and Miyuki Hinton; and in Barcelona, Joan Sorolla, and Isabel Sozzi at Galería RocioSantaCruz.

In May 2017 Abigail Lapin Dardashti and I organized "In Black and White: Photography, Race, and the Modern Impulse in Brazil at Midcentury." The keynote panel was held at MoMA, where Edward Sullivan moderated a conversation, following presentations by Roberto Conduru, Helouise Costa, Heloisa Espada, and me. (A recording is available on the Museum's YouTube channel.) The following day, at CUNY's Graduate Center, we were treated to presentations by Adrian Anagnost, Monica Bravo, Paula Kupfer, Lucas Menezes, Marly Porto, Marcio Siwi, Danielle Stewart (who was also an astute early reader of this manuscript), Alise Tifentale, and Abigail, moderated by Claudia Calirman, Anna Indych-López, and Harper Montgomery. (Audio recordings of each panel are accessible through the Center for the Humanities programming page.) To say that I learned an enormous amount from each of these individuals, not only at the symposium but in the years that followed, is a gross understatement. Thank you all.

At MoMA many colleagues—far more than I can name—played a vital role in making this show happen, beginning with the leadership of Glenn Lowry. In the Department of Photography I want to thank the current and former chief curators, Clément Chéroux and Quentin Bajac, as well as Dana Bell, River Bullock, Megan Feingold, Lucy Gallun, Tasha Lutek, Roxana Marcoci, Dana Ostrander, Jane Pierce, Marion Tandé, Phil Taylor, and two very valued interns, Benjamin Clifford and Sarah Myers. To our honorary department members, Ellen Conti and Lee Ann Daffner, please know how grateful I am for your attention and care. A handful of other colleagues have been exceptionally helpful and kind: thank you Beverly Adams, Starr Figura, Karen Grimson, Ruth Halvey, Jodi Hauptman, and Josh Siegel.

As a consequence of the coronavirus pandemic, this book is slightly smaller, with fewer pages, and without planned contributions from Helouise and Heloisa, or from Sergio Burgi, Rubens Fernandes Junior, Beatriz Jaguaribe, Alexa Le Blanc, and Adele Nelson. I will, nonetheless, always be grateful to each one of them. Thanks to the peerless team in our Department of Publications, this book is still (almost) everything I had hoped it would be. Thank you, Naomi Falk, Emily Hall, Christopher Hudson (now enjoying retirement), Hannah Kim, Curtis Scott, and especially Don McMahon, Marc Sapir, and Amanda Washburn. Even a thousand words couldn't capture my gratitude.

Personal thanks are a luxury I almost cannot afford, but I must mention Sophie Hackett, Corey Keller, Sarah Kennel, Casey Riley, and Liz Siegel for their wise counsel during these Ongoing Moments. And, as always, with love and gratitude to Adam, Madeline, and Lee, who make it all worthwhile.

Sarah Hermanson Meister
Curator, The Robert B. Menschel
Department of Photography

Título da Fotografia Fotógrafo:

Resultado da Apreciação crítica: (1)

Colunas de avaliação: EXCELENTE | BOM | SOFRÍVEL | POBRE

Factor Mecânico-Tecnicológico

- Câmara Fotográfica
 - Foco ..
 - Definição
 - Exposição
 - Escolha de Filtro

- Iluminação

- Impressão do Positivo
 - Papel
 - Profundidade do Tom
 - Abundância de Gradação
 - Habilidade na Impressão
 - Retoque
 - Conveniência da Viragem
 - Processos Não Convencionados

Factor Psicológico

- Tema
 - Género
 - Original
 - Comum
 - Animado
 - Inanimado
 - Composição
 - Utilitária
 - Representativa
 - Expositiva
 - Decorativa
 - Atributos da Forma Temática
 - Unidade
 - Vitalidade
 - Infinidade
 - Repouso

- Esbôço e Composição
 - Perspectiva Visual
 - Conjunto
 - Quanto ao Arranjo
 - Distribuição de Tonalidade .
 - Colocação do Centro de Interêsse
 - Conveniência da Gradação
 - Equilíbrio

Considerações Estético-Filosóficas — Reacção Geral à Fotografia

Análise efectuada por:

..

Nota: (1) Pode-se apresentar o resultado da análise crítica por meio de pontos, se houver conveniência em assim proceder, estabelecendo-se, então, coeficiente relativo.

Excelente, Bom, Sofrível, Pobre

JUDGING POSTWAR PHOTOGRAPHY IN BRAZIL

In 1948 Desidério and Tereza Farkas sent their twenty-four-year-old son Thomaz on an extended adventure across the United States in a failed attempt to cool his affections for the young woman who would soon become his wife. Farkas had been immersed in photography from birth: his family's photographic supply business made the long journey with them from Budapest to São Paulo in 1930; considering the world through a camera lens was as natural as breathing for Farkas. He was an inventive, precocious filmmaker and photographer, and when he joined São Paulo's Foto-Cine Clube Bandeirante (FCCB) in 1939, on the very day the club was formed, he was by far its youngest member—so young, in fact, that his parents' consent was required.[1] He was clearly well-liked: News of a postcard he sent from this trip abroad to his fellow Bandeirantes, or "Pioneers"

Sample *papeleta* (scorecard) listing the four suggested terms for assessing a variety of mechanical, technical, and psychological factors: *excelente, bom, sofrível,* and *pobre* (excellent, good, fair, poor). Reproduced in Alvaro P. Guimarães Jr., "Elementos para a crítica fotográfica" ("Elements of Photographic Critique"), *Boletim foto-cine* 85 (December 1953): 10

(more on the significance of the club's name later), merited its own paragraph in the November 1948 *Boletim foto-cine*, the club's monthly magazine, where he was affectionately referred to by the diminutive "Farkinhas."[2] Elsewhere in the same issue one finds a photograph of him "in action" on a club excursion. His professional and personal milestones were featured frequently on the pages of the *Boletim* over the years, including in March 1949, when he and his bride, having overcome his parents' objections, passed beneath a wedding arch formed by the cameras and tripods of his fellow FCCB members (see Chronology, March 1949, page 166, and "Excursions," page 167).

While in the US, Farkas met with the photographer Edward Weston in California, and in New York with Edward Steichen, the director of the Department of Photography at The Museum of Modern Art.[3] This visit to MoMA was critically important for two reasons: First, one of the seven examples of his work that Farkas sent to Steichen in January 1949 (after their New York encounter) would become the first photograph by a Brazilian artist to enter MoMA's collection (and his gift as a whole is the foundation of the present exhibition). Second, and only slightly less significant, the exhibition designs he encountered at the Museum would inspire creative display strategies for his solo exhibition at the Museu de Arte Moderna de São Paulo (MAM) in June 1949. "How impressed I was with everything in the museum," he wrote in a letter to Steichen. "What I saw in the States was excellent and it was like a cold shower in [sic] a warm day: refreshing and invigorating."[4] Also while in New York, Farkas secured copies of several experimental films by Maya Deren to share with a growing network of amateur cinema enthusiasts back home.[5]

Farkas was a central member of the Foto-Cine Clube Bandeirante from its inception. His regular presence in the *Boletim* evinces not only the camaraderie among members

generally—as its name suggests, FCCB was a club, and a social one at that—but also the affection and esteem the Bandeirantes felt for him personally. Farkas was, nevertheless, an outlier, and not only because of his youth. He was rare among FCCB members in that photography was a primary preoccupation for him, not simply a hobby enjoyed on evenings and weekends.[6] The vast majority of the club's members were amateurs in the sense that they made their livings in business, medicine, law, journalism, civil service, engineering, and many other professions (see list of FCCB members, pages 178–80).[7] Their photographs attest to the seriousness and skill with which they approached the medium; their amateur status figures prominently among the reasons why this chapter of photographic history has been largely overlooked outside Brazil.[8]

Photographers have struggled with the fact that "anyone" can make a photograph since at least 1889, when Kodak introduced the No. 1 camera with the promise "You push the button, we do the rest." The challenge is only intensified today: if anyone with a mobile phone can take a picture—and millions do every hour—how do we distinguish those photos that are truly worthy of our attention? On what basis do we make this judgment? What are the mechanisms by which a photograph is elevated from the Niagara of images—snapshots, selfies, Instagram posts, fashion blogs, commercial advertisements, and other modes of picture taking—to achieve the status of art? Who are the gatekeepers? At least since 1971, with Linda Nochlin's provocative essay "Why Have There Been No Great Women Artists?," we have been encouraged to attend to structural and institutional barriers: the fact that work by FCCB photographers is in so few collections, public or private, outside of Brazil remains a significant obstacle to their integra-

tion into histories written in the northern hemisphere.[9] The perils Nochlin identified in relying on terms such as "genius" continue to resonate today as we reexamine not only gender-based discrimination but also the ways in which these terms reinforce the structures that have historically privileged the work of white male artists in Western Europe and the US. As critical thinkers such as the Cuban scholar and curator Gerardo Mosquera have suggested, the geographic bias of our art historical narratives presents another challenge in bringing these works into dialogue with achievements more familiar to MoMA's audiences.[10]

Nonetheless, for many years following World War II, photographs by FCCB members were an integral part of a dynamic international network of exchange. Their work was awarded prizes in salons on six continents; at their headquarters in São Paulo they received distinguished guests from around the world; they commissioned articles from esteemed members of the Brazilian art establishment to hone their critical perspectives. Their activities were anchored in their hometown, and their sense of Bandeirante pride emanated from their Paulistano identity, yet they fought fiercely for their role on the international stage and reported regularly on developments from abroad. The *Boletim* captures all this and more: through it we are able to grasp whose work was valued by the club's leadership and (often) why. This compulsion to articulate and defend just what it is that makes a "good" photograph is itself an under-studied thread that connects the artists of the New York–based Photo-Secession (who sought to distinguish their work from the hordes of professionals and Kodak-wielding amateurs at the turn of the twentieth century) to the postwar photo-club circuit, and it is close to the heart of MoMA's own history and evolving

Fig. 1. *Boletim foto-cine* covers (from left): n° 8 (December 1946; photograph by Felix de Cossio); n° 13 (May 1947; photograph by Angelo F. Nuti); n° 47 (March 1950; photograph by Aldo Augusto de Souza Lima); n° 121 (February/March 1961; photograph by Nelson Peterilini)

attempts to define what is worthy of being considered "modern art."[11] Thus the near-complete exclusion of these figures to date, in light of their irrefutable appeal, should also be understood as a critique of this institution's own vexed efforts to make sense of the marvelously sprawling, unruly medium of photography.

This book and the exhibition it accompanies focus exclusively on the club's photographs deemed most interesting to a particular New York–based curator writing in 2020, while avoiding those pictures that seem (to her) imitative or clichéd (fig. 1). Selection for an exhibition is implicitly an argument about what work is worthy of close consideration and what work not, but we must acknowledge our own blindness to forces that influence our aesthetic choices—forces as invisible, and inescapable, as taste.[12] This essay seeks to ground its judgments by contextualizing the work of the FCCB, anchoring the analysis in more (and less) familiar contemporaneous activities in Brazil, as well as in a handful of cities elsewhere in the Americas and Europe.

Both the book and the exhibition present in depth the work of six photographers—Gertrudes Altschul, Geraldo de Barros, Thomaz Farkas, Marcel Giró, German Lorca, and José Yalenti—allowing audiences an opportunity to appreciate the range of their achievements.[13] Yet to appreciate the full scope of the club's vibrant heyday, it is essential to share examples of equally compelling work by dozens of other FCCB members who toiled in the same darkroom, sat through the same lectures, participated in the same contests, ventured out on the same excursions, and submitted their prints to the same salons.[14] These diverse works are organized in groupings derived from the assigned subjects of the club's *concursos internos* (internal contests), and those thematic constellations bookend

six focused presentations of individual photographers' work. (The names of these artists and the thematic subjects are listed at the beginning of each section of plates.) The dates that bracket the temporal scope of the exhibition correspond to artistic, political, and practical realities in Brazil: 1946 was the year the FCCB first published its *Boletim*; it was also the year in which a new constitution was adopted and democracy restored, following Gétulio Vargas's repressive Estado Novo regime. On the other end, 1964 marked the beginning of a brutal military dictatorship that would last more than two decades. By the time of that US-backed coup d'état, the innovation and creativity associated with amateur photo clubs around the world was already on the wane, and the censorship and repression ushered in by the dictatorship marked the end of an extraordinarily fertile era for photography in Brazil.[15]

As with most amateur photo clubs around the world, from the nineteenth century to the present day, the FCCB fostered a collegial environment, yet it was also a competitive one. There were strict hierarchies, and the *Boletim* is filled with reports on prizes awarded, charts that ranked each member according to points they had earned in internal contests or international salons, and examples of forms used to judge specific works (see page 10). Helouise Costa—curator, professor, and foremost authority on Brazilian modernist photography—points out the risks in approaching this work without a sufficiently nuanced appreciation for its context, cautioning against "the possibility of forming narrow interpretations based on old models that neglect the inherent otherness of this production."[16] In introducing the FCCB's work to North American audiences today, we underscore the club's historic impulse to rank, compare, and judge as we pursue a fresh—and validating—perspective on amateur practices.

SNAPSHOT: ART IN
BRAZIL AT MIDCENTURY

Seventy years ago the very idea of a museum that exhibited modern art was a challenge for most audiences. To refer to MoMA or any comparably focused museum as an "institution" at that time would have been to suggest a sense of permanence that belied the precarity of its circumstances. Until 1953, for instance, as a matter of Museum policy, paintings by Cézanne, Matisse, and Picasso, once the artists were deemed "established" (and thus, arguably, no longer "modern"), would be transferred by a cooperative agreement from the upstart MoMA to the venerable Metropolitan Museum of Art.[17] Such was the cost a museum such as MoMA had to pay in order to secure, even temporarily, gifts of notable canvases from generous donors. The status of photography as an art form was similarly tenuous. Although MoMA's founding director, Alfred H. Barr Jr., had envisioned a museum that embraced a multivalent approach to modernism, encompassing film, architecture, design, photography, and more, it would take him a decade to persuade the Museum's trustees to create a Department of Photography (which they did, in December 1940). That the city of São Paulo established not one but two major museums attentive to modern art in the years after the Second World War, and that by January 1951 each of these had mounted solo exhibitions of work by young, experimental photographers, is, frankly, remarkable.[18]

On July 21, 1949, the recently inaugurated MAM opened *Estudos fotográficos* (*Photographic Studies*), an exhibition of sixty prints by Farkas. Although the exhibition was installed in the Salão Pequeno (the smaller of the museum's two galleries)—paintings by the Brazilian modernist Cícero Dias filled the larger space—the exhibition design, developed in collaboration with the architects Miguel Forte and Jacob Ruchti, expressed the ambition and daring of the artist whose work appeared in it.[19] The focal point of the display was a long wall against which leaned twenty-four parallel white supports (figs. 2, 3). Farkas's photographs were affixed in irregular patterns to this scaffolding, along with a handful of imageless surrogates (light and dark panels of similar scale). Purposefully resisting the hallmarks of traditional displays, both the imageless panels and the photos were installed without mats or frames, often far above or below optimal viewing height, their shadows forming asymmetric echoes against the wall. Photographs from Farkas's series depicting dancers from the Ballet Russe de Monte Carlo (published in *Rio* magazine, also in July 1949) were mounted on two hollow triangular supports, one white, one black, each dangling between floor and ceiling, in a manner reminiscent of twirling figures on a stage. Some photographs were secured to freestanding panels forming geometric patterns in dialogue with the architecture represented in the images, while other rectangular, high-contrast images of various sizes unfolded along a wall, their top edges aligned. This was ostensibly an exhibition of photographs, but a viewer's approach to the individual prints was everywhere subsumed within taut, immersive graphic arrangements.[20]

Farkas's daring was admired if not entirely understood by his fellow Bandeirantes, who reported in the *Boletim foto-cine*:

We are delighted to report that the renowned amateur "Bandeirante" Thomaz J. Farkas's exhibition of his Estudos fotográficos *opened at the Museu de Arte Moderna on the twenty-first of this month. It seems like only yesterday that the fifteen-year-old Thomaz introduced himself to*

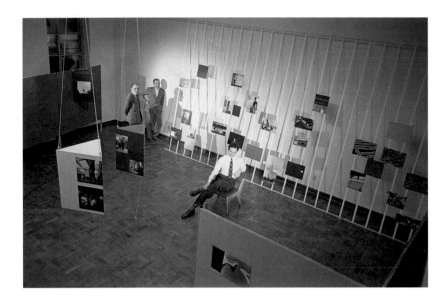

us at the FCCB clubhouse, written parental consent having been granted so that he might join our ranks. Young Farkas trained at the club, and his promising future in Brazilian art photography was obvious from the outset.

He never conformed to convention, breaking from the shackles of tradition, focusing boldly on the investigation of dynamic, luminous rhythms, his temperament steering him away from the prevalent romanticism. From the beginning, he daringly infringed on classical canons so as to highlight content over form. . . . Not always understood, he is nevertheless admired as an artistic photographer both here and abroad, having established himself as a striking, distinctive personality.

His solo exhibition is raising considerable interest and drawing a large crowd of photography lovers to the Museu de Arte Moderna's Salão Pequeno.[21]

A generous suite of installation views, presumably staged by Farkas, enables us to fully appreciate the innovation and intentionality of this display. And while it may be immediately apparent that the show's design represents a dramatic departure from the regular grids of matted and framed photos that were standard methods of photographic display, it should be noted that *Estudos fotográficos* demanded the active engagement of the viewer and an attentiveness to voids and shadows long before these became embedded in expectations for experiencing art.

MAM had opened to the public in March 1949 with the exhibition *Do figurativi-*

simo ao abstracionismo (*From Figurativism to Abstraction*), organized by the Belgian art critic Léon Degand. Although the strict geometries of Concrete art were beginning to gain traction in South America, particularly in Argentina, it would be several years before this commitment was equally evident in Brazil.[22] Farkas found his abstractions in the architecture and industry of postwar Brazil, and the geometric design of his exhibition at MAM underscored his formal interests. That it was a photographer and not a painter who had anticipated the abstract turn in Brazilian art begins to explain why Farkas's precocious work rarely factors into scholarship on postwar geometric abstraction.[23]

A year and a half after *Estudos fotográficos*, attentive audiences in São Paulo would have encountered another solo exhibition of a photographer whose work presented an even greater challenge to the status quo, in the same building on rua Sete de Abril in downtown São Paulo. On January 2, 1951, Geraldo de Barros's *Fotoforma* opened at the Museu de Arte de São Paulo (MASP), featuring some twenty-five photographs that rested on pedestals or were secured on floor-to-ceiling aluminum poles around the perimeter of the museum's temporary exhibition space (figs. 4, 5).[24] MASP

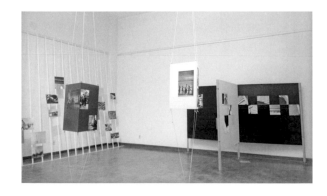

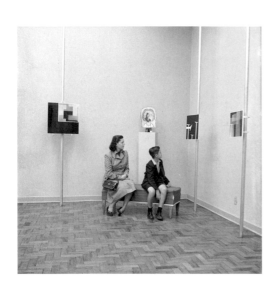

Figs. 4 and 5. Installation views of Geraldo de Barros, *Fotoforma*, Museu de Arte de São Paulo, January 1951

had been open for just over three years, and de Barros, who supported himself through a day job at Banco de Brasil, was not quite twenty-eight.[25] He had been an active member of the FCCB since May 1949 but chafed against the lingering conservatism of the club's leadership. (In response to de Barros's proclamation, reported in the November 1949 *Boletim*, that "the artist must not hold himself to commitments or rules of any sort, allowing himself to build freely upon his own ideas, whether in his choice of subject matter or in its composition," at least four members publicly disagreed.)[26] De Barros was attentive to avant-garde theories of perception and to innovative practices (in photography, painting, and sculpture) outside of Brazil: the title of his exhibition echoes, likely coincidentally, Fotoform, the name of a group just then emerging in Germany.[27] Like Farkas, de Barros was breaking boundaries between his photographs and the physical spaces they inhabited, aligning edges and compositional elements in his pictures with the structures upon which they were displayed, but he also challenged the assumption that photographs were flat, rectangular objects, rendering several of his "images" sculptural by trimming the prints to accentuate the camera's distortions and pointing to the arbitrariness of seeing as if through a window (see pages 3, 117). These unconventional pictorial shapes and structures were so unintelligible to de Barros's fellow FCCB members that the exhibition went unmentioned in the *Boletim*. Pietro Maria Bardi, MASP's founding director, wrote an introductory text for the exhibition brochure

that may have compounded the issue: "Geraldo focuses on certain aspects or elements of reality and, especially, on details that are ordinarily invisible: abstract signs of Olympian fantasticalness; lines it pleases him to interweave with other lines in an alchemy of more or less improvised . . . combinations that always end up in compositions of pleasing formal harmonies."[28]

However perplexed the response to *Fotoforma* may have been, de Barros was not around long to defend himself; he had received a grant from the French government and departed for Paris the following month. His name appears in the *Boletim* as a foreign correspondent in Paris from February through November 1951, during which time he traveled extensively throughout Europe, continuing to photograph. Upon his return to São Paulo, however, he turned to painting, participating in the inaugural exhibition of Grupo Ruptura (a group of abstract artists instrumental in establishing Concrete art in Brazil) at MAM in December 1952.[29] In de Barros's practice,

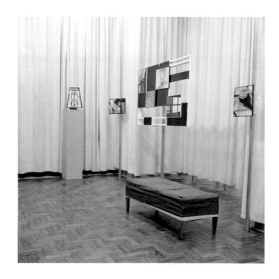

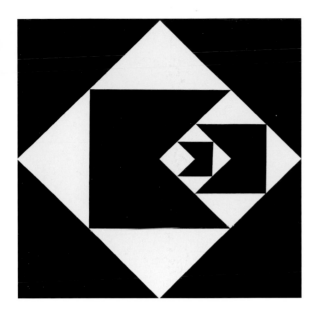

Fig. 6. Geraldo de Barros. *Diagonal Function (Função diagonal)*. 1952. Lacquer on wood, 24¾ × 24¾ × ½ in. (62.9 × 62.9 × 1.3 cm). The Museum of Modern Art, New York. Gift of Patricia Phelps de Cisneros through the Latin American and Caribbean Fund

Fig. 7. Geraldo de Barros, "A sala de fotografia" ("The Photography Gallery"), *Boletim foto-cine* 87 (February/March 1954): 12–15, with photographs by Plínio S. Mendes, Eduardo Salvatore, and José Yalenti

and in Brazil more broadly, abstraction in photography anticipated abstraction in painting.[30] The precision and predictable transformation (through repetition) of the gradually turning, diminishing square in his painting *Função diagonal* (*Diagonal Function*, 1952) (fig. 6) can at times seem worlds away from the sense of improvisation that united de Barros's series Fotoformas. And before long, he would change mediums again, deploying computer punch cards from his day job as "lenses" through which he exposed photographic paper (see page 114). His socialist leanings (as well as this general creative restlessness) would then lead him to utilitarian furniture design: beginning in 1954 the chairs he designed for Unilabor would feature in a new series of multiple exposures.

Even as de Barros was drifting away from photography, an opportunity emerged in late 1953 that was too tempting to resist:

organizing a display of work from the FCCB for the 2ª Bienal de São Paulo. The First Bienal had opened in October 1951, amplifying local efforts to establish the city as the artistic heart of the country (although Rio de Janeiro was still the capital) and to solidify Brazil's reputation in the art world at large. The second installment of the biennial, in the expansive, newly constructed Oscar Niemeyer–designed exhibition hall in Ibirapuera Park, would feature two galleries devoted to photography (see Chronology, December 1953, page 171, and "Photography at the Second São Paulo Bienal," pages 172–73).[31] The most extensive account of this component of the biennial was, unsurprisingly, published in the *Boletim*. In the February/March 1954 issue an article by de Barros features the only three known installation views, with enthusiastic testimonials from leading figures in the São Paulo art world and beyond (fig. 7).

The Second Bienal solidified the turn toward abstraction that had emerged at the first

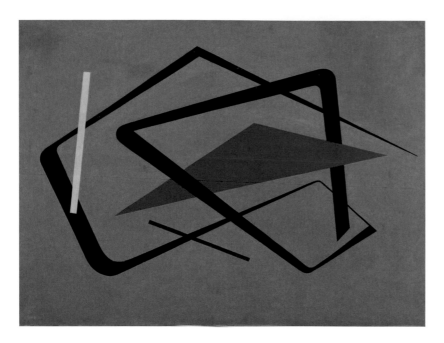

Fig. 8. María Freire. Untitled. 1954. Oil on canvas, 36¼ × 48⁄¹⁶ in. (92 × 122 cm). The Museum of Modern Art, New York. Gift of Patricia Phelps de Cisneros through the Latin American and Caribbean Fund in honor of Gabriel Pérez-Barreiro

iteration of the international exhibition two years earlier; nevertheless, the FCCB's largely abstract photographs' proximity to abstract painting at the show did not imply dialogue between two mediums. Although the possibilities for mutual influence are tantalizing—for instance, photography might have shown painting a path to embracing human vision and experience as a mode of animating geometric abstraction—the figure poised to make this claim most effectively (de Barros) made no contemporary reference to the relationship between his photography and painting. There are, nonetheless, some intriguing connections: the Uruguayan painter María Freire, in the midst of her own shift away from figuration (fig. 8), commented on the photography galleries at the 1953 Bienal:

I think they could go much further, show much more abstract, much less figurative work. . . . Which doesn't mean I consider the photography exhibition to be external to the biennial. There was an awful lot that should never have been selected for viewing [at the Second Bienal], a great deal of decadent painting and sculpture that represents neither the most modern nor the most current practices—not exactly the last word in art. From this standpoint, although the photography exhibition may not represent the last word in its field, I believe it fully conforms to the rest of the gigantic art show.[32]

Inclusion of this sort of critical perspective of a distinguished artist or writer, from across

Latin America and around the world, is typical of the *Boletim* and part of the FCCB's culture of criticality. That fearless self-reflection served as a healthy counterpoint to the club's collegial social atmosphere. It may also be the key to understanding the breadth and depth of achievements associated with the club and the absence of the complacency that characterized so many of their amateur peers.

FOCUS: FCCB AND THE ESCOLA PAULISTA

The founding of the Foto-Cine Clube Bandeirante is a tale rehearsed regularly in the pages of the *Boletim foto-cine*. A typical account appeared on the club's ninth anniversary:

On April 28, 1939, a small group of idealists founded the Foto Clube Bandeirante (currently the Foto-Cine Clube Bandeirante) in the Blue Room of the Martinelli building. It was signed into existence at precisely 2:34 p.m. the 29th of April. . . . The building on the rua São Bento that now houses our club was also home to Foto Dominadora, the photographic materials store owned by Lourival Bastos Cordeiro and Antonio Gomes de Oliveira. That store became a hub where amateur photographers met to discuss composition, frames, processes, hand-tinting, out-of-focus shots . . . , and many other minor details of a photograph or negative.

The idea of founding a club or association grew out of a conversation with Bastos and Gomes. . . . We had already come up with the name: Foto Clube Bandeirante! Why "Bandeirante"? Because bandeirante—for those who don't know the history of the people of São Paulo—was the name given to the men of São Paulo who explored the backlands of Brazil; for these new Paulistas would be the new bandeirantes, bearing a new

— 18 —

standard of dissemination and improvement, exploring art photography (known and practiced by very few initiates) across Brazil.[33]

While it may have been possible in 1939, and even in 1948, to speak in such glowing terms about a group of "standard-bearers" (the literal translation of *bandeirante*), the adventurous spirit being celebrated was one that resulted in the enslavement of Indigenous people, the expansion of territory under Portuguese colonial control, and the rapacious exploitation of the region's natural resources (see Chronology, "Bandeirantes," pages 173–74). The standard FCCB narrative overlooks this reality, but it expressly addresses a second important aspect of the club's identity—namely, its origins in São Paulo. It was only in the 1930s that the wealth and population of the Paulistanos began to rival that of the Cariocas, as the inhabitants of Rio de Janeiro are known. Rio had been the capital of Brazil for centuries, as well as its cultural center: that MASP, MAM, and the Bienal were all established in São Paulo is all the more impressive when set against this backdrop.[34] As evidenced by the works featured in the *Boletim*, and by some of the analysis and opinions presented in its pages, the FCCB may not have been quite as consistently adventurous in the late 1940s as its members credited themselves with being, but the more experimental cohort gained strength over time, even while managing to coexist with the club's more conservative factions.

Since at least 1946, the FCCB has been organized into three distinct departments: photography, cinema, and the women's division. The first, the Department of Photography, not surprisingly, was the primary membership category. After an initiation fee of fifty cruzeiros (or roughly forty US dollars today), the annual dues

(in 1946) were two hundred cruzeiros.[35] This was a club for people with disposable income. Members were granted access to the club's darkroom, library, lecture hall, and social spaces, and they were encouraged to participate in the regularly scheduled excursions and to submit work for national and international salons; additionally, they had the opportunity to get critical feedback from fellow club members through the *concursos internos* (fig. 9; see Chronology, "Internal Contests," pages 167–69).[36] These monthly contests were at the heart of the club's activities, and participation was often promoted through the *Boletim*. Members would submit work according to the month's assigned subject (e.g., portraits, still lifes, landscapes, architectural views, animals, nocturnal views, scenes of childhood, neighborhood life, studies of materials such as glass and metal, reflections, shadows, solitude, movement, "a cup of coffee"); every other month would be *tema livre*, a "free" or "open" subject (which is to say, no assigned theme).[37] The winning photographs were frequently featured on the *Boletim*'s cover or reproduced as plates. Points were awarded for successful entries in the monthly contests, as well as in the annual salon (international since 1946) sponsored by the FCCB; club members also earned points for successful participation in the salons of other photo clubs and organizations throughout Brazil and around the world. Competition was at the core of the club's identity: quantifying the FCCB's standing on the international amateur circuit was a primary preoccupation, and individual points were tallied and published regularly.[38] However, so as not to discourage those with less experience by pitting them against more seasoned members, entrants were divided into three tiers (novices, juniors, and seniors), each judged independently. The competitive spirit was also tempered by the exceptional camaraderie among members,

Fig. 9. Typical page in the club's *Boletim*, highlighting the advantages of membership. *Boletim foto-cine* 59 (March 1951): 4

which was especially apparent in the club's frequent excursions. Images made in a distinctive location by more than one Bandeirante attest to their habit of venturing out together and devising independent approaches to the same subjects: while each member wanted to secure the best score or be awarded the most points, the collegial atmosphere leavened the competitive impulse (see Lorca/Yalenti, pages 54–55; Salvatore/Puig Giró, pages 144–45; Savatore/Manarini, pages 46, 70).

Most of what we know about the Department of Cinema, which lacks the abundant material legacy of the photography department, derives from articles in the *Boletim*: few films screened under the club's auspices remain.[39] What we do know is that the cinema department was extraordinarily catholic in its interests, embracing any film made outside of a commercial studio setting that evinced an ambition beyond that of home movies (the filmic equivalent of albums of snapshots).

Initially spurred by Farkas, the club organized screenings of experimental, medical, animated, travel, and documentary films, offering encouragement, practical advice, and critique. The club also fostered participation within a growing international network of amateur filmmakers (see Chronology, "Film at the FCCB," page 170). That circuit may not have been as robust as its photographic counterpart, but it was important enough to draw de Barros from Paris to Glasgow to serve on the jury for the Union International du Cinéma d'Amateur (UNICA) in late 1951.[40]

Despite the fact that the Women's Section was considered its own department, female members participated in the same monthly contests, ventured out on the same excursions, and competed to have their work hang alongside those of their male peers in the club's São Paulo salon, in other domestic venues, and in salons abroad. Women constituted a small but active subsection of the club, encouraged by a 50 percent discount on membership dues, and their participation was frequently rewarded with a generous presence in the *Boletim*.[41] The majority were related to male club members (Dulce Carneiro was André Carneiro's sister; Alzira Helena Teixeira was a first cousin of Rubens Teixeira Scavone; many were wives of members), which presumably contributed to the convivial, even familial, atmosphere evident in photos of excursions and other club events.[42] Predictably, the *Boletim*'s encouragement was not without a paternalistic tinge: one article calls attention to Barbara Mors and Maria Cecilia Agostinelli, "who have garnered a few prizes in recent competitions for novices. Their works clearly reveal the spirit of observation and other related qualities that, along with study and dedication, will lead them to fill the obvious void evinced by the absence of women among Brazilian entries in

Salons here and abroad. We hope their example will be followed by other members of our Women's Department."[43]

There was one female member of the FCCB whose international acclaim matched her considerable achievement. Gertrudes Altschul fled Nazi Germany in the late 1930s, reuniting with her husband and son in 1941 in São Paulo, where they reestablished a business making artificial flowers for millinery. It would be a decade before she became serious about her work with a camera, joining the club in July 1952. Within a year she was moving up the ranks. Her work *Filigrana* (*Filigree*; page 80) was reproduced in the April–June 1953 issue of the *Boletim*, and *Linhas e tons* (*Lines and Tones*; page 41) appeared on the cover later that year. She was consistently successful in salons, both domestically and abroad, winning prizes, accumulating points, and (although these were not necessarily correlated) expanding the range of her artistic vocabulary.[44] She was attentive to her urban environment, deploying voids between buildings as compositional elements (see pages 41, 47), restlessly creative with multiple exposures and experimental darkroom techniques (pages 77, 109), and singularly imaginative in her renderings of leaves (pages 79, 80)—a rare connection between an FCCB member's day job and the hobby that consumed her leisure time. Upon her untimely death in 1962, the FCCB published an affectionate appreciation in the *Boletim*, along with a second reproduction of *Filigrana* (inexplicably inverted).[45] Almost two years later, she was the subject of a tribute that captures the *Boletim*'s myth-making tendency:

It was 1952. As they did every year, people were enrolling in the FCCB's basic photography course. People from all social classes flocked to the club. People of all races and religions. Amid the hustle and bustle of the evening, one woman drew the attention of veteran members. She was older than most beginners. She made a modest entrance, blending inconspicuously with the others. She identified herself to one of the directors as Gertrudes Altschul, a manufacturer of artificial flowers and jewelry. Like everyone else who was there, she wanted to enroll. Her likewise foreign, tireless supporter and husband, Leon Altschul, stood by her side and smiled with approval. . . .

Gertrudes rose quickly through the ranks of the Bandeirantes. She moved swiftly from absolute beginner to senior ranking and stood out among the few women who were internationally recognized for artistic photography. . . . But this extraordinary woman stood out in ways that went beyond her artistry. From the outset, and despite her advanced age—she started out when many were ending—she embodied club spirit and devoted herself to "her club" with the same passion she brought to "her art." . . .

In early 1962, exactly ten years after she first entered the FCCB, Gertrudes passed away after the long illness that had kept her away from her colleagues. . . . Her name will surely serve as an example to Brazilian women, whose presence is indispensable to art photography.[46]

Altschul joined the FCCB soon after a first mention in the *Boletim* (in October 1951) of a "new school of art photography" (the Escola Paulista, or the Paulista School) characterized by the "pioneering investigations" undertaken by a group of photographers from São Paulo.[47] The rhetoric situates these investigations as a reaction against Pictorialism and its embrace of misty landscapes, romantic portraits, and nods to the innocence of childhood. Yet also evident in the *Boletim* is an artistic conservatism that, then and now, is closely associated with

amateur photo clubs. The inconvenient reality is that seemingly inimical modes of approaching photography have always co-existed, and outmoded styles are never as distant as those invested in establishing hierarchies might wish they were. At the time, even MoMA—an institution as firmly aligned in the public imagination with "pioneering investigations" as any—embraced under Steichen's influence so many different approaches to photography frequently deemed incompatible that to this day it creates a challenge for those intent on asserting the superiority of a particular mode. The FCCB was similarly unusual in its ability to join disparate impulses under a single, proud banner, and to seriously engage with the art-making of members who were satisfied with technically proficient pictorial clichés, while encouraging critical dialogue among those for whom the disorientation of their contemporary urban experience was a source of inspiration.

It would be four years before another reference to the Escola Paulista appeared in the *Boletim*, in a review of a solo exhibition of work by Marcel Giró at the FCCB headquarters, although by then the term appears to have been broadly adopted: "Giró is undoubtedly one of the leading representatives of this type of photography, which has stood out for its bold angles and compositions, its play of lines, light and shadow (one of Giró's favorite subjects) and which critics have named 'the Paulista School.'"[48] Although the Escola Paulista is not, by definition, synonymous with the FCCB, the perfect overlap between individuals associated with the group and the movement inextricably links the two. As with work by the roughly contemporaneous if more amorphous group of photographers later referred to as the New York School, the boundaries were defined, largely, by geography.[49] But in New York approaches that

didn't conform to certain modes of originality were rejected—for example, the decades-old Pictorialist models to which the Photographic Society of America (PSA) hewed[50]—whereas their São Paulo-based colleagues had far more catholic tastes that, for better or worse, warranted no such exclusions.[51] In reassessing the work of disparate amateurs in a remote time and place (remote, that is, for a New York–based curator looking to São Paulo), we must be transparent about our preferences and aesthetic judgments, conscious of their impact on the ways art historical narratives are constructed, and ever vigilant against the biases that are, to a great degree, products of the culture and times we live in and therefore largely concealed from us.

Perhaps the two greatest biases that affected, and apparently continue to affect, the reception of the work produced by the FCCB were twin beliefs held—consciously or not—by the cognoscenti of the cultural capitals of Western Europe and the United States: first, that art produced in the "peripheral" zones of the globe was necessarily derivative or else hopelessly out of step with the aesthetic discourse of the day; and, second, that the amateur, whether in Paris or New York or in "peripheral" cities such as Lagos or São Paulo, was likewise condemned at best to produce convincing simulacra of the advanced art of their time or at worst to traffic in the shopworn, whether clumsily or with uncommon technical finesse. The peripheral and the amateur, no matter how accomplished, carry with them the inescapable musk of the second-rate. But can this longstanding snobbery and parochialism withstand the evidence we see before us of the consummately skilled and at times strikingly original output of the peripheral amateurs of the FCCB? To complicate these questions of

taste, however, we must also ask: Knowing as little as we do about most of the Bandeirantes, can we be sure that, in attempting to overthrow the prejudices of the past, we are not in fact valorizing successful imitations of the advanced photography of the day (or even of decades earlier) rather than the real thing? For, after all, one of the great challenges of the medium is that, with the right equipment and sufficient training, a modestly talented photographer can at times closely approximate the work of a true innovator. Still, if we are able to contextualize the Bandeirantes' work in relation to contemporaneous photographic practices and the international artistic currents of their day, while steeping ourselves in the unique culture of the club and the specificity of its members' work, surely we can secure a firmer foothold for our aesthetic judgments.

While the tangible connections between the FCCB and contemporaneous photographic activities around the world are considered later in this essay, some comparisons here might be useful to distinguish the club's aesthetic ambition. The experimental impulse of many photographers living in New York or Chicago at the time rhymes, more than superficially, with that of many of their Paulista peers. And yet the artists from the US who sent their photographs to the FCCB's annual salon, and whose work appeared in the *Boletim*'s pages, were generally members of the PSA and were aligned more closely with those Bandeirantes who favored photographs of children, beautiful women, and atmospheric seascapes. The FCCB was honored to accept the PSA's invitation to join in 1946, taking it as a signal of their arrival on the international scene, and immediately adopted the PSA's exacting standards for their salon (see Chronology, "The FCCB Salons," page 165). Following Farkas's meeting with Steichen in late 1948, there appears to have been no dialogue at all between MoMA and the FCCB.[52] The primary North American point of contact was the Wisconsin-based photographer Ray Miess, whose work is referenced as frequently in the English-language histories of the medium as anyone from Brazil (which is to say, not at all). The divide between the amateur photo club scene and more avant-garde or experimental efforts in the US is not all that surprising: despite Steichen's populist leanings and his embrace of "new folk art" (a term he used, uniquely, to include not only amateur photography but also Brassaï and Henri Cartier-Bresson),[53] it would have been unusual for a PSA member to be featured on the walls at MoMA. So perhaps it was to be expected that the FCCB club members who were most deeply invested in the international network of amateurs, and the accolades associated with its salons, would have gravitated toward the work of photographers abroad who shared the same commitment, even though many individual works (and the rhetoric around them published in the *Boletim*) betray strong connections with contemporary programming at MoMA. One might argue that, in also reproducing work of a *retardataire* character in the *Boletim*, the FCCB leadership (who edited the magazine) chose to encourage an expansive approach to the medium. Even so, it could be that, from their perspective, there was no contradiction between the aesthetic values they championed in words and the works to which they awarded prizes. More cynical minds might ascribe the FCCB's "big tent" philosophy to opportunism (not wanting to alienate potential members); more critical ones might describe their thinking as muddled; still others might see them simply as embracing the breadth of what can be done with a camera.

The challenge of articulating just what pictorial characteristics ought to be valued and how to describe them permeates the *Boletim*—in commissioned articles, reprinted ones, and transcripts of club seminars (see Chronology, "FCCB Seminars," page 169). The club's long-time president, Eduardo Salvatore (who held that position from 1943 until 1990), occasionally took up his pen to address matters of particular import. In 1951 he addressed the threat of "safe and pleasing" salon photography.[54] The relationship between the FCCB and photography salons was vexed, as the salons were an essential forum for international recognition and yet all of the amateur photo clubs that took responsibility for organizing them not infrequently awarded prizes to works that were poorly aligned with the inventive self-expression at the root of the FCCB's professed vision. As Salvatore declared, "Many others—'Bandeirantes' among them—are unafraid to dismiss academic assumptions, seeking new modes of expression, privileging spirit, content, and human values over mere representation in an original interpretation, even if this leads to further rejections by the salons that remain attached to Pictorialism."[55]

In the same article, Salvatore bemoans the "stagnation" of the "salonite"—photographers whose "main concern is collecting salon labels, albeit at the cost of standardizing their work in accordance with conformism and the annihilation of their own personalities. And the outcome of 'salonitis' is a serious disease whose virus leads its sufferers to spend year after year flooding the salons all around the world with dozens and dozens of copies of the same works in a pure manifestation of vanity, collecting the numbers and statistical rankings so dear to North Americans."[56] Given Salvatore's consistent spot at the top of the rankings, this warn-

ing rings a bit hollow, but he clearly grasped the dangers of failing to innovate:

At São Paulo's FCCB, we are never satisfied with the work we do and always want more; it is progress we are after. . . . [We are always searching for] new themes, new subjects, new forms of expression. . . . In fact, we are witnessing a clash between two mindsets: old 'pictorial' photography (so called because it imitates . . . static, lifeless, academic painting with all the passivity and contemplation that reduced it to a middle ground between drawing, painting, and print work) and a new, more photographic, more vigorous mentality, replete with life and humanity, bold angles and plays of light, and enjoying the photographic process along with all the characteristics that make it unique and distinctive.[57]

The pressure for recognition persisted in part because success was most easily equated with the number of prints accepted by the international salons to which they were submitted. Just as a member would be heralded for her prizes and rankings, the club's overall reputation was buoyed by these individual victories. This pressure to measure success extended to the qualities that allegedly made a photograph "successful," and they were quantified with such specificity as to leave little room for invention.[58] In an article titled "Elementos para a crítica fotográfica" ("Elements of Photographic Critique") the *Boletim* reproduced two sample *papeletas* (literally, "slips," but actually scorecards), each listing dozens of attributes (see page 10). A judge could assign one of four ratings to each attribute: *excelente, bom, sofrível,* or *pobre* (excellent, good, fair, poor).[59] This might be relatively straightforward with respect to mechanical or technical considerations (focus, lighting, tonal range, and so on), but more than half

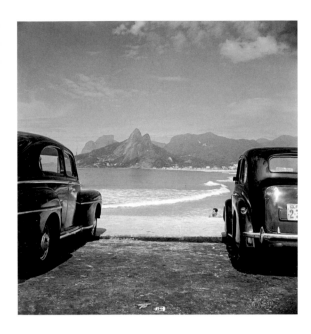

Fig. 10. José Medeiros. *The Pedra da Gávea, Morro Dois Irmãos, and the Beaches of Ipanema and Leblon, Rio de Janeiro (A Pedra da Gávea, o Morro Dois Irmãos e as praias de Ipanema e Leblon, Rio de Janeiro).* c. 1949. Collection Instituto Moreira Salles

Fig. 11. Hans Günter Flieg. *Ocrim do Brasil S.A.'s flour mill in Jaguaré, São Paulo (Moinho Jaguaré da Ocrim do Brasil S/A, São Paulo).* 1956. Collection Instituto Moreira Salles

of the attributes fall into the category *"factor psicológico,"* which is surely more challenging to rank. The scorecard concludes with *"Considerações estético-filosóficas—Reacção geral à fotografia"* (Aesthetic-Philosophical Considerations—General Reaction to the Photograph), which suggests to this author the overall futility of judging according to specific criteria; as the photographer and *Aperture* editor Minor White concluded in 1953, criticism is ultimately intuitive.[60] Whatever criteria might be put forward as the hallmarks of a "good" or "excellent" photograph, the decision to ignore them might make for an even better one.[61] Then as now, the key is an alignment of ambition and execution, a willingness to take a risk instead of relying on perfect execution of a familiar idea. And while we might champion a single photograph as a "success" (this book reproduces nearly 150 such photos), true artistry emerges in time, across a body of work, as evidenced in the monographic anchors of this book. It is possible for a photograph to *look* bold or daring or innovative at first glance, but less so—or not at all so—with further study. If there are individual photographers whose only work of interest appears here, so too will you find pictures by truly great photographers whose work has not come to our attention before now because it was made under the aegis of an amateur photo club in Brazil.

The postwar Brazilian photo world drew a line between commercial or professional work and that of the amateurs associated with the FCCB, and that line was rarely crossed. With few exceptions, if you made a living as a photographer you would likely find it difficult to fit in at the club. This attitude toward commercial photography echoed the art-for-art's-sake position championed by Alfred Stieglitz and fellow members of the Photo-Secession in the early twentieth century, although their snobbery also applied to the legions of amateur photo clubs then active in the US, decrying their perceived complacency. At neither moment were questions regarding class and privilege openly discussed, but regardless of era or hemisphere, the ability to dedicate oneself to an expensive hobby requires financial stability. Francisco Albuquerque and German Lorca were among the few Bandeirantes who sustained successful careers in advertising photography while remaining affiliated with the club; if damage to their reputations came from such professional associations, it was likely offset by their solo exhibitions in 1952: Lorca at MAM and Albuquerque at MASP.[62]

There were a handful of talented photographers whose careers flourished in the postwar era in Brazil without any connection to the FCCB, each making his living through photography. These included José Medeiros (1921–1990), who worked for the illustrated magazine *O Cruzeiro*, Brazil's equivalent of *Life* (fig. 10); the German-born Hans Günter Flieg (b. 1923), whose commanding promotional images mirrored Brazil's industrial ambition (fig. 11);

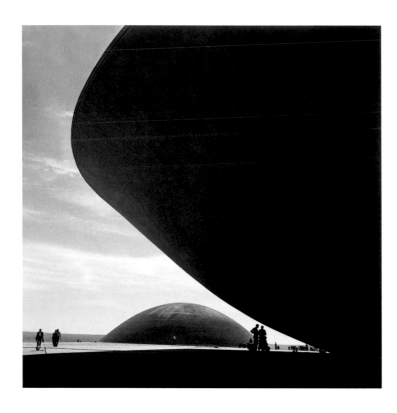

ual explanations for these circumstances may have been, the FCCB as a whole was decidedly less engaged with the modes of photographic reportage typical of *Life* magazine, or the gifted independent visions of photographers associated with Magnum, than was Steichen's MoMA at that moment, which produced, for instance, the magazine and photo agency–heavy *Family of Man*.[64] This bias on the part of the FCCB could be explained well enough by the fact that the majority of its members didn't want to (or need to) earn a living through photography, so photojournalism and the illustrated magazines and newspapers that it served simply lay outside their realm of interest.[65]

In 1957 the FCCB published the first (and only) issue of *Anuário brasilieiro de fotografia* (*Brazilian Photography Annual*), an ambitious, luxurious review of the best work from the FCCB's fifteenth annual international salon and, perhaps, a summation of all that the Paulista School had achieved (see Chronology, June 1957, page 175). Published in Portuguese, French, and English, with nearly three hundred pages and almost as many full-page illustrations, the *Anuário* is a close cousin of the European and North American annual publications that emerged between the World Wars (most notably, *Das deutsche Lichtbild* in Germany, *Photographie* in France, and *U.S. Camera* in the United States) (fig. 13).[66] Clearly the *Anuário* was also modeled on the FIAP Yearbooks (more on FIAP below), published biannually beginning in 1954 and including a wide range of amateur work from around the world; but in the *Anuário* pride of place was, fittingly, given to the Escola Paulista. The Bandeirantes laid out their ethos: "In the part of this book dedicated to Brazil, the Annual reflects all the modes of our photography, whether figurative or abstract. Nearly

and the French-born Marcel Gautherot (1910–1996), best known for his photographs of the construction of Brasília (fig. 12).[63] Formally, there was little dividing the work of Flieg from certain images by Farkas (see page 97), or Gautherot from the many FCCB members who focused on Brazil's striking architectural environment (pages 41–47), or Medeiros from the handful of members who attended to the rhythms of daily life (pages 3, 89–93), and the reasons for the segregation of these amateur and professional practices, despite their visual affinities, merit further study. It may well be that these professional photographers were themselves not interested in paying to join a club inasmuch as they had access to many of the benefits (darkrooms, critical feedback) through their work. Whatever the individ-

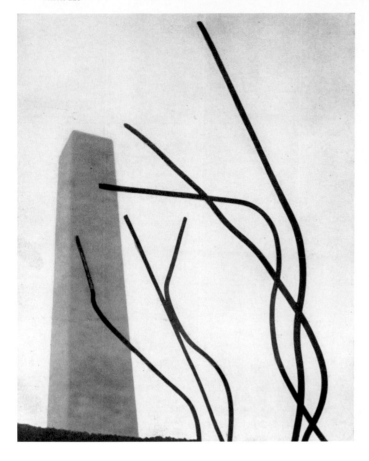

"Símbolo"
Marcél Giró

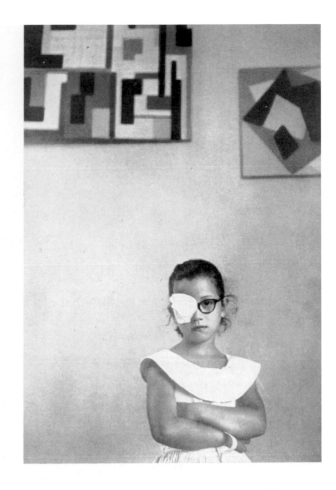

"Ortoptica" —
Rubens Teixeira Scava

Fig. 13. Spread from the 1957 *Anuário brasileiro de fotografia* **(Brazilian Photography Annual), featuring Marcel Giró's** *Symbol* **(***Símbolo***) and Rubens Teixeira Scavone's** *Orthoptics* **(***Ortóptica***)**

all works highlight a meaning, a personality, a formal rigor—the benefit of creating free of conventions or canons, seeking first and foremost to render the medium an expression of autonomous art."[67]

DEPTH OF FIELD: BANDEIRANTES ABROAD AND OPINIONS AT HOME

José Oiticica Filho joined the Foto-Cine Clube Bandeirante in May 1946 and was immediately and regularly acknowledged in the *Boletim*, perhaps because his decision to join the Paulista-based FCCB in addition to his local club (Sociedade Fluminense de Fotografia) was a meaningful endorsement in the face of their ongoing rivalry. Oiticica, son of the professor, poet, activist, and anarchist José Oiticica and father of the artist Hélio Oiticica, was trained as an entomologist and worked at the Museu Nacional da Universidade do Brasil in Rio de Janeiro.[68] In 1948 he moved with his fam-

ily to Washington, DC, after being awarded a Guggenheim Fellowship in Organismic Biology and Ecology. From the US capital he sent a handful of lengthy dispatches to his fellow Bandeirantes, published as "Cartas de Washington" ("Letters from Washington") in the *Boletim*. The first appeared in November 1949, more than a year after his arrival, but he was still marveling at his discoveries about America—primarily the abundance and accessibility of photographic materials (see Chronology, August 1947, page 166). Oiticica's update came as a surprise to this author because the scale and variety of prints produced by FCCB members is consistently impressive, and rua São Bento (where the founding members of the club first met) was renowned for the variety of its photographic supply shops.[69] Oiticica was one of several foreign correspondents for the *Boletim* who were given additional prominence in early 1951 by being listed on the magazine's masthead.[70]

Beyond the reports of its foreign correspondents, the *Boletim* sought out further external perspectives, frequently translating and reprinting articles, both technical and analytical, from a variety of international magazines, including, most frequently, *Correo fotográfico sudamericano* (Buenos Aires) and *Photo-Cinéma* (Paris).[71] Quotes, sometimes extensive, from these publications were offered as validation of the club's international reputation, including this tribute by Alejandro C. Del Conte, the editor of *Correo fotográfico sudamericano*, in November 1948: "São Paulo's Foto-Cine Clube Bandeirante celebrated its ninth birthday last month. It leads Latin American organizations of its kind not only because of the large number of associates it has amassed, but also because of the important work it has done by disseminating, influencing, and promoting art photography."[72] Or this, by Daniel Masclet, a Paris-based photographer and regular contributor to *Photo-Cinéma*, assessing the Brazilian contribution to the Paris Salon of 1950: "After China and Japan, theirs is the most remarkable, a nation of young photographers in which art photography ascends like an arrow. Brazil is becoming for South America what the United States is for North America: a leader."[73] Just as the FCCB sent the prints of its members far and wide to garner acclaim that would be impossible to manufacture locally, the presence of articles from magazines around the world in the *Boletim* was a signal (albeit a self-selective one) of their international integration.

Masclet was a founding member of Groupe des XV, a collective founded in 1946 by fifteen French photographers who epitomized a mode of engagement that would come to be known as Humanist, attending to everyday experience or, as Salvatore would describe the aligned goals of fellow FCCB members, "more humanitarian in content."[74] Marcel Bovis, Robert Doisneau, and Willy Ronis were among those in the Groupe des XV who sought to distinguish their efforts from the social documentarians who had been dominant in the years before World War II, as well as from photojournalists, whose work revolved around newsworthy events.[75] In 1954 the FCCB organized a two-part exhibition of French photography at the club's headquarters and included work by members of the Groupe des XV in both. In the *Boletim*, Scavone's positive review was followed by a scathing assessment penned by Dulce Carneiro, which describes the work as "mediocre" and worse: "Although it naturally reflects the technical precision that constitutes any photographer's minimal requirement, most of the work produced by the 'Group of 15' may be categorized as run-of-the-mill documentation and belongs to that 'kindergarten' stage of Art Photography we imagined to have been long surpassed."[76]

In Carneiro's own works that include a human presence, quotidian experience is framed against dynamic geometries of the urban environment, forsaking through cropping or camera position any facial cues that could foster a sense of identification (see pages 68, 87). By contrast, in the work of Barbara Mors, even when figures are similarly silhouetted or turned away, one detects what the critic and photographer Jean-Claude Gautrand described as the Humanist motivation to capture the "implicit yet fleeting relationship between them and the subject photographed... involv[ing] the routine and the banal, recorded with tenderness and, above all, with a great faith in humanity" (see pages 3, 72).[77] Such was the capaciousness of the club that these profoundly different ambitions, voiced in members' writing and through the work they produced, could coexist.

The closest cousin to the FCCB abroad may have been the Fotoform group in Stuttgart, Germany, which emerged in the late 1940s.[78] No one was as closely identified with the group as Otto Steinert (1915–1978), who had trained as a doctor. As with many FCCB members, photography was something he turned to after establishing his career (see Chronology, June 1955, pages 173–74). After a handful of noteworthy local presentations, *Subjektive Fotografie*, an exhibition featuring all of the Fotoform members and others, opened in July 1951 in Saarbrücken, Germany, accompanied by a modest softcover catalogue akin to those that accompanied nearly every amateur salon. The show's success led quickly to a second iteration, in a "more concentrated form," which opened in October 1951 in Cologne before traveling across Europe accompanied by a substantial trilingual publication.[79] Steinert wanted the term *subjektive Fotografie* to be understood "in contradistinction to 'applied' utilitarian and documentary photography," representing instead "all aspects of individual photographic creation from the nonobjective photogram to profound and aesthetically satisfying Reportage."[80] In this broad embrace of practices that defied superficial likeness, Steinert harked back to the experimentation of interwar photographers such as László Moholy-Nagy and Man Ray, without rejecting the personal, or subjective, creative impulse (fig. 14). Within the FCCB, Lorca's sense of open inquiry most closely parallels Steinert's, each photographer producing experimental renderings of the human face alongside very different approaches that suggest the mysteries of quotidian experience (see pages 105, 135–38).[81]

The German-based group's reputation spread quickly to Brazil, perhaps facilitated by de Barros, who was living in Europe at the time.

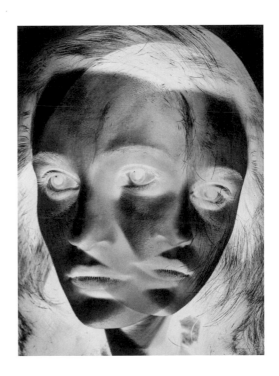

In late 1951 the *Boletim* reprinted a review of the FCCB's Tenth International Salon from *Revista Anhembi*, an esteemed local but internationally oriented scientific and cultural journal:

The mere presence of members of Fotoform and the Groupe des XV—two groups of modern artists normally averse to exhibitions anywhere in the world but who brought many excellent entries to the Salon of the FCCB—suffices to prove how much the Paulista association is respected outside Brazil's boundaries. In fact, the Bandeirante representation at the Tenth Salon widely confirms the superiority upon which we have previously remarked, and that is matched only by the works of Steinert, Brulé, Buese, Chung, Goto, Galzignan, Masclet,

Smolej, among others who have made photography an independent art with its own distinctive traits. Such works may not meet with full approval by those who are still attached to "pictorialism"—the sort of photography that still seeks to imitate painting. . . . Paulistas no longer fear infringement on ancient conceits, the old formulas of "salon photography" that were all the rage in years past.[82]

In an unfortunate signal of the asymmetries that would contribute to the isolation of the FCCB's achievements, this attentive respect was not reciprocated. When *Subjektive Fotografie 2* opened in November 1954, the group of photographers selected was decidedly more international, including nine from Japan and more than thirty from the United States, but, alas, none from the southern hemisphere.[83] Roughly concurrent with *Subjektive Fotografie 2*, the FCCB was collaborating with MAM on an exhibition that would open in mid-1955, *Otto Steinert e seus alunos* (*Otto Steinert and His Students*), an event that was, of course, covered extensively in the *Boletim* (see Chronology, June 1955, pages 173–74).[84]

 Neither Groupe des XV nor Fotoform became members of the Fédération Internationale de l'Art Photographique (International Federation of Photographic Art, or FIAP, as it is known), when it was founded in Switzerland in 1950, although Brazil (and by extension the FCCB) and Cuba were the only non-European countries represented among its fifteen founding members.[85] The honor was duly noted in the *Boletim*, including a quote (in French) from FIAP's founding president, a Belgian photographer named Maurice Van de Wyer: "Given your status as the most vigorous organization in South America, your country is sure to be splendidly presented and welcomed by the FIAP."[86]

Van de Wyer was a doctor by training; his regular visits to Brazil may have been supported by his work as the official doctor of the Belgian soccer team.[87] The relationship between FIAP and the FCCB was strategic (both wanted to encourage internationalization, collaboration, and exchange) and encouraged by a strong mutual respect between the two organizations' presidents. Both characterized their goals in effusive, idealistic terms, and both tolerated a wide range of artistic approaches. The key difference was that for the FCCB critical judgment and artistic ambition were central to the club's identity (and contributed to the enduring quality of the work), while FIAP—and related associations such as the PSA—as the organizing body of a network of amateur photo clubs, prioritized the creation of international standards and a leveling of the playing field in ways that, to the eyes of this curator, suppressed the very creative expression they sought to promote. With hindsight—and cognizant of geographic bias and the related dangers of ascribing "belatedness" to work produced outside North American and Western European artistic circles—it is not difficult to distinguish works that express the pressure of amateur conformity (cute children, kittens, pastoral scenes) from those that resonate with the creative impulses we associate with Humanism or Subjective photography. FCCB's exceptional status stems from its interest in fostering relationships not only with the PSA and FIAP and their associated photo clubs, but also, particularly in Europe, with artists and groups that had limited or no connections to the amateur scene.[88]

 If the FCCB held its own in an international circuit dominated by Western European and North American organizations, its unique position comes further into focus in relation to photographers and photo clubs from Latin American cities such as Buenos Aires and

Figs. 15 and 16. "La Carpeta de los Diez," and "Grupo fotográfico 'La Ventana,'" in *Boletim foto-cine* 103 (June–November 1957): 20–21, 30–31

Mexico City. Like São Paulo and Rio, both had thriving photography scenes before the Second World War (albeit ones deeply invested in ethereal Pictorialist practices), which retrenched, splintered, and evolved in the ensuing decades. In Buenos Aires, the German-born Annemarie Heinrich (1912–2005) epitomizes this complex moment with her remarkable dual success as a professional photographer and a participant in the amateur scene.[89] She was a clear darling of the FCCB, mentioned in dozens of articles over as many years (see Chronology, March 1951, page 169). Her one-person exhibition at MASP, which opened shortly after de Barros's *Fotoforma* in 1951, featured one hundred photographs (more than three times the number in his). Whereas his exhibition went unmentioned in the *Boletim*'s pages, Heinrich's work was featured on the March cover, with much more inside.[90] One breathless recounting of her visit to São Paulo reads, "Annemarie Heinrich's exhibition was one of the most outstanding artistic events of the beginning of this year. These shots depict the renowned artist entering the exhibition space in the company of Mr. and Mrs. E. Salvatore and a corner of the gallery moments after the opening."[91] How to explain the disparate treatment? On the one hand, de Barros was making work that challenged the very foundations of the discourse around photography, so one can understand why few in the FCCB would have been willing to admit they didn't understand what he was doing. On the other, Heinrich was a woman from Argentina, and her presence signaled the club's attentiveness to international trends and reinforced its encouragement of female members. Heinrich made photographs that aligned with an experimental impulse without actually destabilizing

the pictorial principles that the club (and the amateur scene in which it operated) worked so diligently to establish.

The following year, back in Buenos Aires, Heinrich would be one of the founding members of the Carpeta de los Diez (Portfolio of the Ten, or the Group of Ten), who proudly declared their independence from what they perceived as a prevailing conservatism, although the high-production quality of their own work betrays their professional roots and obeisance to the standards of commercial photography, even in their "art" photographs (fig. 15).[92] In its short life (the group was active only until 1959), Carpeta de los Diez was featured twice in the *Boletim*, in 1953 and 1957. The first article, not surprisingly, highlighted their ability to balance collegiality with criticality, which was an important goal for the FCCB as well.[93]

The unifying efforts of FIAP and the PSA notwithstanding, the character of the amateur scenes operating under their aegises varied greatly. In Mexico City, the Club Fotográfico de México was founded in 1949; it encouraged members to concentrate their attention on "lyrical and romantic fields and seas, pretty flowers, [or] happy old people with singular, exotic features."[94] Perhaps predictably, this stultifying atmosphere led some members to break off, and in 1956 a splinter group took the name La Ventana (The Window). This group soon attracted the attention of like-minded peers in the FCCB, who mounted an exhibition of La Ventana's work at the club in mid-1957, as well as dedicating three pages to their work in the *Boletim* (fig. 16). La Ventana was also the driving force behind the 1ª Exposição Latino-Americana de Fotografia Moderna (First Latin American Exhibition of Modern Photography),

Fig. 17. Installation view of *Postwar European Photography*, The Museum of Modern Art, New York, May 26–August 23, 1953. Depicted: Groupings of works by Sabine Weiss, Emmy Andriesse, and Otto Steinert, with single works by Ricarda Rech, Pals-Nils Nilsson, Maria Austria, Yvan Dalain, and Federico Vender

which opened at Galería de Artes Plásticas in Mexico City in June 1959 and traveled to the FCCB and venues in Argentina, Chile, and Uruguay (see Chronology, June 16–July 13, 1959, page 176).[95] Of the show's many exhibitors, the *Boletim* mentioned only Heinrich and the Brazilian participants—Altschul, Dulce Carneiro, Farkas, Marcel Giró, Oiticica Filho, Salvatore, and Ivo Ferreira da Silva—perhaps revealing the limits of the club's integration into the international scene.

From its privileged position in New York, The Museum of Modern Art has long dominated the ways in which the history of modernism is told, a story that has over time been distilled into a neat progression. This narrative, however, is at odds with any close reading of the historical record, and MoMA itself is now committed to dismantling it.[96] But the Museum was never wed to a restrictive narrative when it came to photography, particularly not when the department devoted to the medium was headed by Steichen. His exhibition *Abstraction in Photography* (May 1–July 4, 1951) opened shortly after de Barros's exhibition at MASP and before Steinert's *Subjektive Fotografie* in Saarbrücken, and it included one of the prints Farkas sent to the Museum in early 1949, a generous selection of scientific imagery, and work by (mostly North American) practitioners. In this and other exhibitions during his tenure,

Steichen was consistently attentive to a wide range of work, although not to the amateur photo scene. (This might be understood as a response to the inglorious departure of his predecessor, who was perceived as being too hand-in-glove with Kodak.)[97] Nevertheless, Steichen's association with amateur circles is closer than often assumed. In lieu of a catalogue, an ample sampling from *Abstraction in Photography* was featured in *Photo Arts*, a magazine distinguished by its studious dedication to the female nude—a clear reflection of its target audience, namely, men interested in photos of naked young women but requiring instructional context (use this lighting! try this composition!) to justify it. The publisher's statement nevertheless aligns with much of the rhetoric emanating from Saarbrücken or São Paulo:

Let me make one point clear. We do not preach abstraction nor do we say prayers every night for the salonist. The policy of PHOTO ARTS is to present objectively individuals, groups, and group movements as they appear on the horizon of American photography. Furthermore, we do not intend to slight the accepted and conventional realms of photography and assume an over-all character of futurism. It is the photographer with his own personal vision that we are interested in, no matter what school he represents. There is a genuine need for such a

— 32 —

magazine. A magazine which can truly claim to serve its art. A magazine that young photographers can identify themselves with. A magazine that will map the internal progression of photography as an art form.[98]

For the FCCB, abstraction (either found in or distilled from the world or manufactured in the darkroom) would, by the early 1950s, be a pinnacle of "pure creation," and the club celebrated the many ways in which members approached it.[99] Along with abstraction, though, FCCB members and serious photographers around the world were comparably devoted to exploring the possibilities of self-expression through figuration and landscape. Like this book and the exhibition it accompanies, Steichen's *Postwar European Photography* (1953) interspersed focused monographic displays within groups of prints by a variety of photographers who together point to the vitality and breadth of the moment and transcend traditional genres (fig. 17). Steichen, like the FCCB, built a tent capacious enough to accommodate a range of approaches, makers, and subjects—even, as on the pages of *Photo Arts*, female nudes. For those intent on establishing hierarchies among modes of photographic practice (from Stieglitz and the Photo-Secession to the anti-amateur snobs of our day, including this author not that long ago), this mentality was profoundly threatening. But today it seems evident that these hierarchies need more specific examination, not least of all for the inadvertent but real exclusions they engender. In the end, Steichen's attitude wasn't so different from that of the editors of a popular magazine like *Photo Arts*, which also embraced a blend of popular forms (the nude) and "high art" aspirations, as expressed in the publisher's statement; for this reason, Steichen's legacy continues to pose a challenge to gatekeepers. The irony, of course, is that as a gatekeeper himself—no matter how permissive—the one thing he excluded was the amateur, which is part of why the FCCB was overlooked by MoMA under his watch and in the years that followed, until now.

Despite the FCCB's active and esteemed presence in the amateur salon circuit, its occasional but significant connections to Steichen and Steinert, and the porosity of the photography world after World War II, sustained appreciation for the club's members outside of Brazil was compromised by their absence from two landmark projects to which they were tantalizingly close: Steinert's *Subjektive Fotografie* (discussed above) and Steichen's *Family of Man*. While *Subjektive Fotografie* was hugely important within (relatively small) photographic circles, *The Family of Man* was a worldwide phenomenon: opening at MoMA in January 1955, it featured more than five hundred photographs which then circulated (via five identical copies) around the world, under the auspices of the US Information Agency, for seven years. The exhibition was seen by an estimated nine million people, and its book form reached millions more. The story of this exhibition and its impact has been analyzed exhaustively.[100] Of the more than 250 photographers featured, not one was Brazilian, and precious few hailed from outside North America and Western Europe.[101] The *Boletim* nevertheless positions *The Family of Man*, in part, as an outgrowth of the club's efforts:

Echoes of the "Photography Gallery" organized by the FCCB at the 2ª Bienal de São Paulo continue to reverberate, even as another equally important manifestation at New York's Museum of Modern Art is scheduled to affirm the victory of photography as Art. 1955 will mark the

Museum's twenty-fifth anniversary. . . . The high point of the program is to be an international exhibition of art photography! . . . Unfortunately, we received communication from MoMA that because submissions are now closed, it's too late for FCCB to submit works for this important exhibition. Nevertheless, because it is being organized by the renowned Edward Steichen, the international show's central concept of "The Activities of Man" is worth announcing.[102]

Although Steichen's intent was to underscore commonalities in the human experience around the world, he—like many—was unable to appreciate the structural bias implicit in the perspective of (mostly) privileged white males working for powerful agencies (such as Magnum, Black Star, and Rapho) or widely distributed magazines (such as *Life, Popular Photography,* and *Vogue*). The FCCB asserted their own work as a precedent: an alternative (if perhaps not defensible) history. *Fotoclubismo* seeks to draw attention to the ways in which their exclusion from *The Family of Man* and other international exhibitions contributed to their exclusion from the historical record outside Brazil, and to encourage more inclusive narratives that attend to a broader spectrum of the medium.

GOOD PICTURES

The members of the FCCB were relentless in their questioning of what makes a good picture—a question still being asked by contemporary artists (even as they maintain critical or ironic attitudes toward their precursors' answers). In 2016 the artist Zoe Leonard began a new series of sculptures. Each is made up of multiple (sometimes hundreds of) copies of amateur photo guides, arranged in stacks that are both fastidious and faintly suggestive of

thesarahmeister
Hauser & Wirth

Liked by **kiravoneichel** and **80 others**

thesarahmeister @arnie_mushu supervising my last look at Zoe Leonard's extraordinary exhibition In the Wake just before @ann.temkin walked through the door #thisisphotography #lastday #worthrevisiting

View 1 comment

October 22, 2016

hoarding. Each stack contains multiple copies of a book—*How to Make Good Pictures, This Is Photography, Dealing with Difficult Situations, Total Picture Control,* and so on—all published by Kodak, often in multiple editions.[103] Leonard evokes a sense of nostalgia for photography's analogue era while reminding us of the futility of trying to assign a fixed definition to the medium and just what makes it "good." One could argue further that beyond any comments this work makes about aesthetic rules, Leonard attends to a broader social dimension: a set of exclusions precipitated by the unrelentingly white hetero-

sexual norms on the pages of these publications. Her irresistibly Instagrammable arrangements make us all, as amateur photographers, a part of this history (fig. 18). Other contemporary artists, such as Roe Ethridge and Anne Collier, take photographic clichés as a point of departure: in their hands a subtle pressure on the banality of commonplace subjects (pets, holiday meals) and conventions (misty landscapes, crying women) makes their very embeddedness something unfamiliar and new.

Part of the challenge in photography of defining just what is (or was) and what isn't (or wasn't) worthy of attention has to do with the medium's historically equivocal status among the fine arts. Despite its (exceptional) historical presence at MoMA, MAM, and MASP, its ubiquity and its mechanical roots have required specialized advocates to articulate these distinctions. It has been their task to justify the presence or absence of *these* photographers, of *these* works and not *those*, in the historical narrative or within a particular exhibition. (If this exclusionary impulse began with Stieglitz and the Photo-Secession in the early twentieth century, it persists today, when almost everyone has a camera in their pocket.) Even as these specialists (often curators and critics) have struggled—and continue to struggle—with definitions and boundaries, the barriers that emerged to separate the "amateur" and "art" worlds were not so fixed as we often assume. After the Second World War, MoMA and the FCCB promoted, to varying degrees, photographs that might be called Subjective, creative, Pictorialist, reportage, journalism, documentary, amateur, and folk, and defended

their preferences. Their approach was a commendable embrace of styles, movements, and practitioners of all stripes—an approach we would do well to adopt. Yet to this day, when it comes to the amateur, our ability to judge a work as excellent, good, fair, or poor is undermined by the potential for imitation facilitated by a camera, particularly when we are unable to access more than a handful of examples of an individual's production. And that gets to the heart of the problem of recuperating the work of the Bandeirantes. Speaking about the FCCB at MoMA in 2017, the Brazilian photography historian Helouise Costa asked, "How should we think about authorship and originality, fundamental questions for art museums, when analyzing this type of production? How should we react to the uncomfortable similarity between the images of different photographers?" This essay is, in part, an attempt to examine the means by which this São Paulo–based amateur photo club has been excluded from the established histories outside Brazil, and to reexamine the postwar moment to appreciate their significance at the time. It is a reflection on the ways in which judgment can be personal—shaped by factors we may not recognize and according to criteria that are rarely easy to quantify—and therefore must be strengthened and challenged by research and a heightened understanding of context. Finally, it is an invitation to enjoy photographs that are sure to be unfamiliar to many, and to use that pleasure as a catalyst for committing to challenge why they are unfamiliar, and to uncover other, equally valuable and underknown cultural moments near and far.

Notes

1. On his membership card, Farkas is listed as member no. 61, a *fundador*, or founding member. The date of his enrollment is handwritten (later?) as April 29, 1939, corresponding to the FCCB's founding date: Farkas would have been just fourteen years old. However, in *Boletim foto-cine* 39 [July 1949], the editors state he joined the club with parental consent at age fifteen.

2. "Thomaz J. Farkas, our famous young 'Farkinhas,' is in North America studying film and photography. He sent us a postcard in which he promises plenty of news and sends regards to all his 'Bandeirante' friends and colleagues" ("Snapshots," *Boletim* 31 [November 1948]: 19). Past issues of the *Boletim* are accessible through the FCCB website: http://www.fotoclub.art.br/acervo/.

3. Contemporary accounts of the FCCB tend to repeat certain stories, such as this one, but I have attempted to mention only those that can be verified through contemporaneous sources. Marly Porto has been singularly helpful with this research, and I am grateful for her efforts. Certain stories that are absent here may be true, and I hope future scholars will before long be able to fill in the historical record.

4. Thomaz Farkas, letter to Edward Steichen, January 14, 1949. Department of Photography correspondence files. Six of the seven prints Farkas sent Steichen are featured on pages 45, 89, 93, 95, and 161.

5. Lila Foster, "The Cinema Section of Foto Cine Clube Bandeirante: Ideals and Reality of Amateur Film Production in São Paulo, Brazil," *Film History: An International Journal* 30, no. 1 (Spring 2018): 95.

6. There are two valuable references on Farkas in English and Portuguese: Sergio Burgi, João Paulo Farkas, and Rubens Fernandes Junior, *Thomaz Farkas: Memórias e descobertas/Memories and Discoveries* (São Paulo: Luciana Brito Galeria, 2014) and Burgi, Helouise Costa and Sarah Hermanson Meister, *Estudos fotográficos Thomaz Farkas* (São Paulo: Instituto Olga Kos de Inclusão Cultural, 2018). Burgi's *Thomaz Farkas: Uma antologia pessoal* (São Paulo: Instituto Moreira Salles, 2011) is a valuable Portuguese-language resource.

7. There are (at least) three distinct meanings of the word "amateur" with respect to photographic practices: The earliest alludes to photographers like William Henry Fox Talbot, Gustave Le Gray, and Alfred Stieglitz, for whom the luxury of pursuing art for art's sake was a common point of departure. The second meaning emerged in the late nineteenth century, when technological simplifications made it possible for millions of individuals without special training or expertise to make photographs. (This group of amateurs has, of course, expanded exponentially with the advent of digital photography.) The third sense of the word—and the one most applicable to the photographers central to this essay—refers to those active within dynamic local and international photography networks but whose reputations have been tainted by the imitative nature of some among them.

8. Several important studies of this work exist, most notably Helouise Costa and Renato Rodriguez da Silva, *A Fotografia moderna no Brasil*, 2nd ed. (São Paulo: Cosac Naify, 2004 [1995]). The exhibition *Foto Cine Clube Bandeirante: do arquivo à rede* (Foto Cine Clube Bandeirante: From the Archive to the Network), curated by Rosângela Rennó, was held at MASP from November 27, 2015, to March 20, 2016, accompanied by a catalogue that reproduces the front and back of every print in the exhibition. There are a handful of monographs on the subject; the few that include English translations will be cited in this essay. Until very recently, postwar Brazilian modernist photography was not mentioned in any history of the medium originating outside of Brazil. Two exceptions are Quentin Bajac et al., eds., *Photography at MoMA: 1920 to 1960* (New York: The Museum of Modern Art, 2016) and Simon Baker, *Shape of Light: 100 Years of Photography and Abstract Art* (London: Tate Modern, 2018).

9. Linda Nochlin, "Why Have There Been No Great Women Artists?," in *Art and Sexual Politics*, ed. Thomas B. Hess and Elizabeth C. Baker (New York: Macmillan, 1973), 1–39.

10. Gerardo Mosquera, "Against Latin American Art," in *Contemporary Art in Latin America*, ed. Phoebe Adler, Tom Howells, and Nikolaos Kotsopoulos (London: Black Dog, 2010), 12–23.

11. Pierre Bourdieu's *Photography: A Middle-Brow Art* (Stanford, CA: Stanford University Press, 1990 [1965]) and Harold S. Becker's *Art Worlds*, 25th anniversary edition (Berkeley: University of California Press, 2008) are valuable to consider in this context.

12. Lucas Mendes Menezes warns of a tendency to "overvalue" (*survaloriser*) the "modern" aspects of this work in his excellent writing about Brazilian photography in Paris in the mid-twentieth century. See *Images voyageuses: Photographie amateur brésilienne dans la collection de la Société française de photographie*; dissertation submitted to the Université Paris 1 Panthéon-Sorbonne, December 3, 2019, 18.

13. These six are featured in depth due to the originality and ambition of their work, which, not incidentally, has been preserved sufficiently widely to allow for such an assessment, although this should not be understood as a negative reflection on the potential worthiness of others about whom even less is known.

14. It is interesting to note that *Postwar European Photography*, Steichen's exhibition (at MoMA) of then-recent work, was structured similarly, with key artists featured in depth, animated by a wide array of supporting figures. See fig. 17.

15. The FCCB, today under the leadership of José Luiz Pedro, continues to provide an encouraging, instructive environment for photographers. See https://fotoclub.art.br/. Raul Feitosa published a detailed history of the club (in Portuguese only): *Bandeirante: 70 anos de história na fotografia* (Balneário Camboriú, SC: Editora Photos, 2013).

16. Costa, keynote panel, "In Black and White: Photography, Race, and the Modern Impulse in Brazil at Midcentury," MoMA, May 4, 2017, https://youtu.be/OnB1YZ211w0.

17. For a fascinating account of these plans and their eventual dismantling (although not before the transfer of several major works), see Kirk Varnedoe, "The Evolving Torpedo: Changing Ideas of the Collection of Painting and Sculpture of The Museum of Modern Art," in *The Museum of Modern Art at Mid-Century: Continuity and Change*, Studies in Modern Art 5 (New York: The Museum of Modern Art, 1995), 12–73.

18. For more on these museums and the circumstances of their founding, see Zeuler R. M. A. Lima, "Nelson A. Rockefeller and Art Patronage in Brazil after World War II: Assis Chateaubriand, the Museu de Arte de São Paulo (MASP) and the Museu de Arte Moderna (MAM)," Rockefeller Archive Center Research Reports Online (2010), n.p., and Adrian Anagnost, "Limitless Museum: P. M. Bardi's Aesthetic Reeducation," *Modernism/modernity* 4, cycle 4 (December 13, 2019): n.p.

19. Helouise Costa's exceptional scholarship is at the foundation of my understanding of the FCCB. Her original research and astute observations regarding Farkas and this exhibition are recorded in "The *Photographic Studies* by Thomaz Farkas: 70 years of a singular exhibition," in *Estudos fotográficos, Thomaz Farkas*, 36–61.

20. Among the exhibitions that Farkas may have seen at MoMA the previous fall that prefigure some of these display strategies are *Art in the Neighborhood: Focus on World Unity* (November 10–28, 1948) and *Photographs by Bill Brandt, Harry Callahan, Ted Croner, Lisette Model* (November 30, 1948–February 10, 1949). Costa notes that Forte and Ruchti had traveled to the United States in 1947, where they saw exhibitions at MoMA and at Peggy Guggenheim's The Art of This Century gallery.

21. *Boletim* 39 (July 1949): 14.

22. Aleca Le Blanc cautions, "It warrants emphasizing that while geometric abstraction would come to occupy the prevailing critical position by the end of the decade, and continues to dominate the historiography of the period, in the early 1950s it was a fluid debate, and even in 1953 that position had not yet solidified. The supposed transition from figura-

tion to abstraction at the critical forefront was neither immediate, nor straightforward, nor totalizing. In fact, what is most important is that a debate like this had a forum in which to exist, and people that wanted to engage with it, thanks in large part to the creation of new exhibition spaces, art publications and critics, which together provided a more robust context that could sustain a prolonged public debate." From "Serpa, Portinari, Palatnik and Pedrosa: The Drama of an 'Artistic Moment' in Rio de Janeiro, 1951," *Diálogo* 20, no. 1 (Spring 2017): 15.

23. Steichen's exhibition *Abstraction in Photography* (MoMA, May 1–July 4, 1951) is an important point of reference discussed later in this essay.

24. This exhibition design, and specifically the aluminum poles, was typical of Lina Bo Bardi's work at MASP in its original location. See Lima, "Nelson A. Rockefeller and Art Patronage in Brazil after World War II."

25. The most comprehensive consideration of de Barros's work (in Portuguese only) is Heloisa Espada's *Geraldo de Barros e a fotografia*, exh. cat. (São Paulo: Instituto Moreira Salles/Edições Sesc São Paulo, 2014). Danielle Stewart's "Geraldo de Barros: Photography as Construction," *H-ART Revista de historia, teoría y crítica de arte* 2 (2018): 73–92, is valuable both for its research and analysis, distilled from the first chapter of her dissertation at the Graduate Center, CUNY, "Framing the City: Photography and the Construction of São Paulo, 1930–1955." See also *Geraldo de Barros Fotoformas-Sobras* (bilingual edition) (Lausanne: Idpure éditions/Musée de l'Elysée, 2013).

26. *Boletim* 43 (November 1949): 18. Despite these disagreements, de Barros was regularly selected for the club's Seminários, featured (and illustrated) in the *Boletim* in October and November 1949 and in January 1950.

27. Fernando Castro offers that de Barros coined the term: "The prefix 'foto' acknowledging the role of light . . . and the suffix 'forma' testifying to the impact Gestalt theories were already having in the Brazilian art world (*Gestalt*

may be translated as 'shape' or 'form')" ("Geraldo de Barros: Fotoformas," *Aperture* 202 [Spring 2011]: 22).

28. Pietro Maria Bardi was Italian (he moved to Brazil with his wife, the architect Lina Bo Bardi, in 1946), which may explain some of the strangeness of his phrasing, but Bardi was in good company in finding de Barros's work difficult to explain. This is but one example of the nuance Tiê Higashi brought to my understanding of this era.

29. For a persuasive materials-based approach to de Barros's paintings and their contemporary context, see Pia Gottschaller and Aleca Le Blanc, *Making Art Concrete: Works from Argentina and Brazil in the Colección Patricia Phelps de Cisneros* (Los Angeles: The Getty Conservation Institute and the Getty Research Institute, 2017), esp. 39–43.

30. Renato Rodrigues da Silva articulates these interdisciplinary forces with respect to the work of de Barros: "The *Fotoformas* of Geraldo de Barros: Photographic Experimentalism and the Abstract Art Debate in Brazil," *Leonardo* 44, no. 2 (2011): 152–60.

31. Any mention of the presence of photography at the Second Bienal, unless explicitly noted otherwise, requires acknowledging the exceptional research and collegiality of Adele Nelson, whose text on this subject will, I hope, be published in the near future.

32. *Boletim* 87 (February/March 1954): 24.

33. José Donati, "1939–1948," *Boletim* 24 (April 1948): 6.

34. See Barbara Weinstein, *The Color of Modernity: São Paulo and the Making of Race and Nation in Brazil* (Durham, NC: Duke University Press, 2015), for a comprehensive account of politics and race in São Paulo, anchored in the Constitutionalist Revolution of 1932 and the fourth centenary of the city's founding in 1954. It should be noted that in 1955 Rio opened its own Museu de Arte Moderna (MAM Rio).

35. By 1954 the initiation fee had risen to two hundred and the annual dues to six hundred cruzeiros; the 50 percent discount for

women and those living outside the State of São Paulo remained in effect.

36. Soon after the opening of their own building, the editors of the *Boletim* enthused that it had become a "mecca" of photography: "This is why we always remind members that the FCCB clubhouse is like their own home. And because they were already connected by a common ideal before they got here, there need be no formality between them once they got to know each other. Bandeirantes require no introductions. From the moment they become members, they are all friends" (*Boletim* 43 [November 1949]: 5).

37. No in-house contests were held the months of October and November, when the club focused on preparing for and hosting its annual international salon.

38. The art historian Alise Tifentale has argued persuasively that this competitive element was central to the club's activities. One regular column listed "Those Who Stand Out," and the Prestes Maia, one of several trophies awarded annually, went to the member with the most points. See Tifentale, "Introduction to José Oiticica Filho's 'Setting the Record Straighter,'" *ARTMargins* 8, no. 2 (June 2019): 105–15.

39. For an excellent account of the FCCB's filmic endeavors, see Foster, "The Cinema Section of Foto Cine Clube Bandeirante," 86–113.

40. "O Congresso e Concurso Cinematográfico da U.N.I.C.A." in *Boletim* 65 (September 1951): 30–32, includes a photo of de Barros on the jury in Glasgow.

41. The Foto-Cine Clube Sancarlense in São Carlos, Brazil, organized a dedicated salon for female photographers in 1951. See Menezes, *Images voyageuses*, 153–55, where he cites Priscila Miraz de Freitas Grecco, "A presença feminina em fotoclubes no século XX: apontamentos preliminares," *Domínios da Imagem* 11, no. 20 (January–June 2017): 72–94. See also Helouise Costa, *Três autores do sexo fraco (Three Authors of the Gentler Sex): Alice Kanji, Dulce Carneiro, Annemarie Heinrich*, exh. cat. (São Paulo: Galeria Utópica, 2020).

42. Melanie Farkas joined a few months after her wedding and is listed as Member no. 644 in the July 1949 issue of the *Boletim*; Altschul's husband joined on the same date she did; in their case, the wife was undeniably the primary figure in terms of contributing to the life and legacy of the club.

43. *Boletim* 35 (March 1949): 13, 17.

44. For two original considerations of Altschul's work, see Abigail Lapin Dardashti, "Gertrudes Altschul and Modernist Photography at the Foto Cine Clube Bandeirante" on *Medium* (stories. moma.org), June 7, 2017, and Paula Kupfer, "Gertrudes Altschul: An Adopted Brazilian Photographer in São Paulo," on *post: notes on art in a global context*, May 2, 2018 (post. moma.org). Isabel Amado's exhibition of Altschul's work at Casa da Imagem in São Paulo (*Uma mulher moderna—Fotografias de Gertrudes Altschul*, March 7–September 13, 2015) was, for this author, a singularly important introduction to the artist. MASP will dedicate a major solo exhibition to her in 2021.

45. "Although everyone knew about the illness that had kept renowned photographer-artist Gertrudes Altschul away from club activities for quite some time, Bandeirante members were painfully caught by surprise to hear of her death last month. The FCCB and Brazilian photography have lost one of their most expressive leaders, a highly sensitive artist who honored the country she adopted as home through her outstanding shows in several international salons" (*Boletim* 131 [May/June 1962]: 26). A subsequent mention in the column "Para você ler ou estudar" ("For You to Read or Study") in *Boletim* 140 (November/December 1963), 45, noted that a book titled *Photo International*, by Rita Maahs and Heinz Bronowski (Leipzig: VEB Editions, 1963), reproduces Altschul's *Filigree* and includes an homage to the artist.

46. Corrêa Ribeiro, "Uma foto . . . uma saudade" ("A Photograph . . . A Remembrance"), originally published in the journal *Microfilmando*, reprinted in *Boletim* 141 (January–March 1964): 8–10.

47. "A nota do mês," *Boletim* 66 (October 1951): 5.

48. "Exposição Marcel Giró," *Boletim* 94 (January–March 1955): 14–15.

49. See Jane Livingston, *The New York School: Photographs, 1936–1963* (Stewart Tabori & Chang, 1992), an excellent account that acknowledges the challenge of associating various individuals who might not have done so themselves at the time. Max Kozloff declined to refer to the "group" of photographers active in New York City at that time as such. See *New York: Capital of Photography* (New Haven: Yale University Press, 2002).

50. Wellington Lee's work is an instructive example.

51. The vastly larger photography scenes (encompassing commercial and artistic work) in, say, New York and Paris, also explain why dialogue between all interested parties would have been impractical.

52. With the exception of an extended (critical) response to the didactic circulating exhibition *Creative Photography* (discussed in the Chronology, page 166) in 1947, MoMA is rarely mentioned in the *Boletim*. One short article about *The Family of Man* (quoted here on pages 33–34) appears in *Boletim* 88 (April 1954): 24–25. A review of MoMA curator Beaumont Newhall's *History of Photography* describes it as "nothing more than a quasi-report on the history of photography. . . . The work is almost exclusively restricted to the US and Europe, ignoring the progress of photography in other parts of the world, which is plainly a failure in terms of [providing] a general history" (no. 100 [June/July 1956]: 46). Steichen is featured upon his retirement (no. 129 [January/February 1962]: 6–9), and his exhibition *The Bitter Years* is reviewed (no. 138 [July/August 1963]: 22–23). The only other mentions are an announcement for the exhibition *The Photographer and the American Landscape* (no. 140 [November/December 1963]: 28) and a mention that the French-born Chilean photographer Sérgio Larrain has photographs in MoMA's collection (no. 141 [January–March 1964]: 20).

53. See the press release for *Five French Photographers*, MoMA (December 18, 1951–February 24, 1952), which reads, "This is photography with a tender simplicity, a sly humor, a warm earthiness, the 'everydayness' of the familiar and the convincing aliveness found only in the best of the folk arts. Here is the offering of a new sphere of influence and inspiration to amateur photographers. It supplies a threshold leading to a new folk art that waits to be given life by the millions now practicing photography."

54. See Marly T. C. Porto, *Eduardo Salvatore e seu papel como articulador do fotoclubismo paulista / Eduardo Salvatore and His Role as Articulator of the São Paulo State Photo-Club Movement* (São Paulo: Porta de Cultura/Grau Editoria, 2018), in Portuguese and English.

55. Eduardo Salvatore, "Considerações sôbre o momento fotográfico," *Boletim* 67 (November 1951): 12.

56. Ibid., 12.

57. Ibid., 14.

58. See Alise Tifentale, "Rules of the Photographers' Universe," *Photoresearcher* 27 (2017): 68–77.

59. Alvaro P. Guimarães Jr., *Boletim* 85 (December 1953): 8–11.

60. Minor White, "Criticism," *Aperture* 2 (1953), reprinted in Peter C. Bunnell, ed., *Aperture Magazine Anthology—The Minor White Years, 1952–1976* (New York: Aperture, 2012), 149–50.

61. Clément Cheroux's exhibition at San Francisco Museum of Modern Art, *Don't! Photography and the Art of Mistakes* (July 20–December 1, 2019), highlighted the ways in which photographic "mistakes" can become creative fodder for future generations.

62. German Lorca, conversation with the author, August 2016. De Barros's review of this exhibition (reproduced in *Boletim* 74 [June 1952]) is quoted in the Chronology, page 171.

63. For a survey of the work of Thomaz Farkas, Hans Günter Flieg, Marcel Gautherot, and José Medeiros, see Sergio Burgi and Helouise Costa, *Modernidades fotográficas, 1940–1964* (São Paulo: Instituto Moreira Salles, 2014). Also

published in German and French editions.

64. One of the only mentions of Magnum in the pages of the *Boletim* is with respect to the photographer Sérgio Larraín, noting that he worked for *O Cruzeiro* and had belonged to Magnum since 1958; in *Boletim* 141 (January–March 1964): 20. *Life* magazine appears not to have been mentioned at all.

65. Alise Tifentale has observed that photo essays or articles featuring multiple images undermined the amateur club's commitment to single, singular images. See "The 'Cosmopolitan Art': FIAP Yearbooks of Photography, 1954–1960," paper presented at CAA 2017 in New York City, February 17, 2017, in the session "Photography in Print."

66. Each remain under-studied relative to their contemporary circulation. Yusuke Isotani's dissertation, "Arts et Métiers PHOTO-Graphiques: The Quest for Identity in French Photography between the Two World Wars" (PhD diss., CUNY, 2019), focuses on the first issue of *Photographie* but also provides helpful context for its German counterpart. For a lively biography of T. J. Maloney, the publisher of *U.S. Camera*, see Gary Saretzky, "*U.S. Camera*: A Thomas J. Maloney Chronology," *The Photo Review*, 26:4/27:1 (2004).

67. Rubens Teixeira Scavone, untitled introduction, in *Anuário brasilieiro de fotografia* (São Paulo: Foto-Cine Clube Bandeirante, 1957), n.p. This quotation is translated from Portuguese by Stephen Berg, sparing readers the awkwardness of the original published translation.

68. Irene V. Small includes a helpful perspective on Oiticica Filho in *Hélio Oiticica: Folding the Frame* (Chicago: University of Chicago Press, 2016), 191–92.

69. See Rubens Fernandes Junior, *Papéis efêmeros da fotografia* (Fortaleza, Brazil: Tempo d'Imagem, 2015). Farkas's family business, Fotoptica, was located on rua São Bento as well.

70. Those listed include (in this order) Alejandro C. Del Conte (Buenos Aires), Marius Guillard (Lyon, France), Domenico C. Di Vietri (Rome), Ray Miess

(Wisconsin, US), and Geraldo de Barros (Paris).

71. For example, at least three articles from the US-based *Popular Photography* appeared in the *Boletim* in translation, including "O que faz uma boa fotografia?" ("What Makes a Good Photo?"), which includes comments from *New York Times* photography critic Jacob Deschin, Irving Penn, and others; in no. 107 (March 1959): 17–18.

72. "A nota do mês," *Boletim* 26 (June 1948): 3.

73. "O bandeirante no exterior" ("The Bandeirante Abroad"), *Boletim* 56 (December 1950): 29.

74. *Boletim* 42 (October 1949): 20.

75. Jean-Claude Gautrand, "Looking at Others: Humanism and Neo-Realism" in Michel Frizot, ed., *A New History of Photography* (Cologne: Könemann, 1998), 613–32.

76. *Boletim* 91 (August 1954): 23–25.

77. Gautrand, "Looking at Others," 613.

78. See Andreas Valentin, "Light and Form: Brazilian and German Photography in the 1950s," in *Konsthistorisk tidskrift/Journal of Art History* 85, no. 2 (2016): 159–80, for a valuable analysis of Oiticica and de Barros's work with respect to Subjective photography.

79. Otto Steinert, "What This Book Is About," in *Subjektive Fotografie: Ein Bildband moderner europäischer Fotografie/ A Collection of Modern European Photography* (Bonn: Brüder Auer Verlag, 1952), 26. Steinert noted that in Saarbrücken the exhibition took place at the Staatliche Schule für Kunst und Handwerk, and in Cologne under the auspices of the Deutsche Gesellschaft für Photographie.

80. Ibid., 26.

81. See *German Lorca: Mosaico do tempo, 70 anos de fotografia* (São Paulo: Itaú Cultural, 2018), in Portuguese with English translation.

82. "'Anhembi' and the X° Salon," *Boletim* 68 (December 1951): 8.

83. The Japanese photographers included Hideo Gotoh, Tadao Higuchi, Koro Honjo, Yasuhiro Ishimoto, Takeji Iwamiya, Kaoru Ohto, Konichi Sako, Ryukichi Shibuya, and Osamu Yagi. Among those from the US were Ansel Adams, Wynn Bullock, Shirley C. Burden, Harry Callahan, Elliott Erwitt, Lotte Jacobi, Pirkle Jones, William Klein, Dorothea Lange, Irving Penn, Arthur Siegel, Frederick Sommer, Brett Weston, Edward Weston, and Minor White.

84. *Boletim* 97 (August–October 1955): 8–13. Steinert's work appeared on the cover and is featured extensively inside (see Chronology, June 1955, pages 173–74).

85. Alise Tifentale offers a compelling account of FIAP with particular attention given to the FCCB, in "The 'Olympiad of Photography': FIAP and the Global Photo-Club Culture, 1950–1965" (PhD diss., CUNY, 2020). She positions this network against the dominant forces in the mid-twentieth-century photography world, which she identifies as *Life* magazine, "the monopolization of photojournalistic production by Magnum cooperative," and *The Family of Man*, v.

86. "Comme Vous êtes la Société la plus puissante de l'Amérique du Sud, Votre Pays sera certes magnifiquement representé au sein de la FIAP" [errors/irregularities in original], *Boletim* 49 (May 1950): 5.

87. Tifentale, "The 'Olympiad of Photography,'" 2.

88. Tifentale observed, "In the US, similarly to the UK, the degree of specialization and professionalization of photography was relatively high during the 1950s. Fine art photographers became a distinct professional subgroup that was gradually assimilated into the infrastructure of professional visual art and their work was exhibited in art galleries and museums. Photo clubs in the US in the 1950s, meanwhile, served a distinctively amateur milieu" (ibid., 15).

89. A recent exhibition of her work, *Annemarie Heinrich: Secret Intentions; Genesis of Women's Liberation in Her Vintage Photographs*, took place at the Fundación Costantini/Museo de Arte Latinoamericano de Buenos Aires (MALBA), Buenos Aires (March 20–July 6, 2015), accompanied by a catalogue of the same title, in Spanish and English.

90. In *Boletim* 59 (March 1951) Jacob Polacow wrote an extensive review of the exhibition, followed by a nude study of hers reproduced on its own page.

91. *Boletim* 59 (March 1951): 26.

92. See Facundo de Zuviría, *Inner World: Modern Argentine Photography, 1927–1962* (Buenos Aires: MALBA, 2019). Zuviría's excellent survey features Grupo Forum, led by Sameer Makarius and Max Jacoby (also a member of Carpeta de los Diez), who aligned themselves with Subjective photography. Grupo Forum is never mentioned in the *Boletim*.

93. *Boletim* 85 (December 1953): 20–21. My sincere thanks to Facundo de Zuviría, Marina Pellegrini, and Alicia Sanguinetti (Annemarie Heinrich's daughter) for their patience and generous support of my research into Carpeta de los Diez.

94. José Antonio Rodríguez's *Ruth D. Lechuga: Una memoria mexicana* (Mexico City: Artes de México and Museo Franz Mayer, 2002) is one of the few published accounts of the Club Fotográfico de México. Quoted in Sarah Hermanson Meister, "Members Only," *Aperture* 236 (Fall 2019): 102–5.

95. Reported in *Boletim* 110 (July/August 1959): 14, and again in *Boletim* 132 (July–September 1962): 34, where the dates of the exhibition at the FCCB headquarters are noted: July 16–31, three years after its debut in Mexico.

96. For succinct summaries of the reductive narrative of modernism promoted by MoMA from the 1930s until at least the 1980s, and of the Museum's new, corrective curatorial philosophy, see Quentin Bajac, ed., *Being Modern: Building the Collection of The Museum of Modern Art* (New York: The Museum of Modern Art, 2017), and Ann Temkin et al., "Reimagining the Modern," in *MoMA Now: 375 Works from The Museum of Modern Art, New York* (New York: The Museum of Modern Art, 2019), 19–29.

97. *The American Snapshot* (March 1–May 10, 1944) was organized by Willard D. Morgan (the short-lived director of the Department of Photography) with the support of the Eastman Kodak company. Yet even Morgan decried the production of amateur salons: "It is the unstudied, spontaneous freshness of the snapshot that sets it apart from the carefully contrived picture of the conventional photographic salon. The question of which is the greater art is unimportant; the significant thing is that here, in this exhibition, the snapshot has come into its own, recognized and presented for what it is—and nothing more."

The American Snapshot: An Exhibition of the Folk Art of the Camera (New York: The Museum of Modern Art, 1944), n.p. [15].

98. John Raymond, Publisher's Statement, *Photo Arts*, October 1951, 48. Available online: https://assets.moma.org/documents/moma_catalogue_2413_300062089.pdf.

99. "Geraldo de Barros's fotoformas, Manarini's compositions, and the work of Malfatti and others, all take into account the exact measure of abstraction's possibilities to obtain truly magnificent effects. Equally outstanding in this regard are Moraes Barros, Ayrosa, and Altschul, who reveal themselves to be exclusive practitioners of form—an abstraction whose point of departure is reality itself." *Boletim* 93 (October–December 1954): 18.

100. The most recent and most valuable resource is Gerd Hurm, Anke Reitz, and Shamoon Zamir, eds., *The Family of Man Revisited: Photography in a Global Age* (London: I. B. Taurus, 2018).

101. To add insult to injury, the British photographer Leonti Planskoy's photographs made in Brazil were included in both *Postwar European Photography* and *The Family of Man*.

102. "O Museu de Arte Moderna de New York comemorará o seu 25° aniversário com uma exposição de fotografias," *Boletim* 88 (April 1954): 24–25.

103. These sculptures were first shown in Leonard's solo exhibition *In the Wake*, at Hauser & Wirth, New York, in 2016.

I.

ARCHITECTURE

Arquitetura (February 1948), *Arquitetura, Monumentos (ângulos, detalhes)* (October 1951), *Arquitetura e Interiores* (August 1956)

JOSÉ YALENTI

ABSTRACTIONS FROM NATURE

Formas e linhas na natureza (December 1954), *Composições naturais e Abstrações* (December 1956), *Natureza morta e/ou "Abstracionismo"* (November 1963)

FIAP

-ABSTRAÇÃO 2-57-

4

JOSÉ OITICICA FILHO

Rua Alfredo Chaves, 59

Rio de Janeiro - Brasil

JOSÉ OITICICA Fº
"ABSTRAÇÃO"

1958

ANNUAIRE
1960

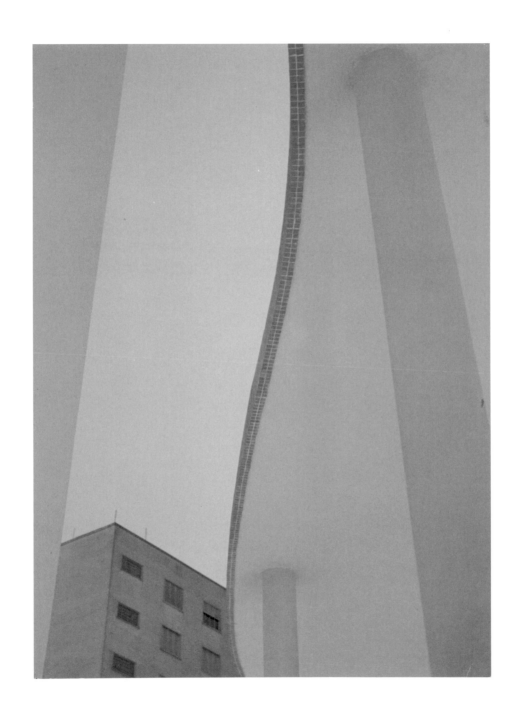

Gertrudes Altschul
Lines and Tones (Linhas e tons). 1953
Gelatin silver print, 14⅞ × 11 in. (37.8 × 27.9 cm)
The Museum of Modern Art, New York. Acquired through
the generosity of Amie Rath Nuttall

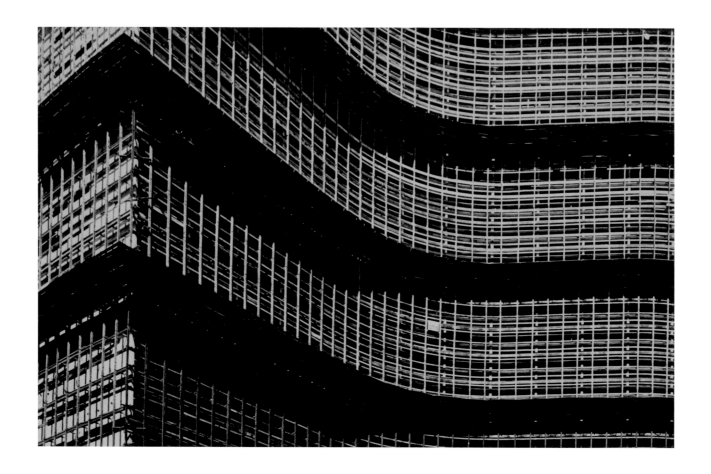

Ivo Ferreira da Silva
Paulista Flag (Bandeira paulista). c. 1960
Gelatin silver print, 10¹⁄₁₆ × 15³⁄₁₆ in. (25.5 × 38.5 cm)
Long-term loan MASP FCCB

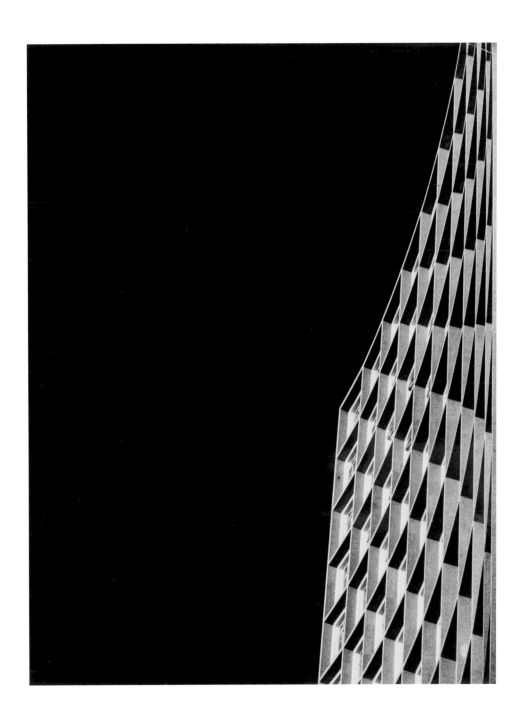

José Yalenti
Untitled. c. 1948
Gelatin silver print, 15¾ × 11¹³⁄₁₆ in. (40 × 30 cm)
Collection Fernanda Feitosa and Heitor Martins

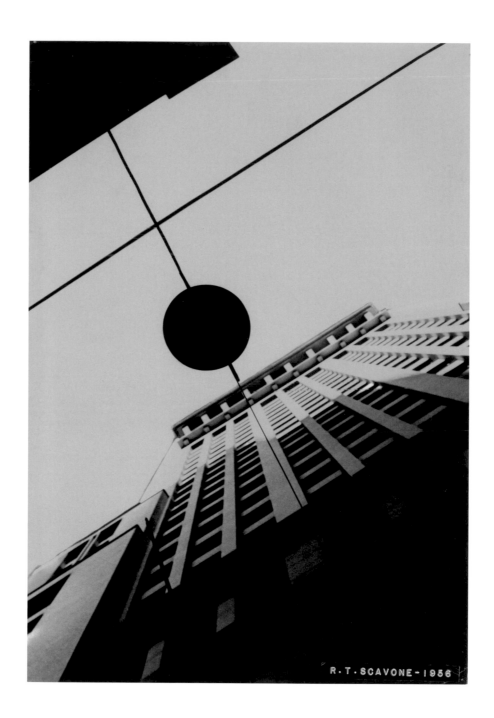

Rubens Teixeira Scavone
Vertical Composition with Lines and Masses
(*Composição vertical com linhas e massas*). 1956
Gelatin silver print, 15 ³⁄₁₆ × 10 ⅝ in. (38.5 × 27 cm)
Long-term loan MASP FCCB. Special acknowledgment
Lorenzo and Marcio Scavone

Thomaz Farkas
Ministry of Education (Ministério da Educação)
[Rio de Janeiro]. c. 1945
Gelatin silver print, 12¹³⁄₁₆ × 11¾ in. (32.6 × 29.9 cm)
The Museum of Modern Art, New York. Gift of the artist

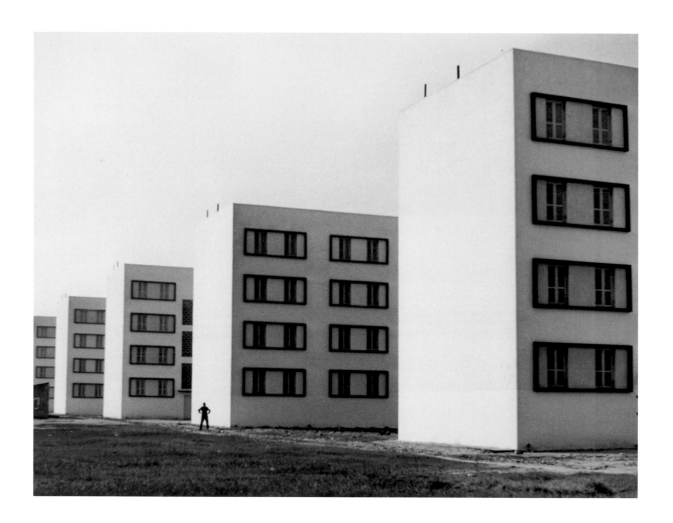

Eduardo Salvatore
Untitled [Várzea do Carmo housing complex, São Paulo]. c. 1951
Gelatin silver print, 11¹⁵⁄₁₆ × 15⁹⁄₁₆ in. (30.4 × 39.5 cm)
The Museum of Modern Art, New York. Acquired through
the generosity of Richard O. Rieger

Gertrudes Altschul
Architecture (*Arquitetura*) or *Composition* (*Composição*). 1956
Gelatin silver print, 15 ³⁄₁₆ × 11¼ in. (38.5 × 28.5 cm)
Long-term loan MASP FCCB. Special acknowledgment
Ernst Oscar Altschul and family

Kazuo Kawahara
Architecture (*Arquitetura*) or *Ascension* (*Ascenção*). 1951
Gelatin silver print, 14 15/16 × 11 5/16 in. (38 × 28.7 cm)
Collection Fernanda Feitosa and Heitor Martins

Thomaz Farkas
Brazilian Press Association (Associação Brasileira de Imprensa) [Rio de Janeiro]. c. 1945
Gelatin silver print, 12 × 13⅜ in. (30.5 × 34 cm)
Collection João Farkas and Kiko Farkas

João Bizarro da Nave Filho
Brasília. 1960
Gelatin silver print, 9⁷⁄₁₆ × 15¹⁵⁄₁₆ in. (24 × 40.5 cm)
Long-term loan MASP FCCB

Eduardo Ayrosa
Curves (Curvas). 1951
Gelatin silver print, 14 ⅜ × 11 ⅝ in. (36.5 × 29.5 cm)
Long-term loan MASP FCCB

German Lorca*
Stairs (Escada). c. 1954
Gelatin silver print, 11⅝ × 15⁹⁄₁₆ in. (29.5 × 39.5 cm)
Long-term loan MASP FCCB

*Although Lorca's name is written on the back of the print, when he was shown the work
in 2015 he did not recognize it as his own. For this reason, MASP considers the authorship
of the photograph to be unknown.

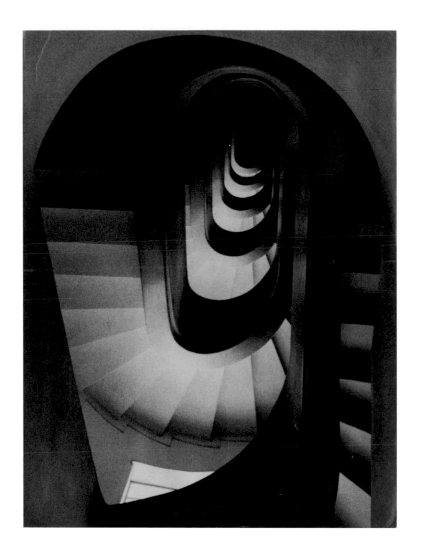

Antonio Ferreira Filho
The Manner of Modern Painting (À guisa da pintura moderna). c. 1954
Gelatin silver print, 15 ⁹⁄₁₆ × 11 ⁷⁄₁₆ in. (39.5 × 29 cm)
Long-term loan MASP FCCB

Carlos Frederico Latorre
Snail (Caracol). 1949
Gelatin silver print, 12 × 11 ⅝ in. (30.5 × 29.5 cm)
Long-term loan MASP FCCB

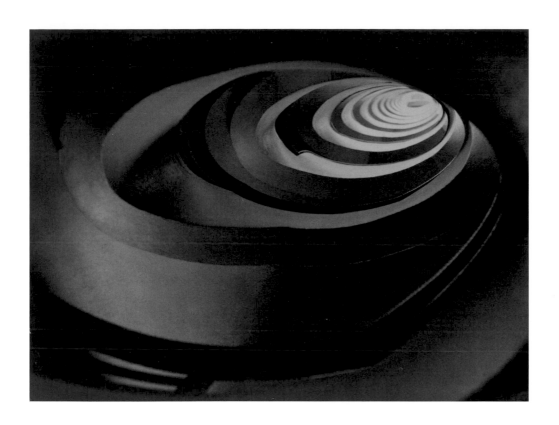

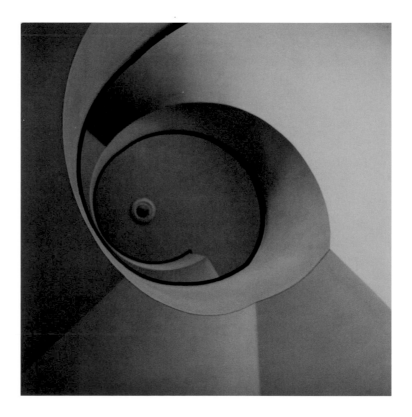

Eijiryo Sato
Stairs (*Escada*). c. 1953
Gelatin silver print, 11⁷⁄₁₆ × 15³⁄₁₆ in. (29 × 38.5 cm)
Long-term loan MASP FCCB

Frederico Soares de Camargo
Little Fan (*Ventoinha*). c. 1954
Gelatin silver print, 11⅝ × 11¹³⁄₁₆ in. (29.5 × 30 cm)
Long-term loan MASP FCCB

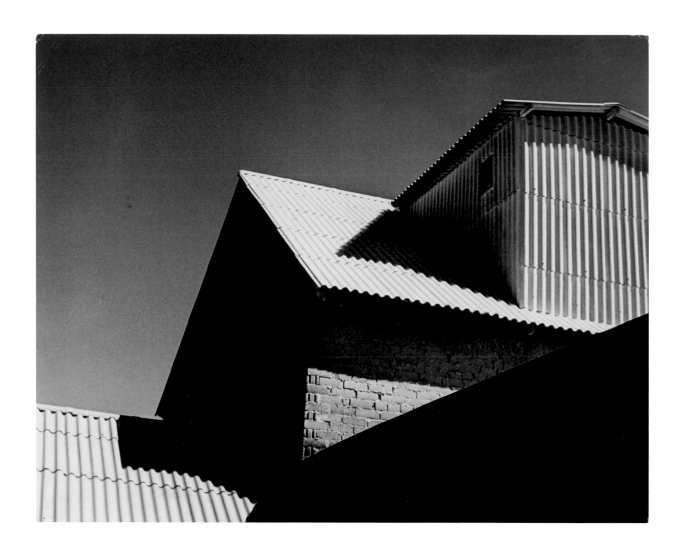

German Lorca
White Roofs (*Telhados brancos*). 1951
Gelatin silver print, 11¾ × 14¾ in. (29.8 × 37.5 cm)
Collection Fernanda Feitosa and Heitor Martins

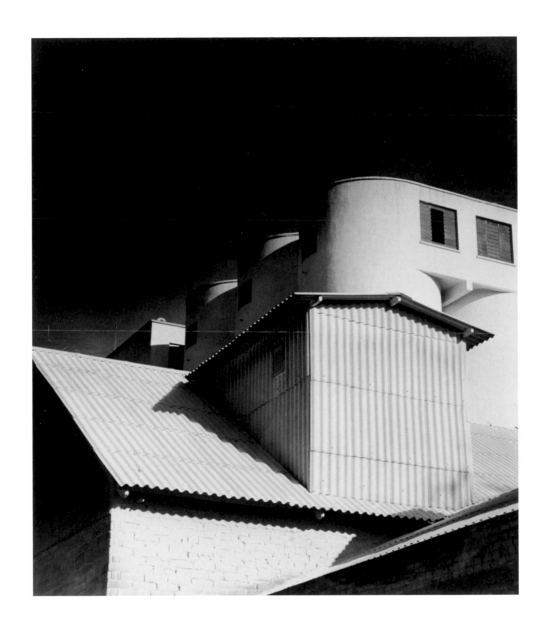

José Yalenti
Angles (Ângulos). 1951
Gelatin silver print, 13 ¾ × 11 ¹³⁄₁₆ in. (35 × 30 cm)
Collection Fernanda Feitosa and Heitor Martins

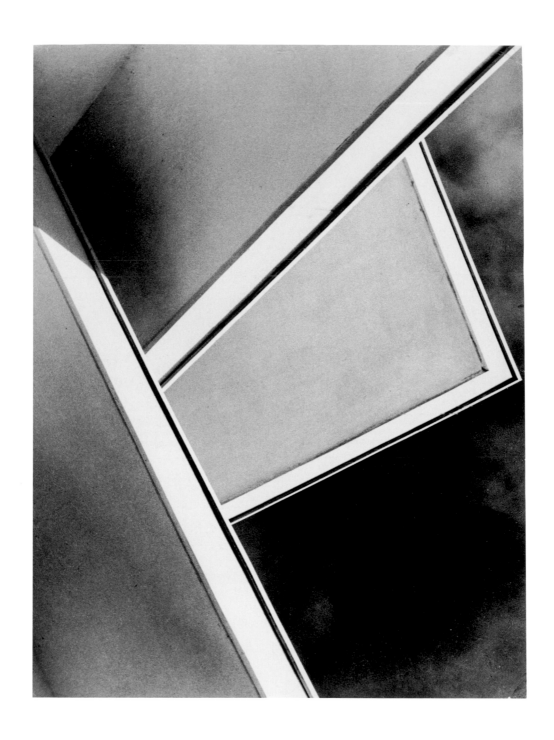

José Yalenti
Borders (*Beirais*). 1953
Gelatin silver print, 15 ⅜ × 11 ⅝ in. (39 × 29.5 cm)
Collection Fernanda Feitosa and Heitor Martins

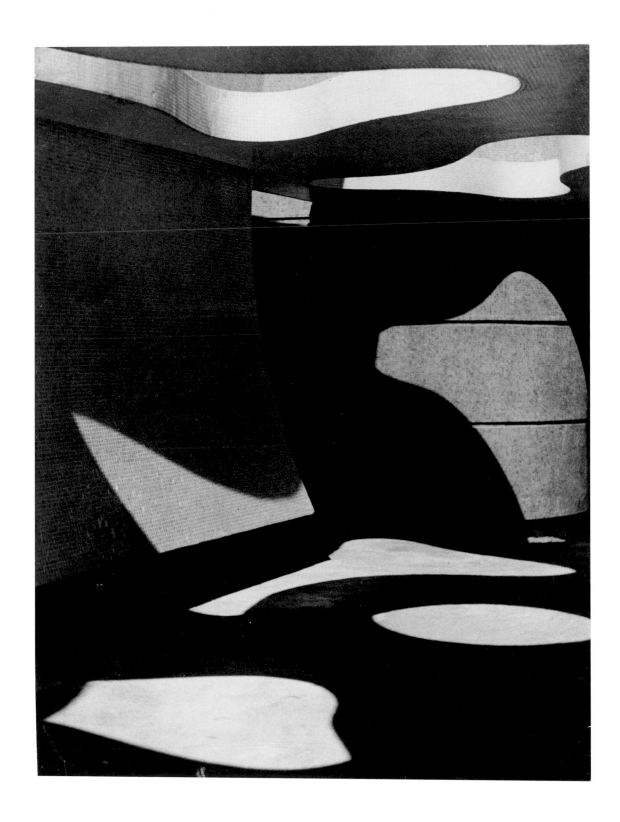

José Yalenti
Architecture (*Arquitetura*). c. 1957
Gelatin silver print, 18⅞ × 14¼ in. (48 × 36.2 cm)
Itaú Collection

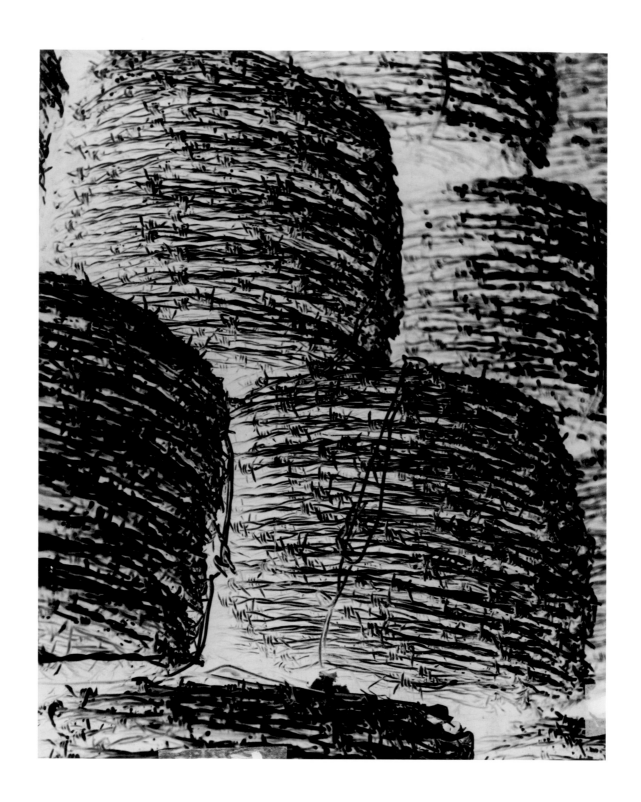

José Yalenti
Barbed Wire (*Farpas*). c. 1950
Gelatin silver print, 19½ × 15¾ in. (49.5 × 40 cm)
Collection Fernanda Feitosa and Heitor Martins

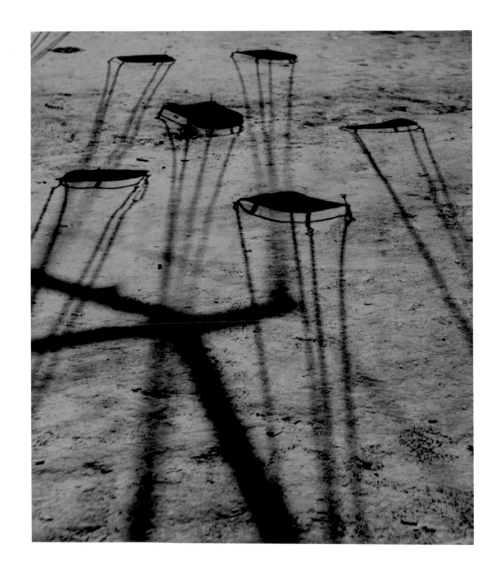

José Yalenti
Swinging (*Balancê*). c. 1953
Gelatin silver print, 12¹³⁄₁₆ × 11⁷⁄₁₆ in. (32.5 × 29 cm)
Long-term loan MASP FCCB

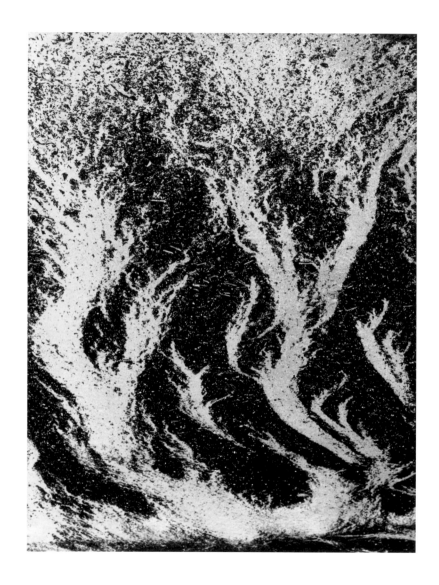

José Yalenti
Sand (Areia). c. 1950
Gelatin silver print, 15¾ × 11⅞ in. (40 × 30.2 cm)
The Museum of Modern Art, New York. Acquired through the generosity of
Patricia Phelps de Cisneros through the Latin American and Caribbean Fund

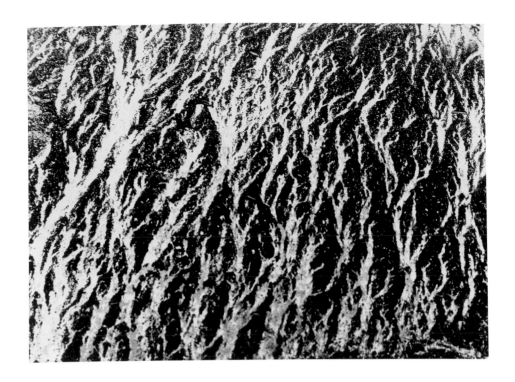

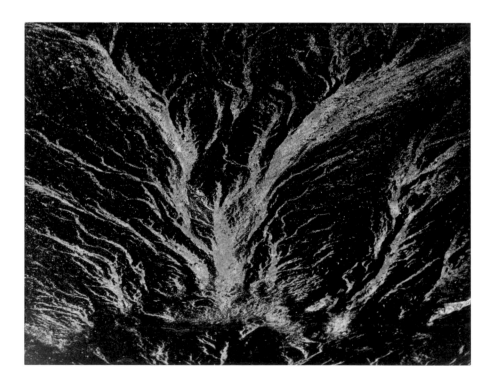

José Yalenti
Sand (Areia). c. 1950
Gelatin silver print, 11⅛ × 15⅜ in. (28.3 × 39 cm)
The Museum of Modern Art, New York. Committee on
Photography Fund

José Yalenti
Sand (Areia). c. 1950
Gelatin silver print, 11⅞ × 15¾ in. (30.1 × 40 cm)
The Museum of Modern Art, New York. Committee on
Photography Fund

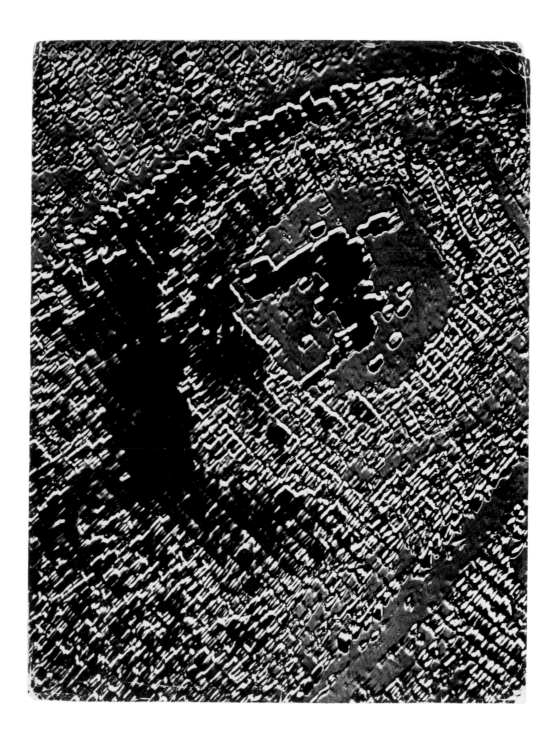

José Oiticica Filho
Abstraction 2-57 (Abstração 2-57). 1958
Gelatin silver print, 15 ¹³⁄₁₆ × 11 ⅞ in. (40.2 × 30.2 cm)
Collection Fernanda Feitosa and Heitor Martins

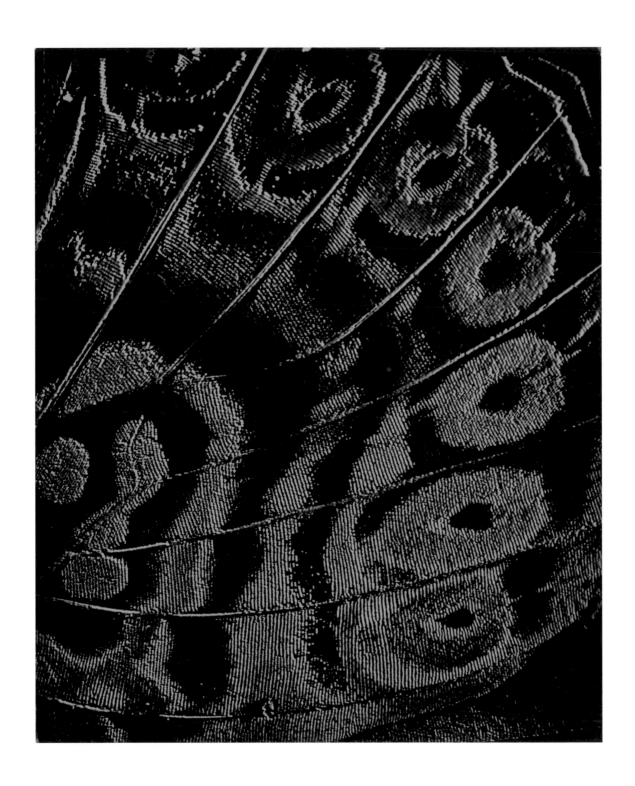

José Oiticica Filho
Abstraction 3-57 (Abstração 3-57). c. 1958
Gelatin silver print, 16 9/16 × 13 3/8 in. (42 × 34 cm)
Long-term loan MASP FCCB. Special acknowledgment
César and Claudio Oiticica

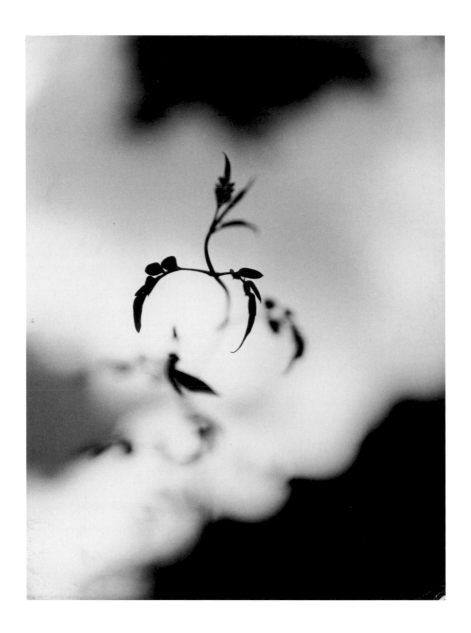

Dulce Carneiro
Oneiric (Onírica). c. 1958
Gelatin silver print, 15 5/8 × 11 11/16 in. (39.7 × 29.7 cm)
The Museum of Modern Art, New York.
John Szarkowski Fund

Eduardo Salvatore
Untitled. c. 1947
Gelatin silver print, 15 ¹⁵⁄₁₆ × 19 ⅛ in. (40.5 × 48.5 cm)
Long-term loan MASP FCCB. Special acknowledgment Leme Salvatore Family,
Luis Alberto Leme Salvatore, and the Instituto Brasil Solidário, for their efforts
to preserve the memory and history of photography in Brazil

II.

SOLITUDE

Retratos e figuras ao ar livre (May 1949), *Figuras ambientadas*
(April 1952), *Solidão* (December 1952), *Flagrantes de rua
e/ou Tritonal* (August 1961)

GERTRUDES ALTSCHUL

SHADOWS

Sombras (June 1951), *Résteas de luz* (June 1954)

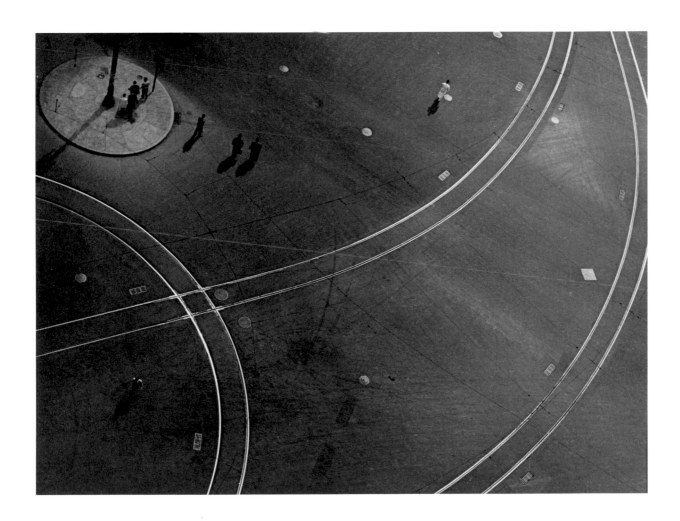

André Carneiro
Rails (Trilhos). 1951
Gelatin silver print, 11⅝ × 15⁹⁄₁₆ in. (29.6 × 39.6 cm)
The Museum of Modern Art, New York. Acquired through the generosity of
José Olympio da Veiga Pereira through the Latin American and Caribbean Fund

Dulce Carneiro
Right Step (Passo certo). c. 1957
Gelatin silver print, 8 7/16 × 14 3/4 in. (21.5 × 37.5 cm)
Long-term loan MASP FCCB

Gaspar Gasparian
Divergent (*Divergente*). 1949
Gelatin silver print, 15¾ × 11⁹⁄₁₆ in. (40 × 29.4 cm)
The Museum of Modern Art, New York. Latin American
and Caribbean Fund

Ademar Manarini
Untitled [Várzea do Carmo housing complex, São Paulo]. c. 1951
Gelatin silver print, 11¹¹⁄₁₆ × 14⁹⁄₁₆ in. (29.7 × 37 cm)
The Museum of Modern Art, New York. Acquired through
the generosity of Richard O. Rieger

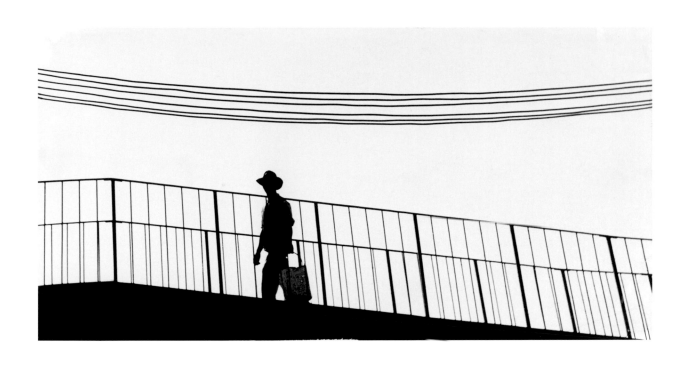

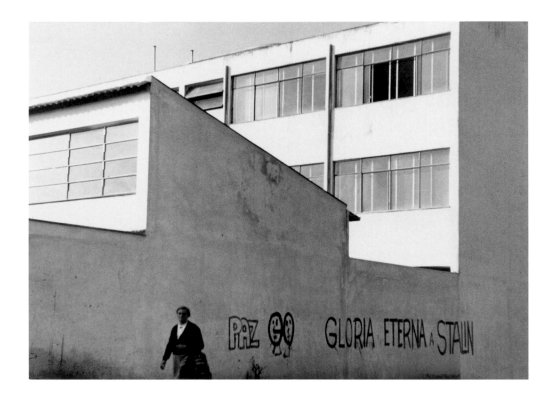

Ademar Manarini
Walkway, Largo Ana Rosa (Passarela, Largo Ana Rosa)
[São Paulo]. c. 1951
Gelatin silver print, 7⅞ × 15¾ in. (20 × 40 cm)
Itaú Collection

Ademar Manarini
Untitled. c. 1951
Gelatin silver print, 11¹³⁄₁₆ × 15¾ in. (30 × 40 cm)
Itaú Collection

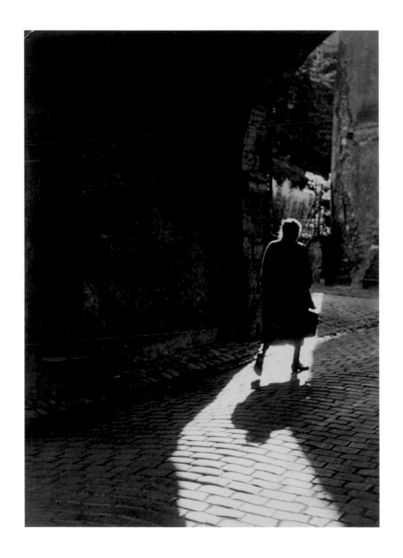

Barbara Mors
Study with Sun II (*Estudo com sol II*). c. 1953
Gelatin silver print, 15⅜ × 11⅛ in. (39.1 × 28.3 cm)
The Museum of Modern Art, New York.
John Szarkowski Fund

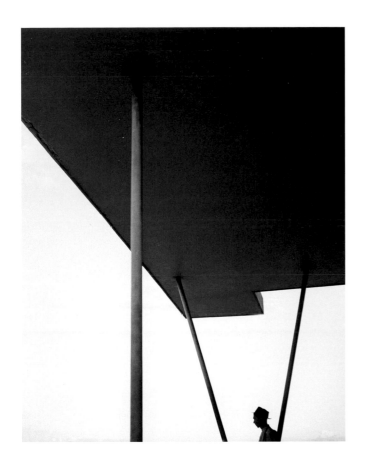

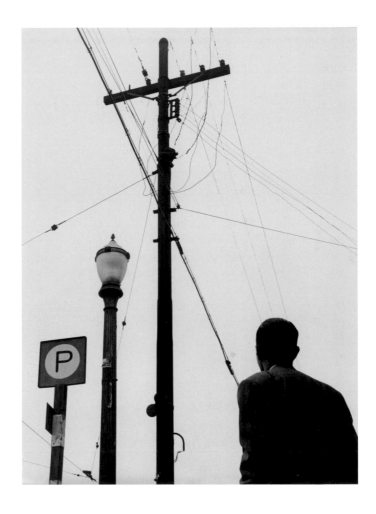

Thomaz Farkas
Pampulha [Belo Horizonte]. c. 1949
Gelatin silver print, 11⁷⁄₁₆ × 9¹⁄₁₆ in. (29 × 23 cm)
Collection João Farkas and Kiko Farkas

Ademar Manarini
Untitled. c. 1955
Gelatin silver print, 15³⁄₈ × 11⁵⁄₈ in. (39 × 29.5 cm)
The Museum of Modern Art, New York. Acquired through
the generosity of Thomas and Susan Dunn

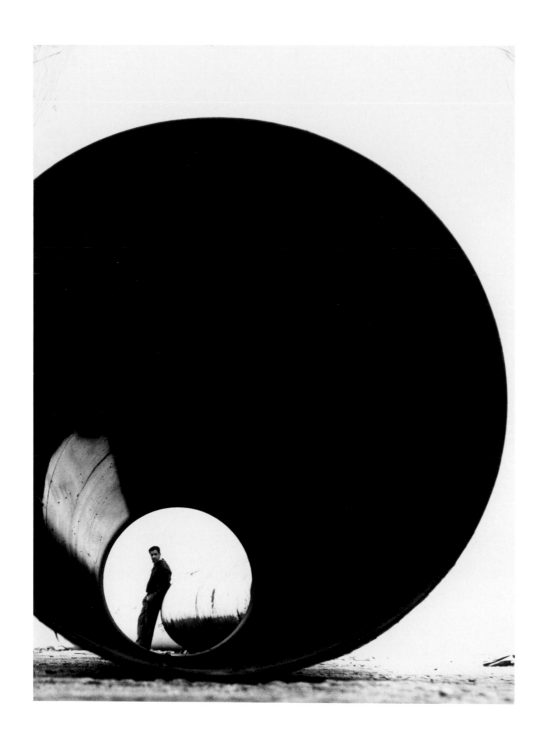

Eduardo Salvatore
Composition with Figure (Composição com figura). c. 1955
Gelatin silver print, 15 9/16 × 11 5/8 in. (39.5 × 29.5 cm)
Collection Fernanda Feitosa and Heitor Martins

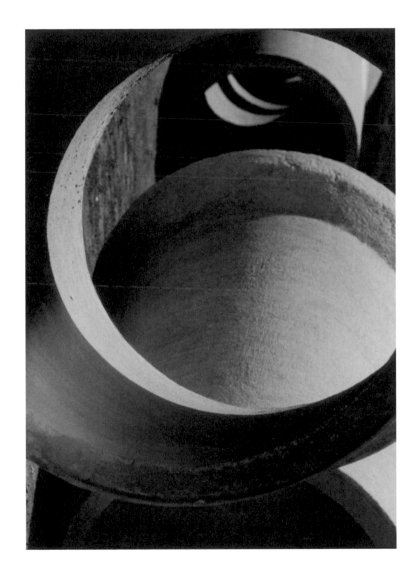

Gertrudes Altschul
Abstract Concrete (Concreto abstrato). c. 1953
Gelatin silver print, 11⅜ × 8⅜ in. (28.9 × 21.3 cm)
The Museum of Modern Art, New York. Acquired through
the generosity of Thomas and Susan Dunn

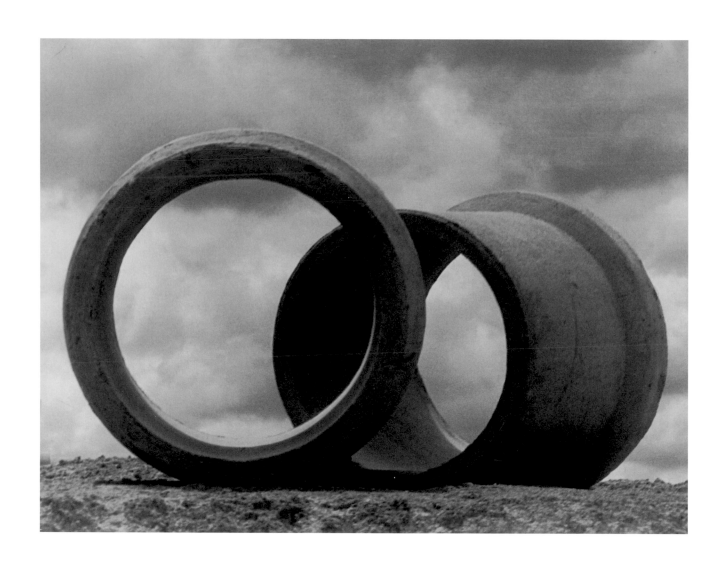

Gertrudes Altschul
Untitled. c. 1953
Gelatin silver print, 11⁷⁄₁₆ × 15¼ in. (29.1 × 38.7 cm)
The Museum of Modern Art, New York. Acquired through
the generosity of Lois and Bruce Zenkel

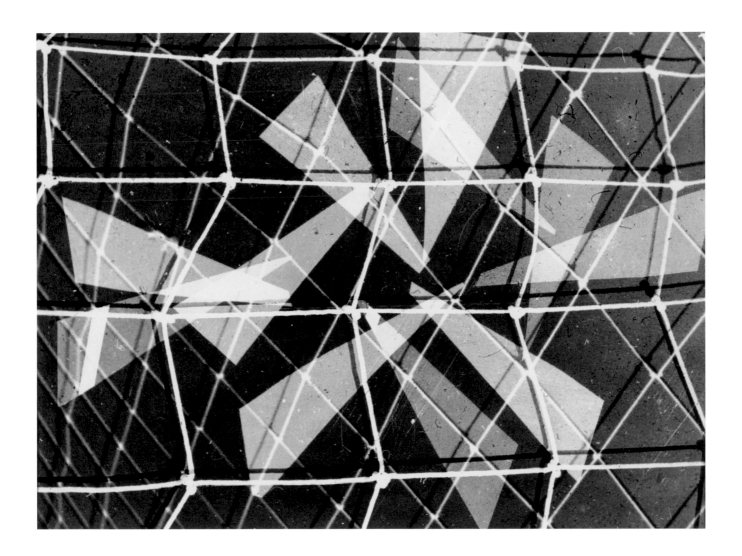

Gertrudes Altschul
Untitled. c. 1953
Gelatin silver print, 11⅝ × 15⁹⁄₁₆ in. (29.5 × 39.5 cm)
The Museum of Modern Art, New York. Acquired through
the generosity of Ian Cook

Gertrudes Altschul
Untitled. 1950s
Gelatin silver print, 15⁹⁄₁₆ × 11⅝ in. (39.5 × 29.5 cm)
Long-term loan MASP FCCB. Special acknowledgment
Ernst Oscar Altschul and family

Gertrudes Altschul
Untitled. c. 1955
Gelatin silver print, 11¹³⁄₁₆ × 15½ in. (30 × 39.4 cm)
The Museum of Modern Art, New York.
John Szarkowski Fund

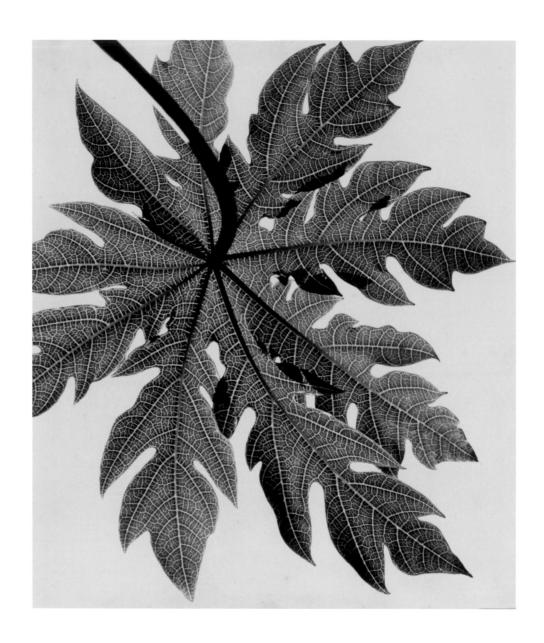

Gertrudes Altschul
Filigree (Filigrana). 1953
Gelatin silver print, 13⅝ × 11⅝ in. (34.6 × 29.5 cm)
The Museum of Modern Art, New York. Acquired through
the generosity of Amie Rath Nuttall

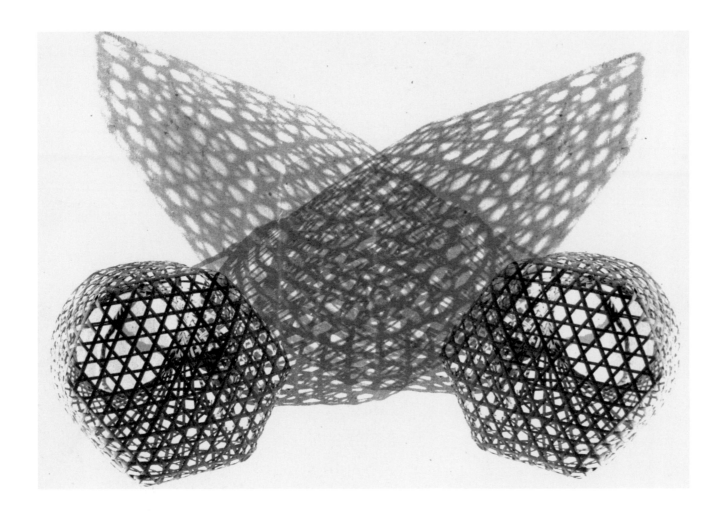

Gertrudes Altschul
Untitled. c. 1955
Gelatin silver print, 10 ¹³⁄₁₆ × 15 ¼ in. (27.5 × 38.7 cm)
The Museum of Modern Art, New York. Acquired through
the generosity of David Dechman and Michel Mercure

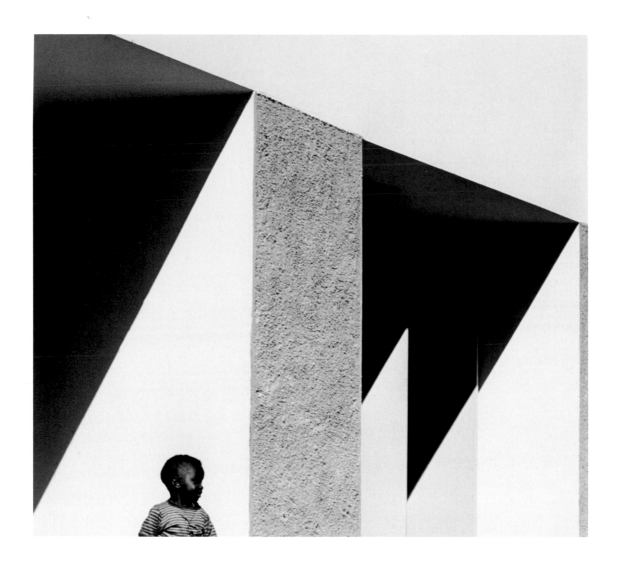

Ademar Manarini
Composition (Composição). c. 1953
Gelatin silver print, 11¾ × 13 in. (29.9 × 33 cm)
Collection Fernanda Feitosa and Heitor Martins

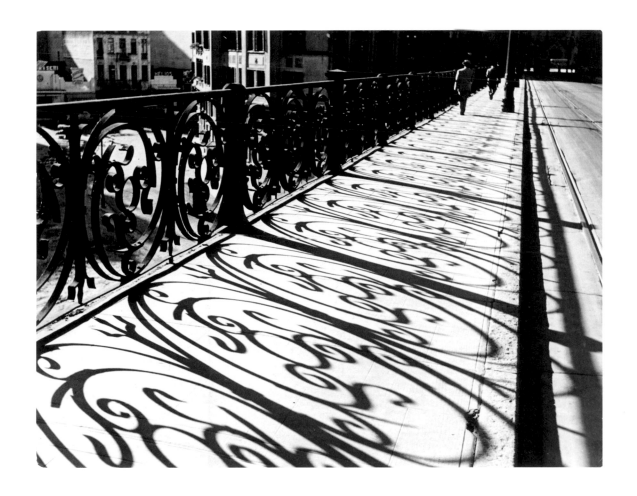

Thomaz Farkas
Railing of Santa Ifigênia Viaduct (Gradil do Viaduto
Santa Ifigênia) [São Paulo]. 1945
Gelatin silver print, 9 1/16 × 11 13/16 in. (23 × 30 cm)
Collection João Farkas and Kiko Farkas

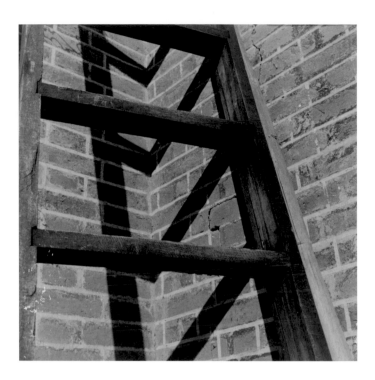

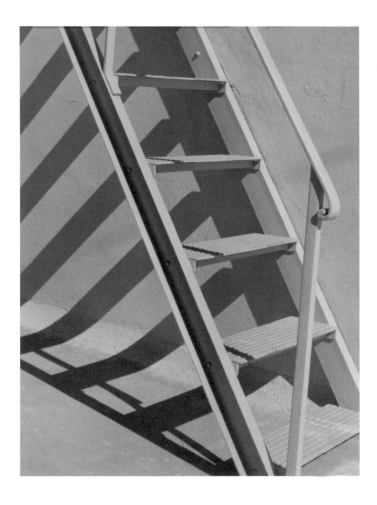

Gertrudes Altschul
Untitled. c. 1955
Gelatin silver print, 11⅜ × 11⅜ in. (28.9 × 28.9 cm)
The Museum of Modern Art, New York.
Agnes Rindge Claflin Fund

Gertrudes Altschul
Untitled. c. 1955
Gelatin silver print, 15¹⁄₁₆ × 11½ in. (38.3 × 29.2 cm)
The Museum of Modern Art, New York.
John Szarkowski Fund

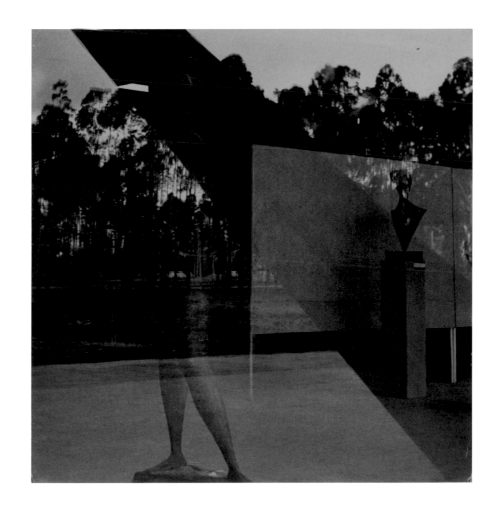

Armando Moraes Barros
The Second Bienal Viewed from Outside (II Bienal vista de fora) [São Paulo]. 1953–54
Gelatin silver print, 12¹³⁄₁₆ × 11¹³⁄₁₆ in. (32.5 × 30 cm)
Long-term loan MASP FCCB

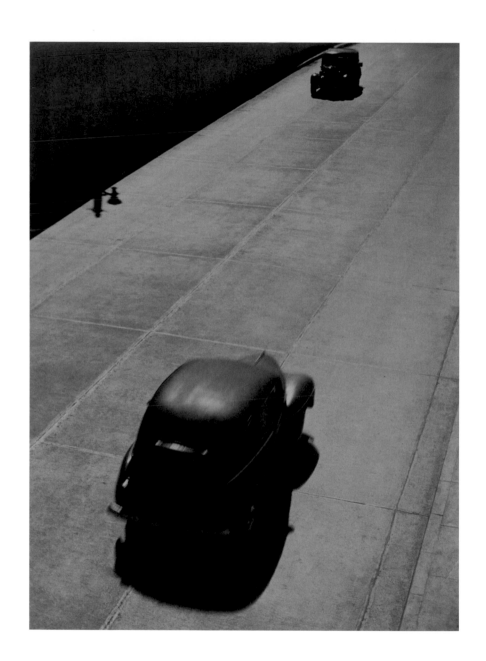

Nelson Kojranski
In Opposite Directions (*Em direções opostas*). 1950
Gelatin silver print, 15 ⅜ × 11¼ in. (39 × 28.5 cm)
Long-term loan MASP FCCB

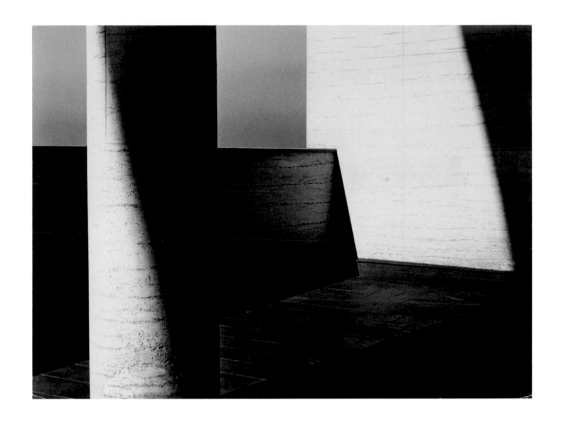

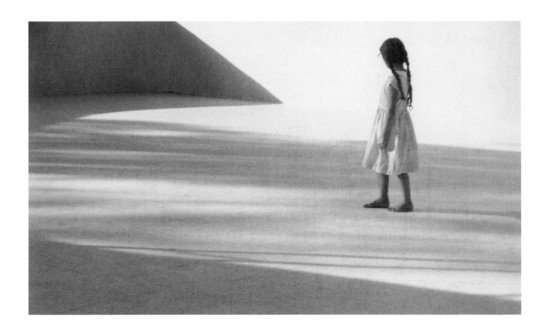

Francisco Albuquerque
Balance of Masses (*Equilíbrio de massas*). c. 1950
Gelatin silver print, 11½ × 15½ in. (29.2 × 39.4 cm)
Collection Fernanda Feitosa and Heitor Martins

Dulce Carneiro
Tomorrow (*Amanhã*). c. 1957
Gelatin silver print, 9 ³⁄₁₆ × 15½ in. (23.3 × 39.4 cm)
The Museum of Modern Art, New York.
John Szarkowski Fund

FOTO CINE CLUBE ARACOARA

ARARAQUARA SÃO PAULO BRASIL

TÍTULO SINFONIA FLUORESCENTE

AUTOR Lucilio Corrêa Leite Junior

3.º
SALÃO DE ARTE
FOTOGRÁFICA
DE
ARARAQUARA
∗∗∗
29 AGOSTO — 8 SETEMBRO
1.953
∗∗∗
Foto Cine Clube Aracoara
ARARAQUARA
SÃO PAULO

275 3

1º Premio

IV SALÃO DO
CINE FOTO CLUBE
DE RIBEIRÃO PRETO

1 9 5 3

III.

DAILY LIFE

Cenas de gênero (December 1948), *Cenas de bairros* (October 1953),
Cenas de rua e retratos ao ar livre (April 1956)

THOMAZ FARKAS

NOCTURNES

Noturnos da cidade (August 1947), *Noturnos*
(July 1949, February 1953), *Noturno e atmosfera* (August 1958),
Antigo e novo e/ou Noturnos (December 1961)

BRASIL

SOCIEDADE FOTOGRÁFICA DE NOVA FRIBURGO
Rua Alberto
NOVA FRIBURGO E. DO RIO

F. C. C. P.
CURITIBA
16º SALÃO FOTOGR.·1954

2ª EXPOSIÇÃO INTERNACIONAL
DE FOTOGRAFIA
1955
ABAF
ASSOCIAÇÃO BRASILEIRA DE ARTE FOTOGRÁFICA
RIO DE JANEIRO • BRASIL
OSCAR

2.º SALÃO
1615
TIAM PER ME BRASILIA MAGNA
ARTE FOTOGRÁFICA
JUNDIAÍ, São Paulo

SANTOS CINE FOTO CLUBE
Salão Internacional de Arte Fotográfica

FOTO-CINE CLUBE DE JUNDIAÍ
2º Salão Ano 1956

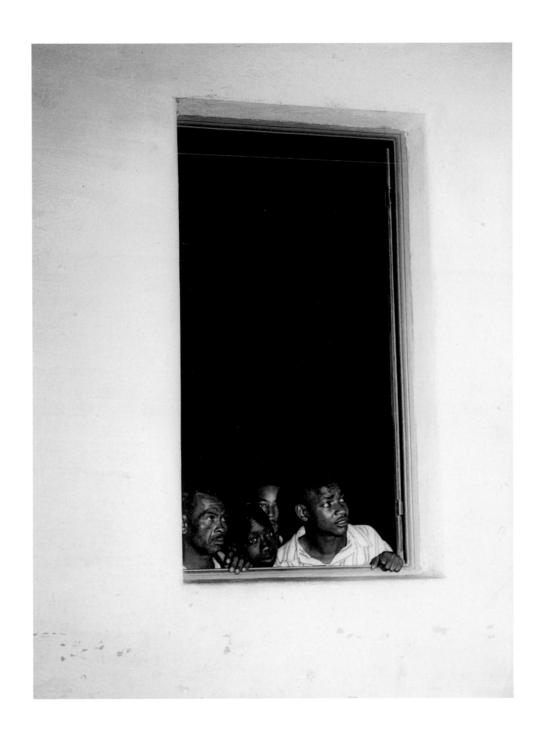

Thomaz Farkas
Blacks at the Window (Pretos na janela). c. 1945
Gelatin silver print, 15¹⁵⁄₁₆ × 11¹³⁄₁₆ in. (40.5 × 30 cm)
The Museum of Modern Art, New York. Gift of the artist

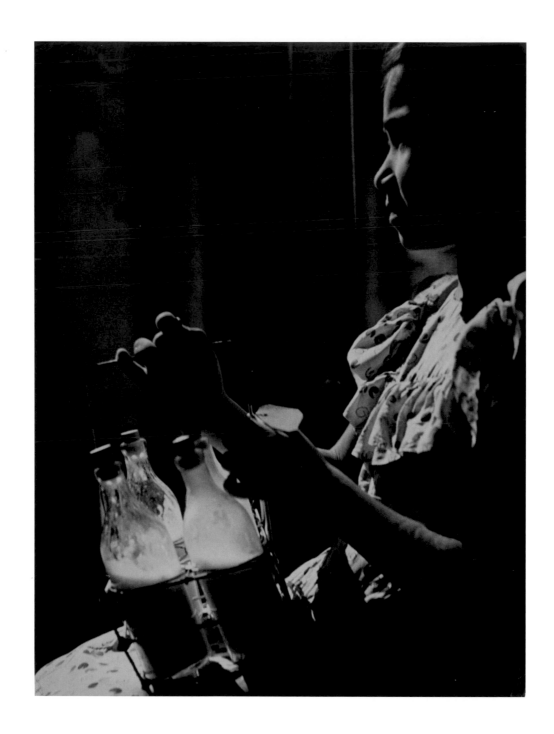

Geraldo de Barros
Milk Girl (Menina do leite). c. 1946
Gelatin silver print, 15⅜ × 11⁷⁄₁₆ in. (39 × 29 cm)
Long-term loan MASP FCCB

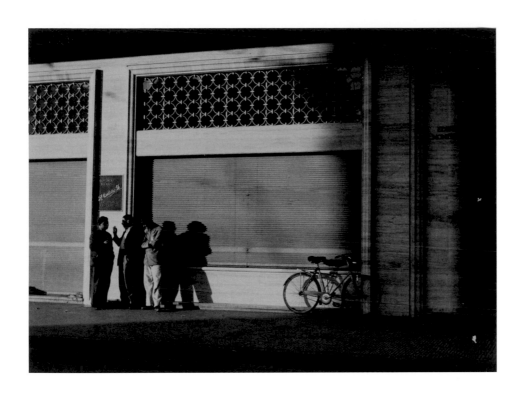

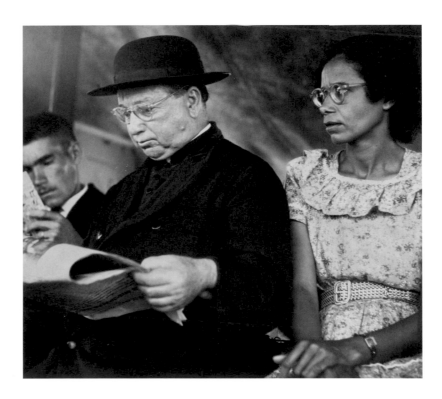

Antonio da Silva Victor
The Business (O negócio) or *The Trouble*
(A encrenca). 1949
Gelatin silver print, 11¼ × 15³⁄₁₆ in. (28.5 × 38.5 cm)
Long-term loan MASP FCCB

German Lorca
Everyday Scenes (Cenas quotidianas). 1949
Gelatin silver print, 11⅛ × 12⅞ in. (28.3 × 32.7 cm)
The Museum of Modern Art, New York. Committee on
Photography Fund

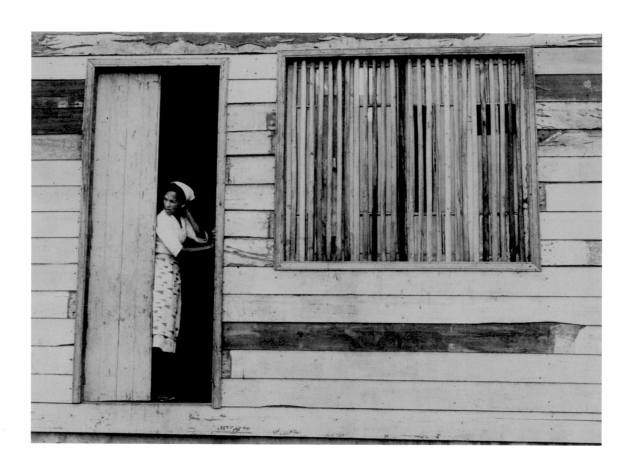

Palmira Puig Giró
Waiting for Her Daughter (*Esperando a filha*). c. 1960
Gelatin silver print, 11¼ × 15⁹⁄₁₆ in. (28.5 × 39.5 cm)
Long-term loan MASP FCCB. Special acknowledgment
Toni Ricart Giró

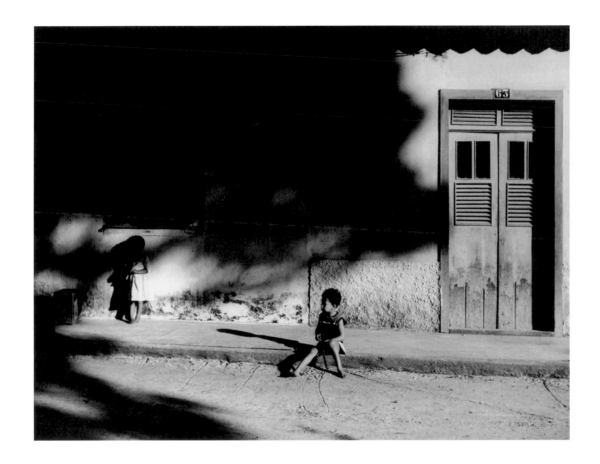

Thomaz Farkas
Paquetá, Rio de Janeiro. c. 1945
Gelatin silver print, 11¾ × 15 in. (29.8 × 38.1 cm)
The Museum of Modern Art, New York. Gift of the artist

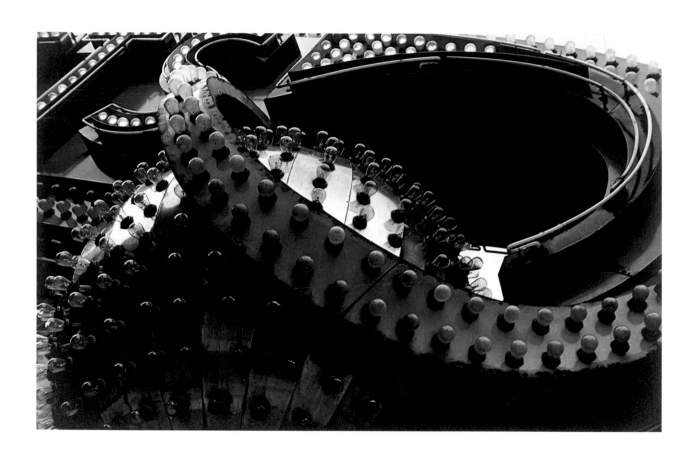

Thomaz Farkas
Untitled. c. 1948
Gelatin silver print, 9 7/16 × 14 15/16 in. (24 × 38 cm)
Collection João Farkas and Kiko Farkas

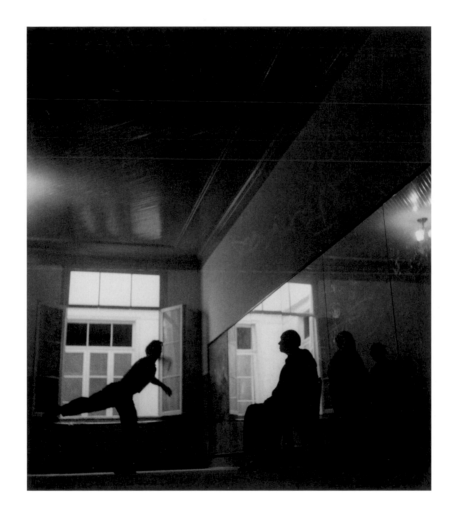

Thomaz Farkas
Ballet Rehearsal (*Ensaio de balé*). 1947
Gelatin silver print, 12 ¾ × 11 ⁵⁄₁₆ in. (32.4 × 28.7 cm)
The Museum of Modern Art, New York. Gift of the artist

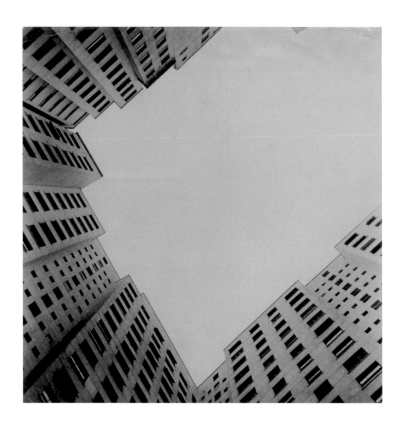

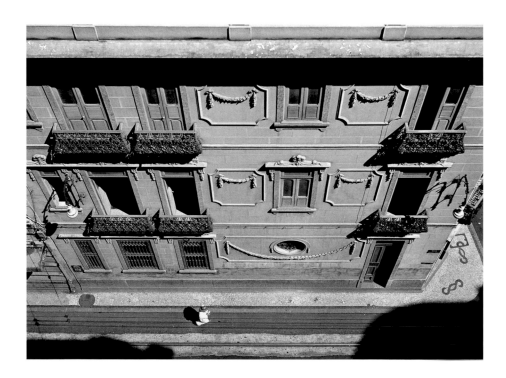

Thomaz Farkas
Apartments (Apartamentos) [Interior facade, Edifício
São Borja, Rio de Janeiro]. c. 1945
Gelatin silver print, 12 × 11⁷⁄₁₆ in. (30.5 × 29 cm)
Long-term loan MASP FCCB. Special acknowledgment
Farkas Family

Thomaz Farkas
Street (Rua). c. 1947
Gelatin silver print, 11⁷⁄₁₆ × 15⁹⁄₁₆ in. (29 × 39.5 cm)
Collection João Farkas and Kiko Farkas

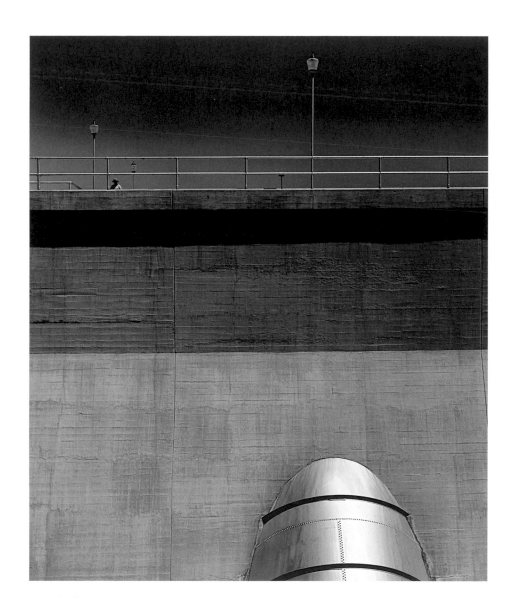

Thomaz Farkas
Power Plant Dam (Barragem de usina). c. 1948–49
Gelatin silver print, 12⁵⁄₈ × 11 in. (32 × 28 cm)
Collection João Farkas and Kiko Farkas

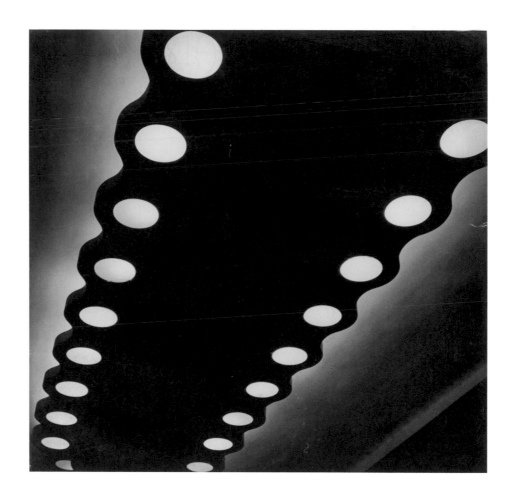

Thomaz Farkas
Lights, Cine Ipiranga (Luminária, Cine Ipiranga)
[São Paulo]. c. 1945
Gelatin silver print, 11½ × 11¹³⁄₁₆ in. (29.2 × 30 cm)
Collection Fernanda Feitosa and Heitor Martins

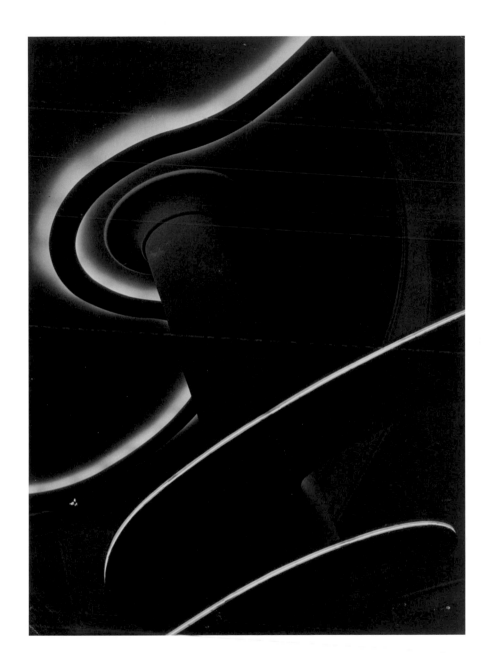

Lucílio Corrêa Leite Filho
Fluorescent Symphony (Sinfonia fluorescente). 1953
Gelatin silver print, 15¾ × 11¹³⁄₁₆ in. (40 × 30 cm)
The Museum of Modern Art, New York. Acquired through the generosity of
Estrellita Brodsky through the Latin American and Caribbean Fund

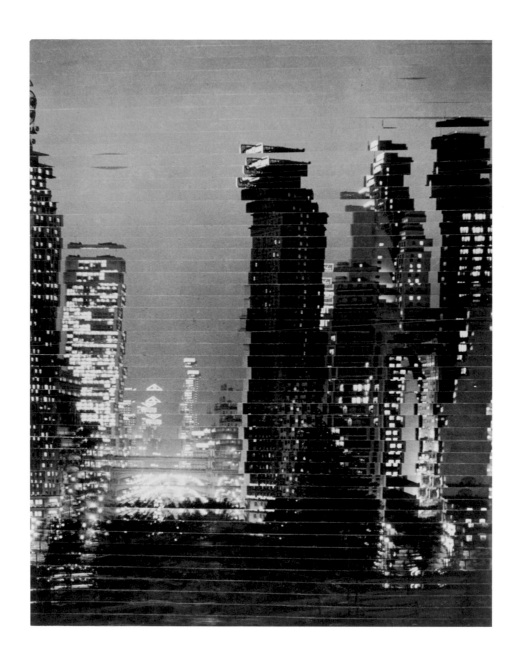

Roberto Yoshida
Skyscrapers (Arranha-céus). 1959
Gelatin silver print, 14 ⁹⁄₁₆ × 11 ⁹⁄₁₆ in. (37 × 29.3 cm)
Collection Fernanda Feitosa and Heitor Martins

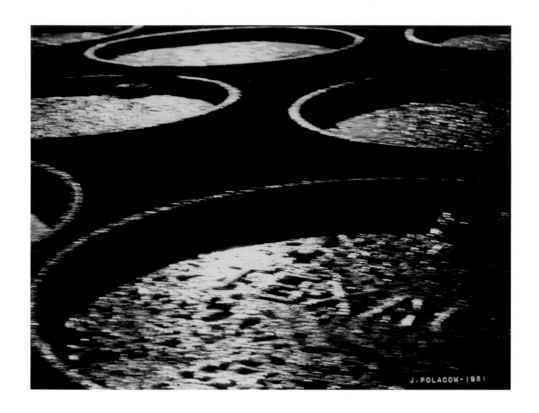

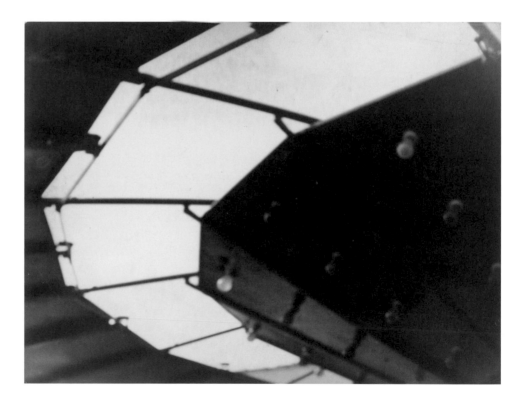

Jacob Polacow
Study with Drums (Estudo com tambores). 1951
Gelatin silver print, 11⅞ × 15¹¹⁄₁₆ in. (30.1 × 39.8 cm)
Itaú Collection

Alzira Helena Teixeira
Untitled. c. 1956
Gelatin silver print, 11¹¹⁄₁₆ × 15¹¹⁄₁₆ in. (29.8 × 39.8 cm)
The Museum of Modern Art, New York.
Agnes Rindge Claflin Fund

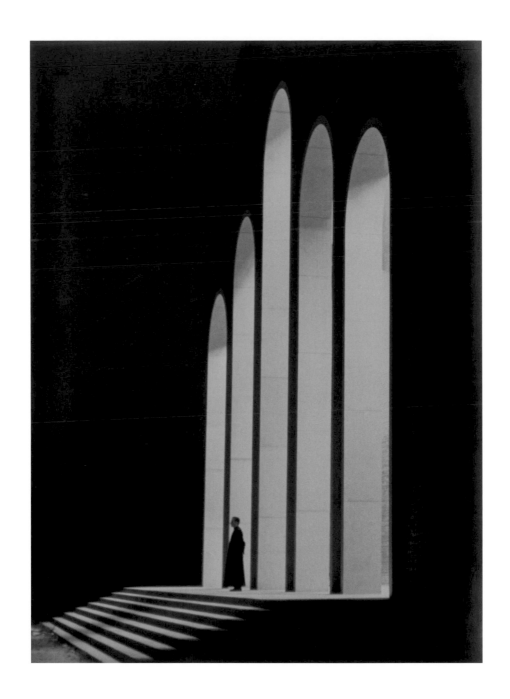

Sergio Trevellin
Peace (*Paz*). c. 1948
Gelatin silver print, 15 ¾ × 11 ⁷⁄₁₆ in. (40 × 29 cm)
Long-term loan MASP FCCB

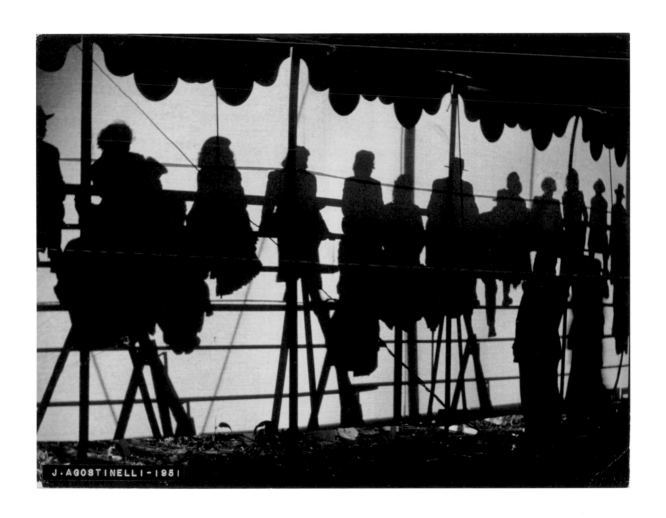

Julio Agostinelli
Circus (Circense). 1951
Gelatin silver print, 11⁷⁄₁₆ × 15 in. (29 × 38.1 cm)
The Museum of Modern Art, New York. Acquired through
the generosity of Richard O. Rieger

FOTO-CINE CLUBE
BANDEIRANTE

Rua Avanhandava, 316
SÃO PAULO BRASIL

N.º 1

Título: A MARCA DO TEMPO

Autor: IVO FERREIRA DA SILVA

Enderêço: Foto-Cine Clube Bandeirante
Rua Avanhandava N.º 316 (Séde Propria)
SÃO PAULO — BRASIL

Processo, etc.

(AA)

Western Salon
OF PHOTOGRAPHY

WESTON-SUPER-MARE 1953

B 7/23/2

FOTO-CINE CLUBE DE MILÓPOLIS
« ESTADO DO RIO DE JANEIRO »
SALÃO DE ARTE FOTOGRÁFICA

AUTOR	INSCRIÇÃO	CATÁLOGO

FOTO CLUBE BRASILEIRO
II Salão Brasileiro de Fotografia

| 65 | 158 | 321 | ★ | R |

299/1

SFNF
1961

21 de Agosto 1954
4º Salão de Arte Fotografica de Araraquara

SOUTHAMPTON CAMERA CLUB

This Print was accepted for the

41st Exhibition

held at the

Civic Art Gallery

November, 1953

(Coronation Year)

Judges

K. H. Gaseltine, A.I.B.P., F.R.P.S.
H. A. Murch, F.R.P.S.
Reginald Smith, A.I.B.P., F.R.P.S.

IV.

EXPERIMENTAL PROCESSES

Fotogramas e outros processos especiais (December 1953),
Natureza morta e/ou Criações no laboratório (April 1960)

GERALDO DE BARROS

TEXTURE AND SHAPE

Textura (February 1952), *Formas* (October 1952), *Composição com
3 objetos* (February 1954), *Textura e/ou Formas* (November 1964)

CLUB FOTOGRÁFICO DE CHILE

CONCURSANTE	FOTOGRAFIA
N.º 200	27

2
3/3

3ª EXPOSIÇÃO DE ARTE FOTOGRÁFICA DE
BARRA MANSA - EST. DO RIO

ORGANIZADO PELO

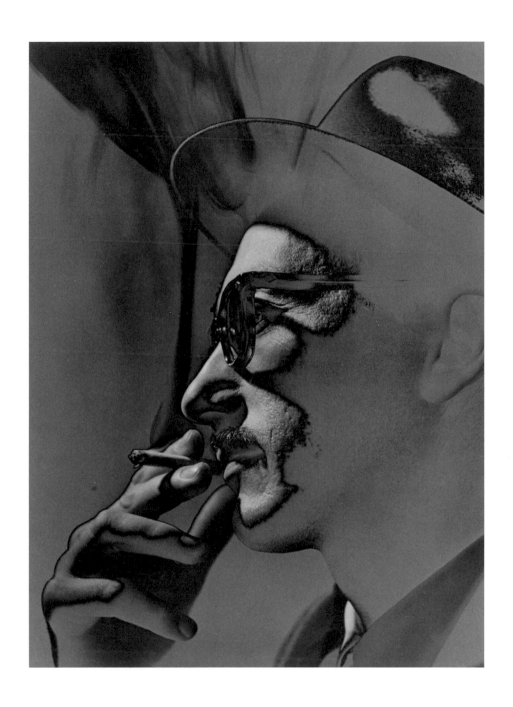

German Lorca
Solarized Portrait (Retrato solarizado). c. 1953
Gelatin silver print, 15 ⅜ × 11 ½ in. (39.1 × 29.2 cm)
The Museum of Modern Art, New York. Acquired through the generosity of
Alfredo Egydio Setubal through the Latin American and Caribbean Fund

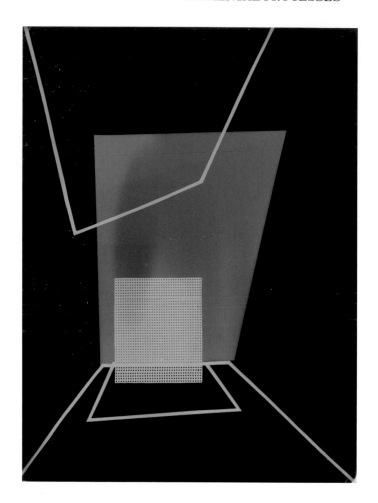

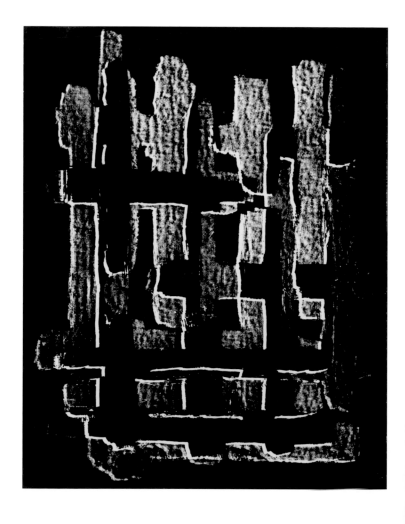

Paulo Suzuki Hide
Photogram n° 3 (Fotograma n° 3). 1956
Gelatin silver print, 15 ¹⁵⁄₁₆ × 11 ¹³⁄₁₆ in. (40.5 × 30 cm)
Long-term loan MASP FCCB

José Oiticica Filho
Recreation 141 (Recriação 141). 1958
Gelatin silver print, 16 ⁵⁄₁₆ × 12 ¹⁵⁄₁₆ in. (41.5 × 32.9 cm)
Itaú Collection

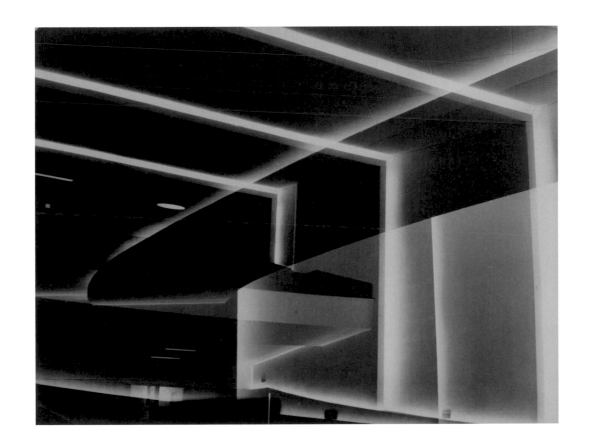

Oswaldo Willy Fehr
Obtuse Angles (Ângulos obtusos). c. 1954
Gelatin silver print, 11¹³⁄₁₆ × 15¾ in. (30 × 40 cm)
Long-term loan MASP FCCB

Paulo Pires da Silva
Painter (*Pintor*). 1950s
Gelatin silver print, 15 ⅜ × 11 ⁷⁄₁₆ in. (39 × 29 cm)
Itaú Collection

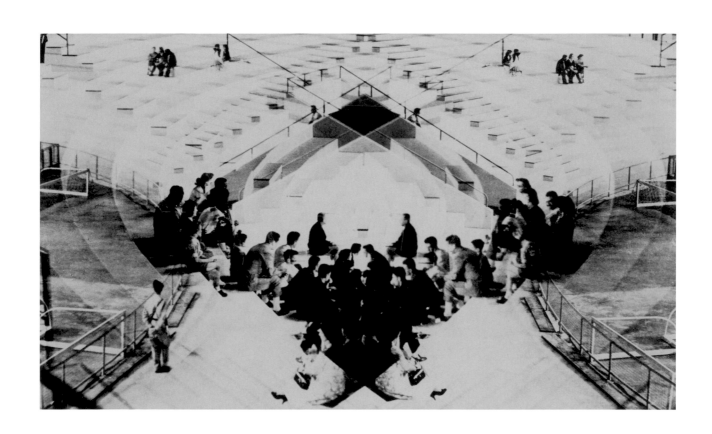

Gertrudes Altschul
Untitled. c. 1959
Gelatin silver print, 8 11/16 × 14 3/4 in. (22 × 37.5 cm)
Long-term loan MASP FCCB. Special acknowledgment
Ernst Oscar Altschul and family

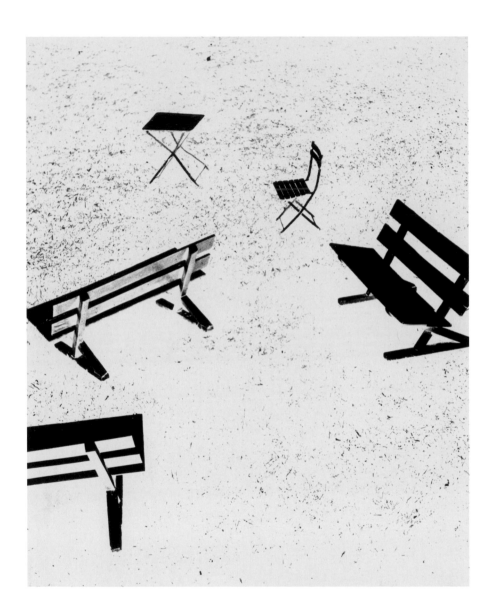

Eduardo Salvatore
Composition in Black and White (Composição em branco e preto). c. 1951
Gelatin silver print, 13 11/16 × 10 13/16 in. (34.7 × 27.5 cm)
The Museum of Modern Art, New York. Acquired through the generosity of
Ramiro Ortiz through the Latin American and Caribbean Fund

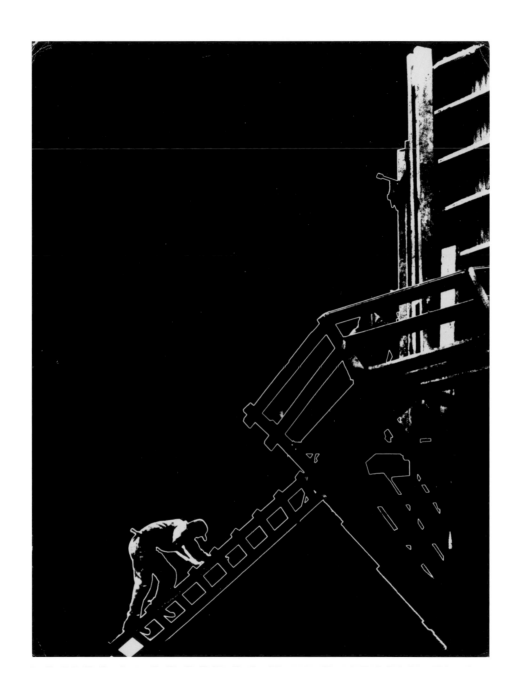

Paulo Pires da Silva
Ascension (Ascenção). 1960
Gelatin silver print, 15¾ × 11¾ in. (40 × 29.8 cm)
The Museum of Modern Art, New York. Acquired through the generosity of
Ramiro Ortiz through the Latin American and Caribbean Fund

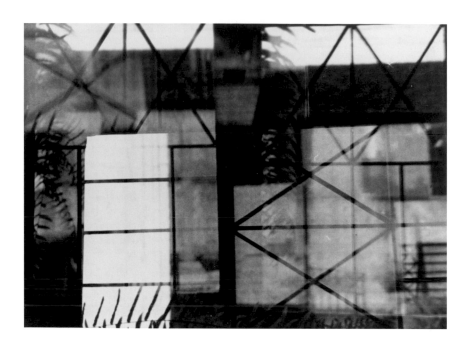

Geraldo de Barros
Abstraction (Abstração). 1949
Gelatin silver print, 10¾ × 14¾ in. (27.3 × 37.5 cm)
The Museum of Modern Art, New York. Latin American
and Caribbean Fund

Geraldo de Barros
Fotoforma. c. 1949
Gelatin silver print, 13¹⁵⁄₁₆ × 10⁹⁄₁₆ in. (35.3 × 26.8 cm)
Collection David Dechman and Michel Mercure

Geraldo de Barros
Self-Portrait (*Autorretrato*). c. 1949
Gelatin silver print, 15 ⁷⁄₁₆ × 11½ in. (39.2 × 29.2 cm)
The Museum of Modern Art, New York.
Christie Calder Salomon Fund

Geraldo de Barros
Fotoforma. 1952–53
Gelatin silver print, 11¹³⁄₁₆ × 15⅛ in. (30 × 38.4 cm)
The Museum of Modern Art, New York. Acquired through
the generosity of John and Lisa Pritzker

Geraldo de Barros
Untitled. 1948–50
Gelatin silver print, 9 × 14¹⁵⁄₁₆ in. (22.8 × 37.9 cm)
The Museum of Modern Art, New York. Gift of Agnes Gund
through the Latin American and Caribbean Fund

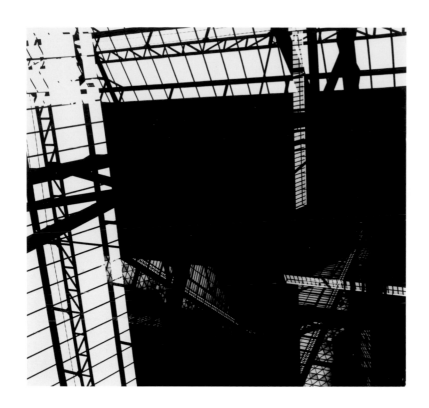

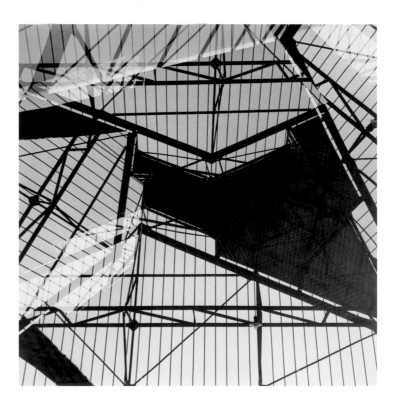

Geraldo de Barros
Fotoforma. c. 1949
Gelatin silver print, 11¹³⁄₁₆ × 12⅜ in. (30 × 31.4 cm)
Susana and Ricardo Steinbruch Collection

Geraldo de Barros
Abstract (Abstrato). c. 1949
Gelatin silver print, 12³⁄₁₆ × 11 in. (31 × 27.9 cm)
Collection Fernanda Feitosa and Heitor Martins

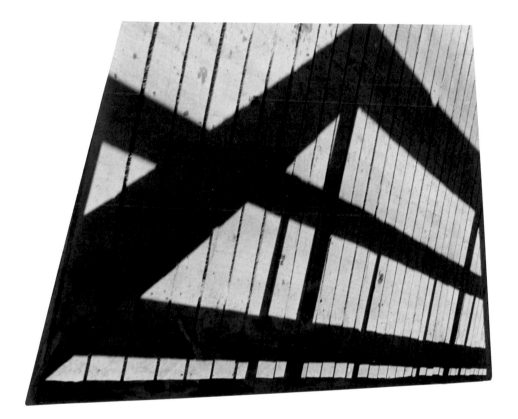

Geraldo de Barros
Untitled [Porto de Santos]. 1949
Gelatin silver print, 10 $^{13}/_{16}$ × 13 ¾ in. (27.5 × 35 cm)
Collection Fernanda Feitosa and Heitor Martins

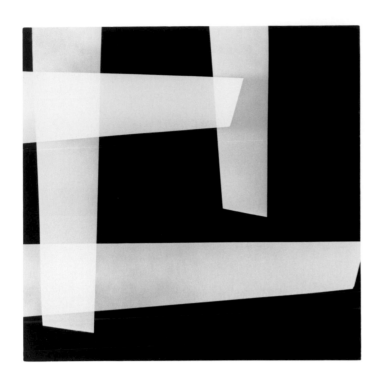

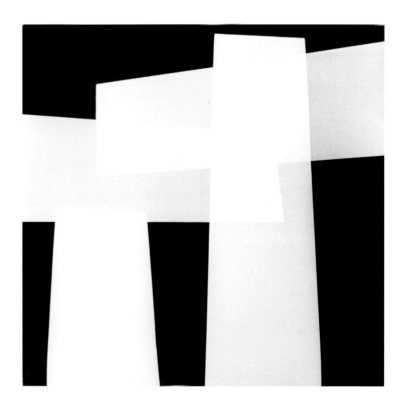

Geraldo de Barros
Fotoforma. 1950
Gelatin silver print, 11¹³⁄₁₆ × 11⅝ in. (30 × 29.5 cm)
Collection Fernanda Feitosa and Heitor Martins

Geraldo de Barros
Fotoforma. 1950
Gelatin silver print, 12 × 12³⁄₁₆ in. (30.5 × 31 cm)
Collection Fernanda Feitosa and Heitor Martins

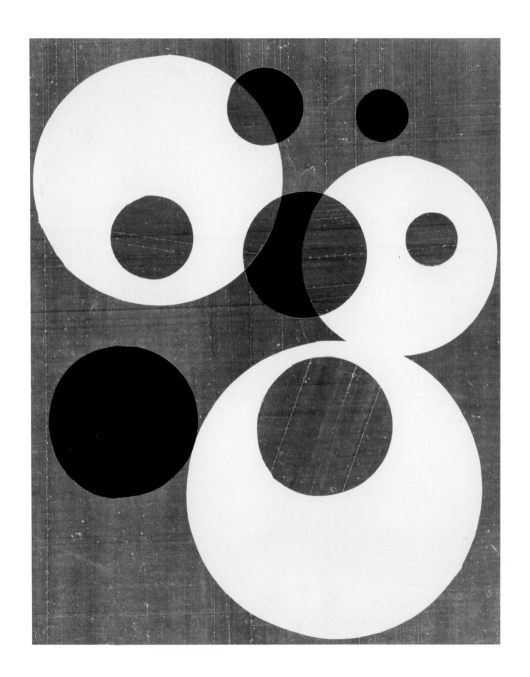

Geraldo de Barros
Fotoforma. 1952–53
Gelatin silver print, 15 1/16 × 11 7/16 in. (38.2 × 29.1 cm)
Susana and Ricardo Steinbruch Collection

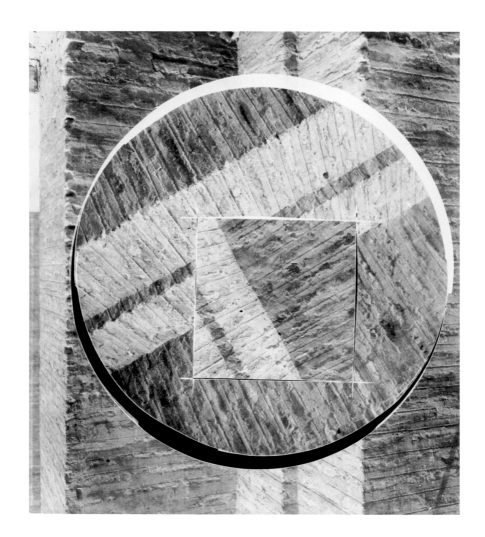

Geraldo de Barros
Rotating Movement (Movimento giratório). 1952–53
Gelatin silver print, 12 5/16 × 10 15/16 in. (31.2 × 27.8 cm)
Collection Fernanda Feitosa and Heitor Martins

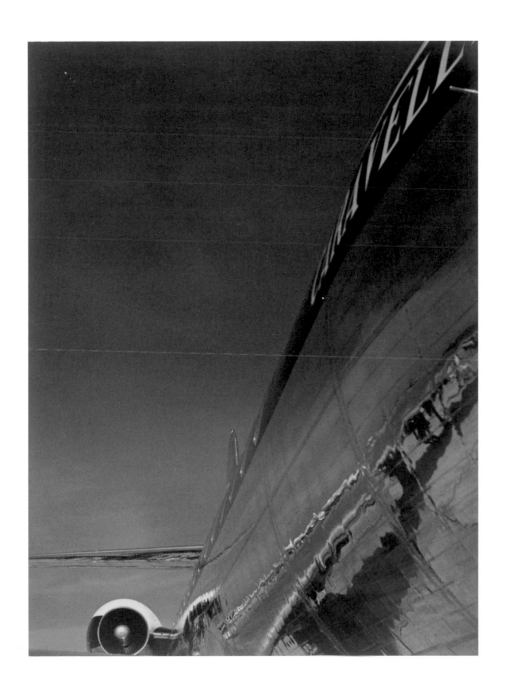

Rubens Teixeira Scavone
The Caravelle (*La Caravelle*). c. 1960
Gelatin silver print, 15 ¾ × 11 ¹³⁄₁₆ in. (40 × 30 cm)
Collection David Dechman and Michel Mercure

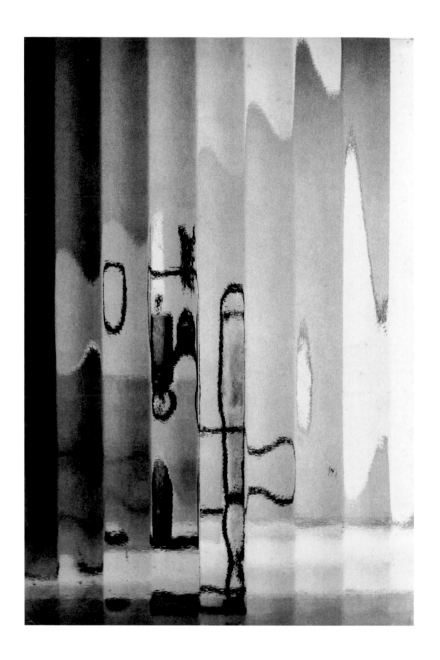

Gaspar Gasparian
Abstract (Abstrato). 1953
Gelatin silver print, 15¾ × 10⁹⁄₁₆ in. (40 × 26.9 cm)
The Museum of Modern Art, New York. Gift of
Gaspar Gasparian Filho

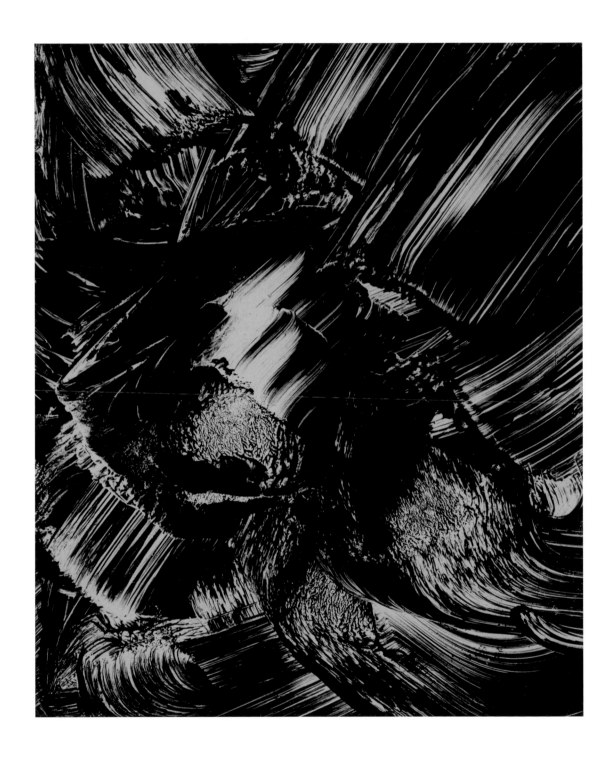

José Oiticica Filho
Recreation 38a-64 (Recriação 38a-64). c. 1964
Gelatin silver print, 19⅛ × 15¾ in. (48.5 × 40 cm)
Long-term loan MASP FCCB. Special acknowledgment
César and Claudio Oiticica

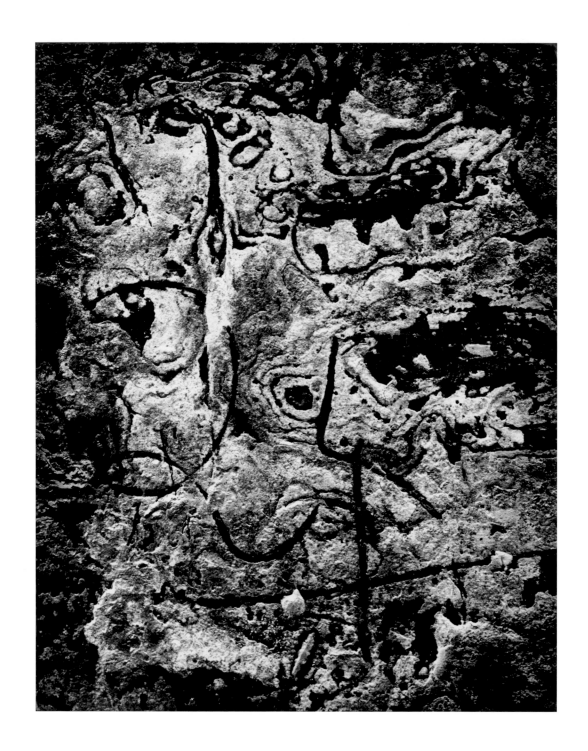

José Oiticica Filho
Ouropretense. 1955
Gelatin silver print, 16 5/16 × 12 13/16 in. (41.5 × 32.5 cm)
Itaú Collection

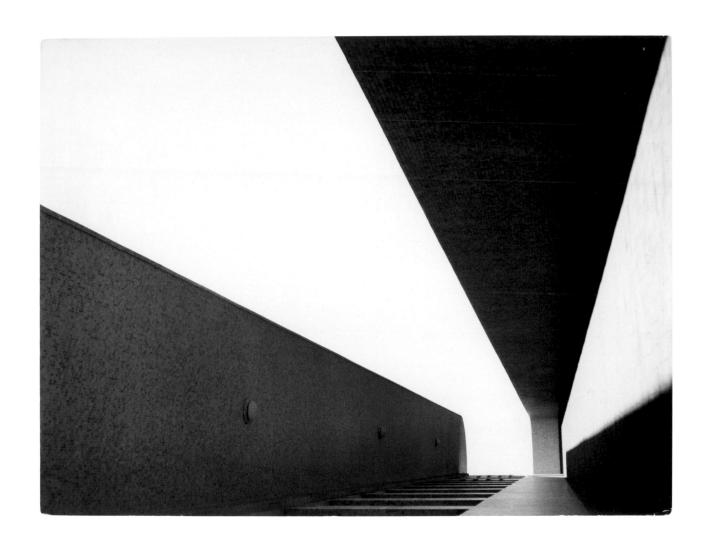

Marcel Giró
Forms (Formas). c. 1960
Gelatin silver print, 11 9/16 × 15 3/8 in. (29.3 × 39 cm)
Collection Fernanda Feitosa and Heitor Martins

Francisco Albuquerque
Triangle (Triângulo). c. 1950
Gelatin silver print, 11¼ × 14⁵⁄₁₆ in. (28.5 × 36.4 cm)
Collection Fernanda Feitosa and Heitor Martins

Geraldo de Barros
Fotoforma. c. 1949
Gelatin silver print, 14 13/16 × 10 11/16 in. (37.7 × 27.2 cm)
The Museum of Modern Art, New York. Latin American
and Caribbean Fund

Marcel Giró
Mud (Lama). c. 1957
Gelatin silver print, 15 ¾ × 12 in. (40 × 30.5 cm)
Collection David Dechman and Michel Mercure

Rubens Teixeira Scavone
Abstraction n° 5 (Abstração n° 5). 1953–54
Gelatin silver print, 15¾ × 11¹³⁄₁₆ in. (40 × 30 cm)
Collection Fernanda Feitosa and Heitor Martins

Ivo Ferreira da Silva
The Mark of Time (*A marca do tempo*) or
Sign of the Times (*Sinal dos tempos*). 1951
Gelatin silver print, 15 × 11¼ in. (38.1 × 28.5 cm)
Collection Fernanda Feitosa and Heitor Martins

FOTO CINE CLUBE DE ANGOLA
1952

1$ SALÃO INTERNACIONAL DE ARTE FOTOGRÁFICA

S. Paulo de Luanda - Angola

FOTO-CINE CLUBE
BANDEIRANTE

Rua Avanhandava, 316
SÃO PAULO — BRASIL N.º 1

Titulo: UM PULO NO ESPAÇO

Autor: ASTERIO ROCHA

Endereço: Foto-Cine Clube Bandeirante
Rua Avanhandava, N.º 316 (Séde Propria)
SÃO PAULO — BRASIL

Processo, etc.

V.

RAIN
Dias de chuva (June 1950), *Chuva* (April 1955),
Chuva e/ou Árvores (February 1962)

GERMAN LORCA

SIMPLICITY
Simplicidade (December 1951), *Retrato à luz ambiente e/ou
Simplicidade* (June 1963), *Foto seletivo e/ou Simplicidade*
(February 1964)

FCB 1951

FOTO CLUBE BRASILEIRO

X SALÃO BRASILEIRO ANUAL
DE ARTE FOTOGRÁFICA

F.C.C.P.

CURITIBA

16º SALÃO FOTOGR- 1954

M M

2º SALÃO NACIONAL
DE ARTE FOTOGRAFICA
DE PERNAMBUCO
FOTO - CINE CLUBE DO RECIFE

13? 1 291 40

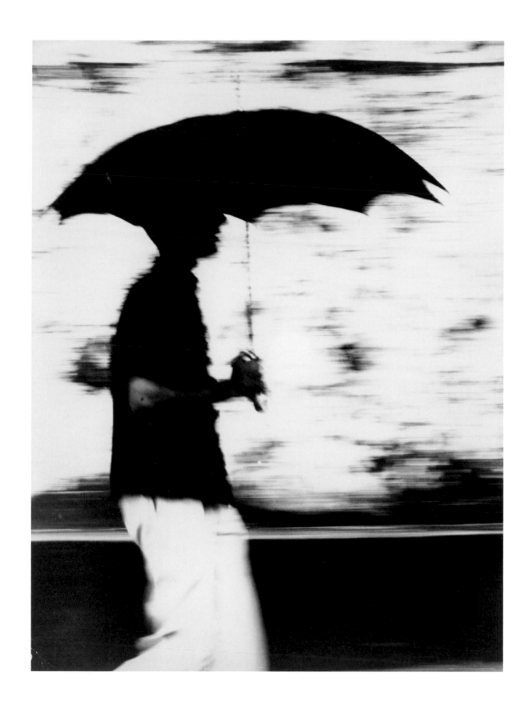

Marcel Giró
Untitled. c. 1950
Gelatin silver print, 15¹¹⁄₁₆ × 11¹⁵⁄₁₆ in. (39.9 × 30.3 cm)
The Museum of Modern Art, New York. Acquired through the generosity of Marie-Josée and
Henry R. Kravis through the Latin American and Caribbean Fund

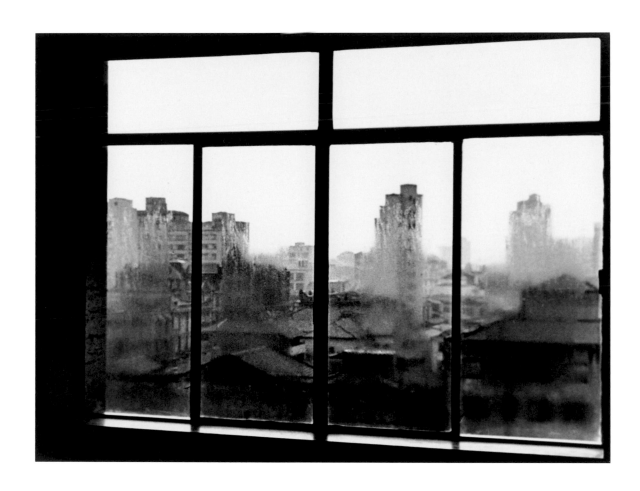

German Lorca
Rain (*Chuva*). 1952
Gelatin silver print, 10 ⅝ × 14 3/16 in. (27 × 36 cm)
Collection Fernanda Feitosa and Heitor Martins

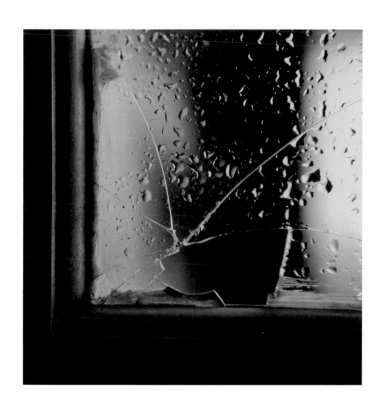

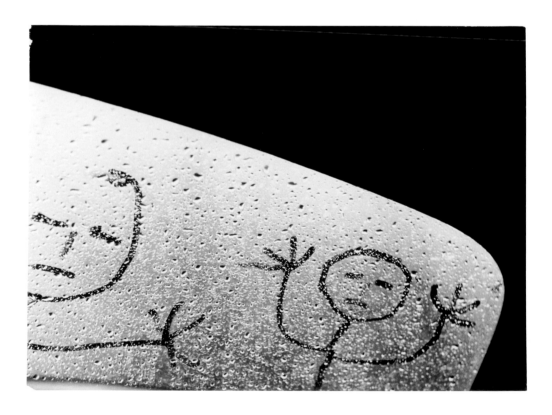

Maria Helena Valente da Cruz
The Broken Glass (O vidro partido). c. 1952
Gelatin silver print, 11⅞ × 11½ in. (30.2 × 29.2 cm)
The Museum of Modern Art, New York. Acquired
through the generosity of Donna Redel

Ademar Manarini
Untitled. c. 1955
Gelatin silver print, 11⁷⁄₁₆ × 15¾ in. (29 × 40 cm)
Collection Fernanda Feitosa and Heitor Martins

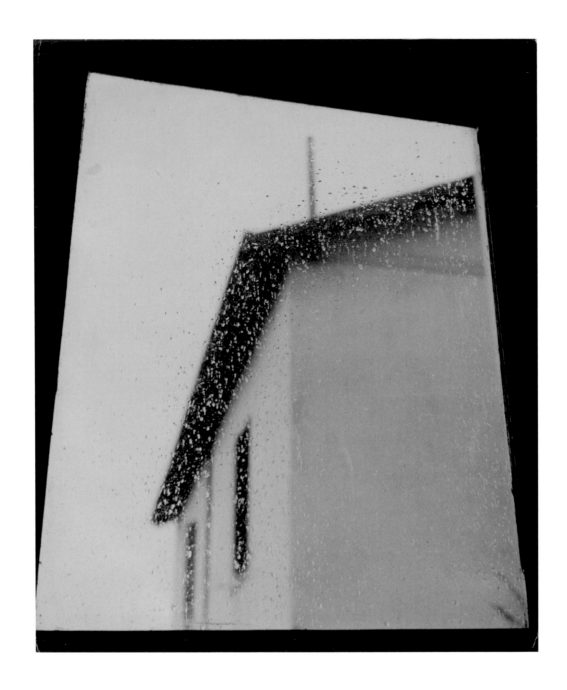

German Lorca
Rain on the Window (*Chuva na janela*). 1950
Gelatin silver print, 13 ⅜ × 11 in. (34 × 28 cm)
Long-term loan MASP FCCB. Special acknowledgment
German Lorca

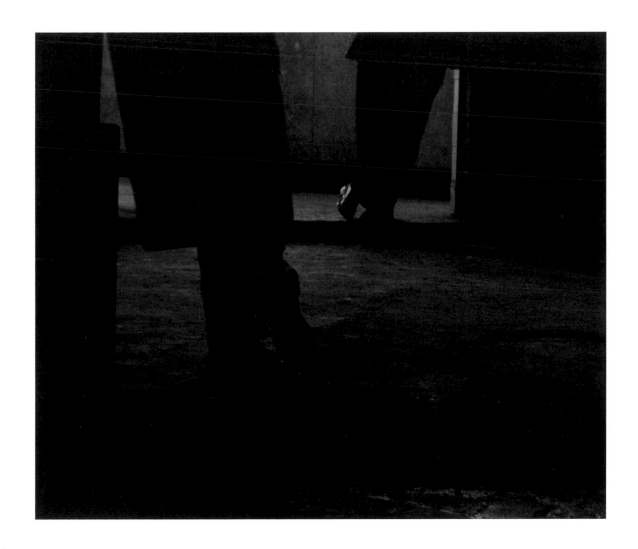

German Lorca
Rascality (Malandragem). 1949
Gelatin silver print, 10 ¾ × 12 ¾ in. (27.3 × 32.4 cm)
The Museum of Modern Art, New York. Acquired through
the generosity of Richard O. Rieger

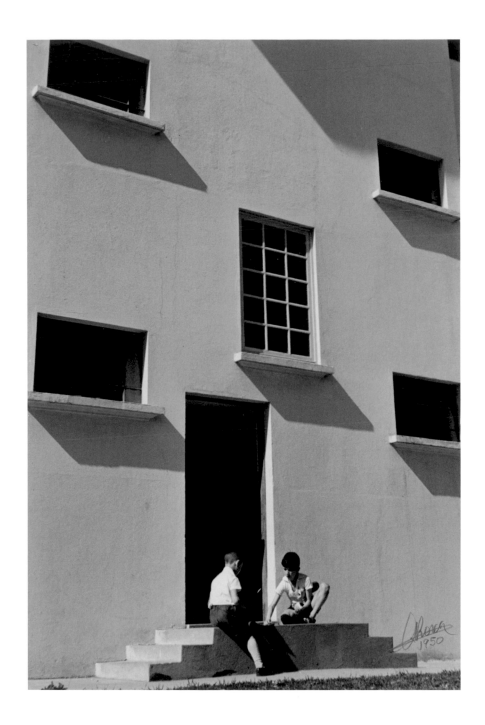

German Lorca
Apartments (Apartamentos). 1950–51
Gelatin silver print, 15 1/16 × 10 1/8 in. (38.3 × 25.7 cm)
The Museum of Modern Art, New York. Acquired through the generosity of
Ernesto Poma through the Latin American and Caribbean Fund

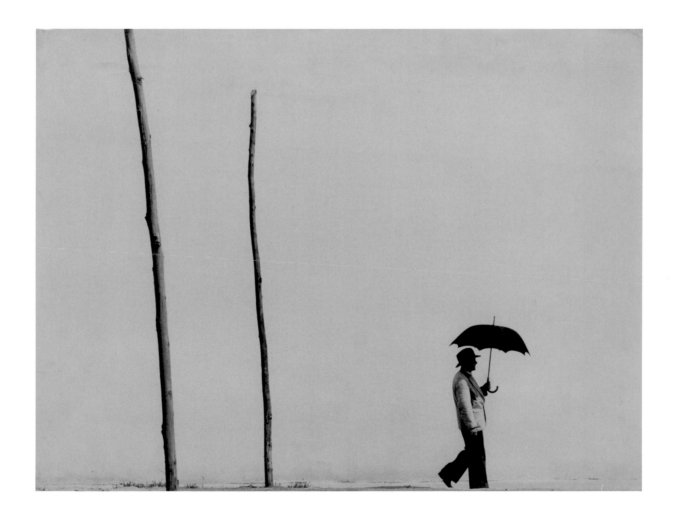

German Lorca
Tropics (Trópicos). 1954
Gelatin silver print, 11⅝ × 15⅜ in. (29.5 × 39 cm)
Long-term loan MASP FCCB. Special acknowledgment
German Lorca

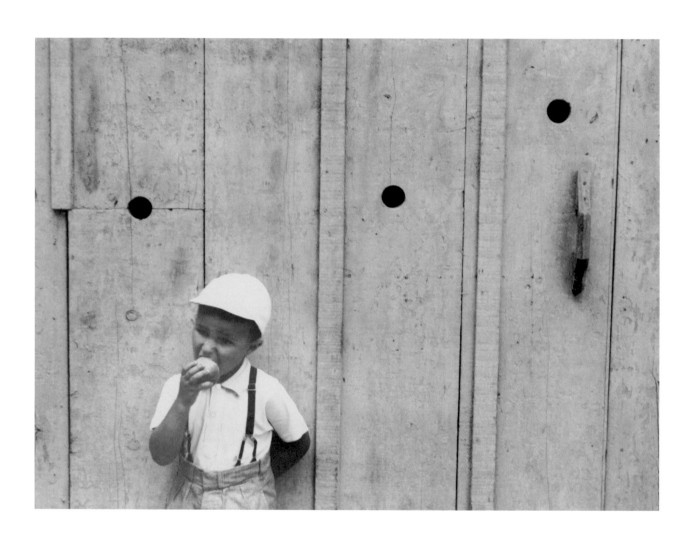

German Lorca
Eating an Apple (*Comendo maçã*). 1953
Gelatin silver print, 11⅛ × 14¾ in. (28.3 × 37.5 cm)
The Museum of Modern Art, New York. Acquired through the generosity of
David Dechman in honor of Sarah Meister

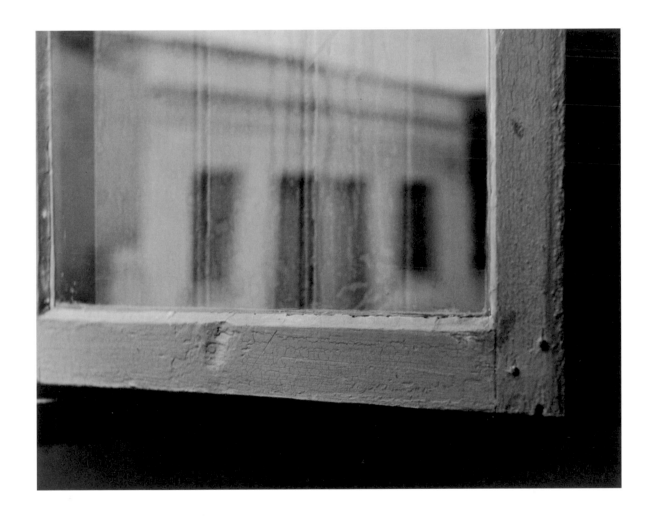

German Lorca
Open Window (Janela aberta). 1951
Gelatin silver print, 10 ¾ × 13 ⅞ in. (27.3 × 35.2 cm)
The Museum of Modern Art, New York. Gift of Agnes Gund
through the Latin American and Caribbean Fund

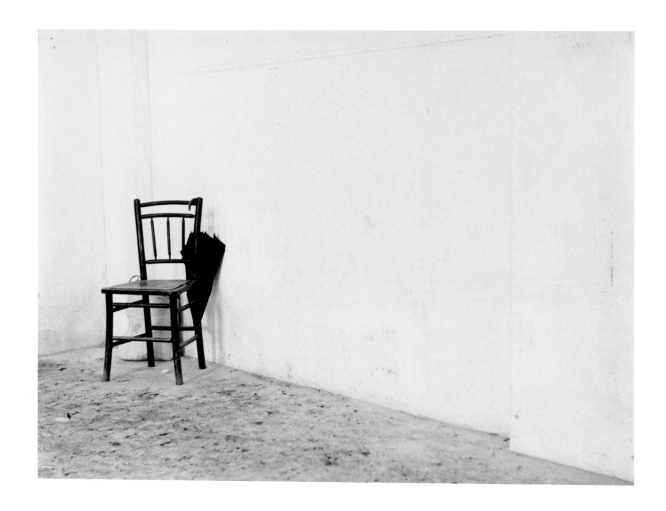

German Lorca
Study with Chair (*Estudo com cadeira*). 1951
Gelatin silver print, 11 ⁹⁄₁₆ × 15 ³⁄₁₆ in. (29.4 × 38.5 cm)
Collection Fernanda Feitosa and Heitor Martins

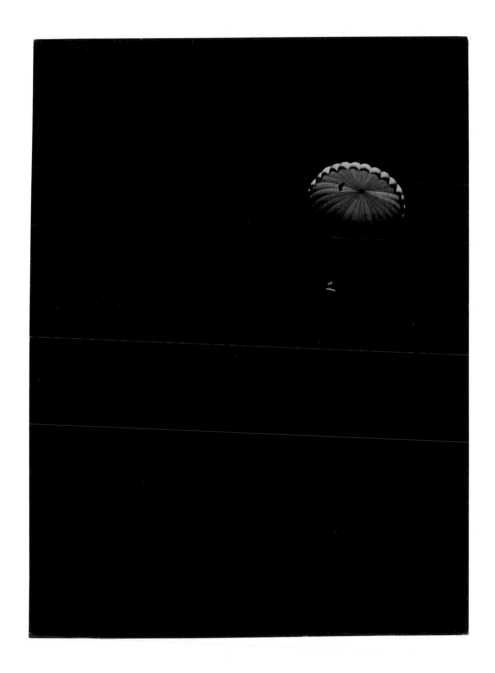

Astério Rocha
A Leap in Space (Um pulo no espaço). 1949
Gelatin silver print, 15¼ × 11⁵⁄₁₆ in. (38.8 × 28.8 cm)
Collection Fernanda Feitosa and Heitor Martins

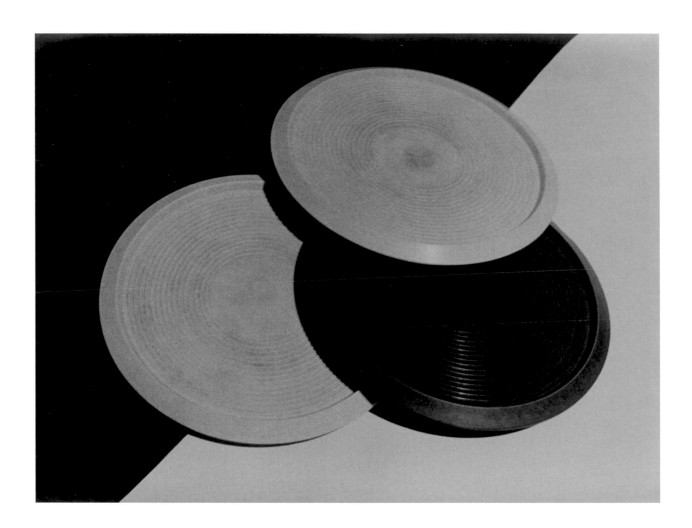

Gertrudes Altschul
Trio (*Trio*). c. 1956
Gelatin silver print, 11⅝ × 15⁹⁄₁₆ in. (29.5 × 39.5 cm)
Long-term loan MASP FCCB. Special acknowledgment
Ernst Oscar Altschul and family

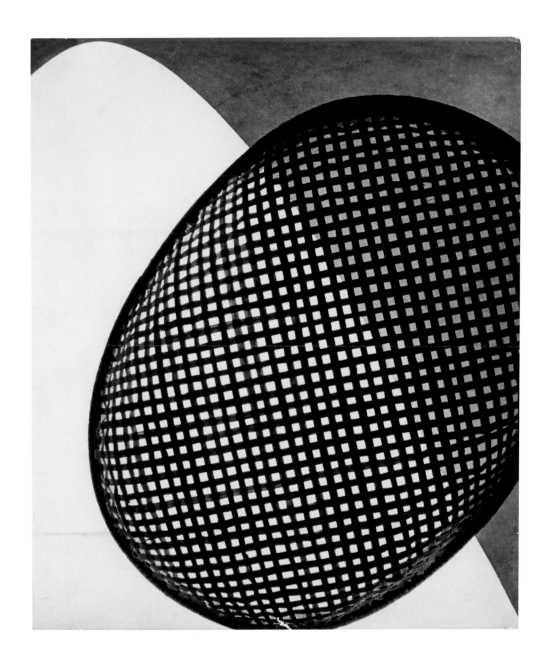

Gertrudes Altschul
Sieve (Peneira) or *Composition (Composição)*. 1956
Gelatin silver print, 13⅞ × 11⅝ in. (35.2 × 29.5 cm)
Collection Fernanda Feitosa and Heitor Martins

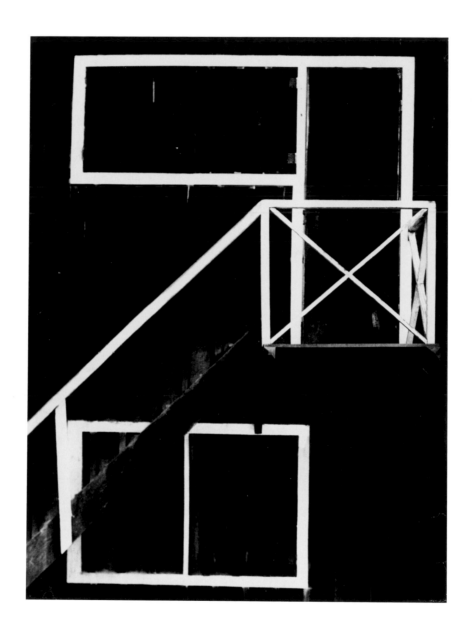

Eduardo Salvatore
Window (Janela). c. 1956
Gelatin silver print, 15 ⅜ × 11 ¹³⁄₁₆ in. (39 × 30 cm)
Collection Fernanda Feitosa and Heitor Martins

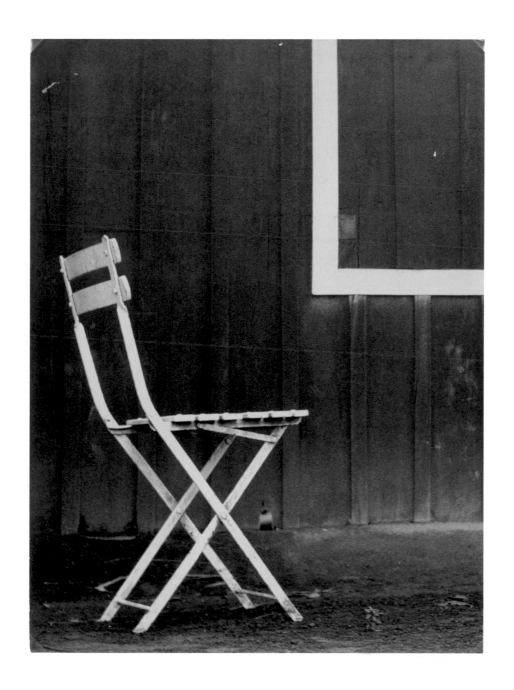

Palmira Puig Giró
Study (*Estudo*). 1956
Gelatin silver print, 15¾ × 11¹³⁄₁₆ in. (40 × 30 cm)
Collection David Dechman and Michel Mercure

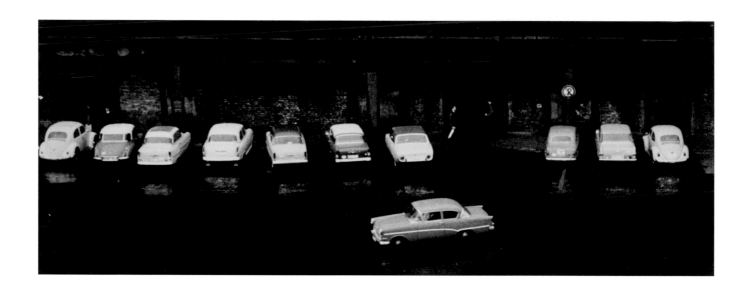

João Bizarro da Nave Filho
One Plus Ten (Um mais dez). c. 1960
Gelatin silver print, 5¾ × 15¹⁄₁₆ in. (14.6 × 38.3 cm)
The Museum of Modern Art, New York. Acquired through the generosity of
Ramiro Ortiz through the Latin American and Caribbean Fund

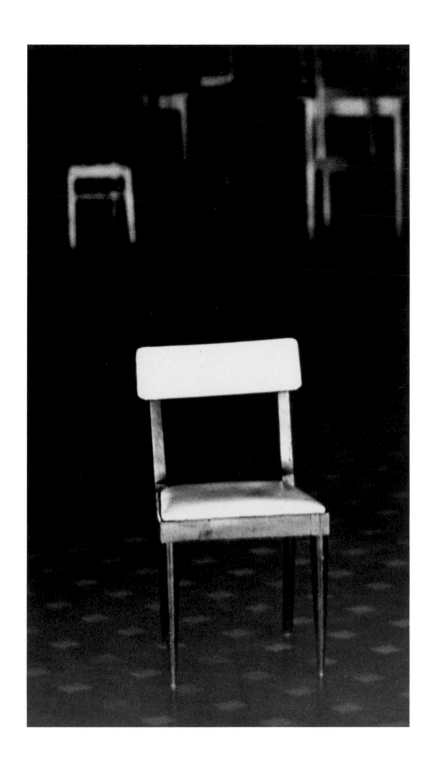

Ivo Ferreira da Silva
Confidential (Confidencial). c. 1960
Gelatin silver print, 15 ⅜ × 8 ⅞ in. (39 × 22.5 cm)
The Museum of Modern Art, New York. Acquired through the generosity of
Glenn and Susan Lowry through the Latin American and Caribbean Fund

VI.

"TABLE-TOPS"
"Uma chicara de café" (Composição) (December 1950),
Detalhes e "table-top" (June 1953)

MARCEL GIRÓ

MOVEMENT
Movimento (April 1953), *Movimento e/ou Favela* (April 1962)

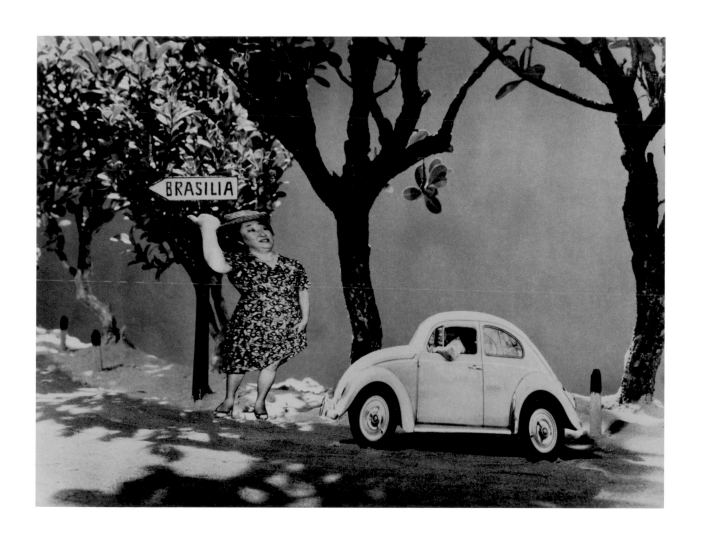

Roberto Yoshida
Untitled (Table-top IV). 1960s
Gelatin silver print, 11⅝ × 15⅜ in. (29.5 × 39 cm)
Long-term loan MASP FCCB

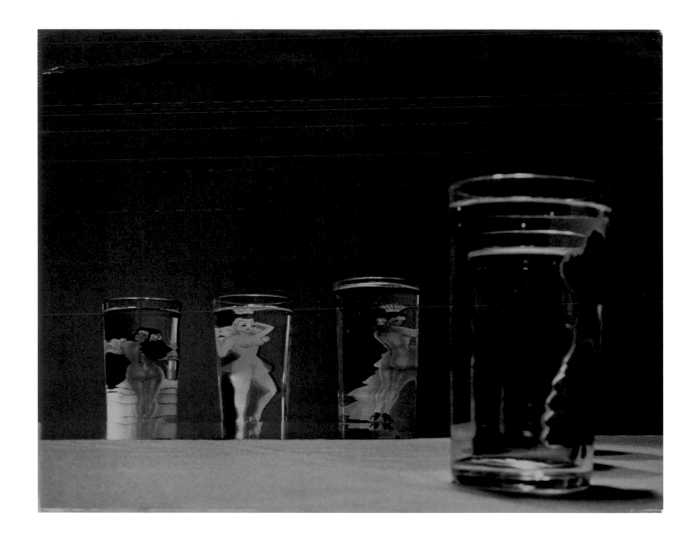

Armando Moraes Barros
Drunk's Dream (Sonho de bêbado). c. 1955
Gelatin silver print, 11⅝ × 15³⁄₁₆ in. (29.5 × 38.5 cm)
Long-term loan MASP FCCB

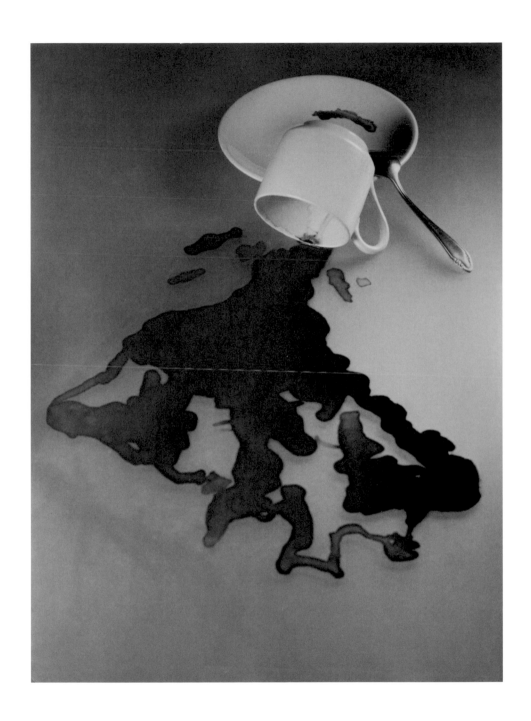

Aldo Augusto de Souza Lima
Origin (Origem). 1950
Gelatin silver print, 15 ⅜ × 11 ⅝ in. (39 × 29.5 cm)
Long-term loan MASP FCCB

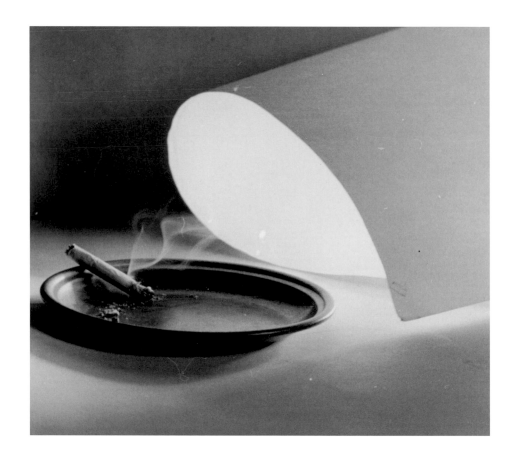

Gertrudes Altschul
Untitled. c. 1953
Gelatin silver print, 10¹³⁄₁₆ × 12³⁄₁₆ in. (27.5 × 31 cm)
The Museum of Modern Art, New York.
John Szarkowski Fund

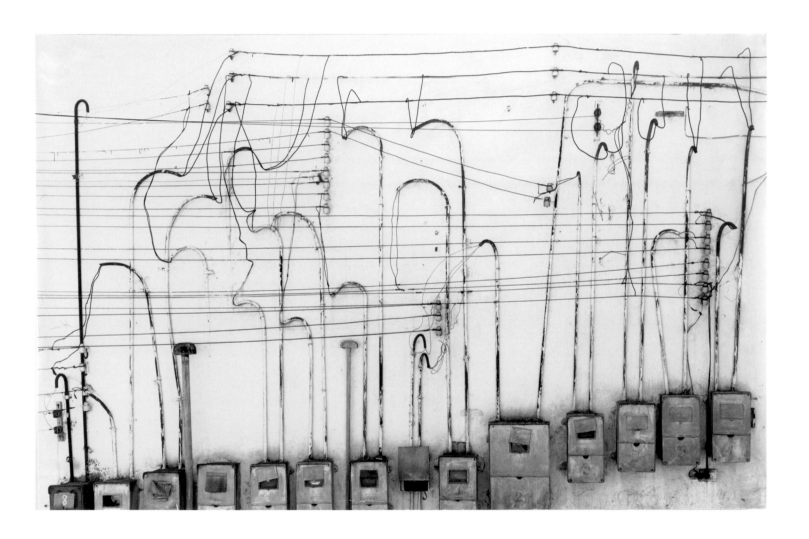

Marcel Giró
Light and Power (Luz e força). c. 1950
Gelatin silver print, 13 1/16 × 20 3/16 in. (33.1 × 51.2 cm)
The Museum of Modern Art, New York. Acquired through
the generosity of Richard O. Rieger

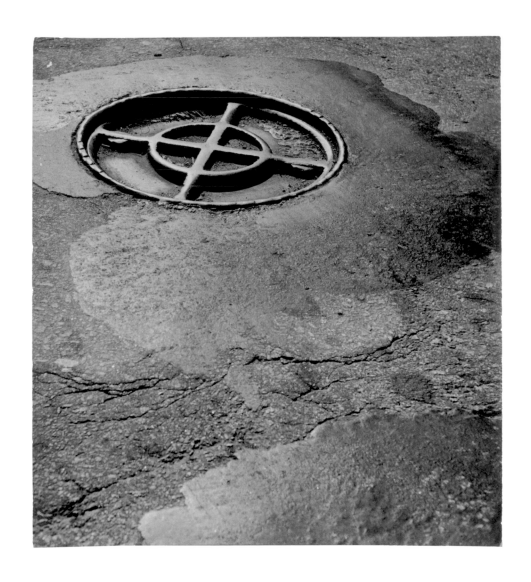

Marcel Giró
Asphalt (*Asfalto*). c. 1950
Gelatin silver print, 12½ × 11⅝ in. (31.8 × 29.5 cm)
Collection David Dechman and Michel Mercure

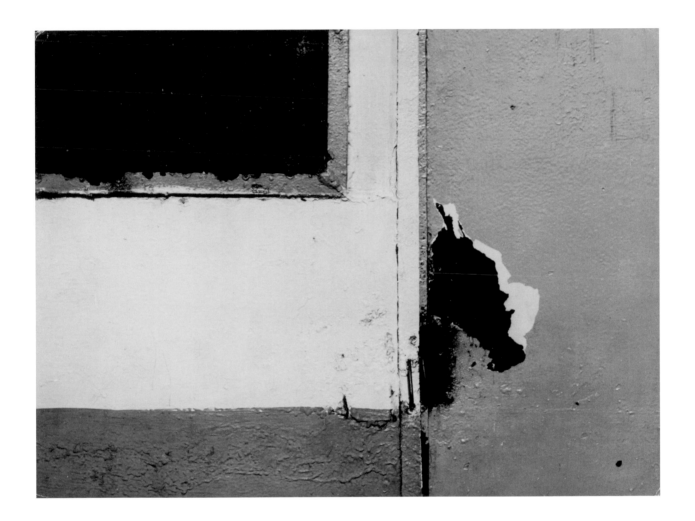

Marcel Giró
Composition (Composição). c. 1953
Gelatin silver print, 11 9/16 × 15 1/2 in. (29.3 × 39.4 cm)
The Museum of Modern Art, New York. Acquired through the generosity of
Ramiro Ortiz through the Latin American and Caribbean Fund

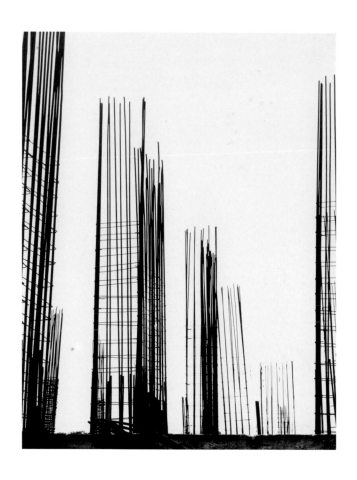

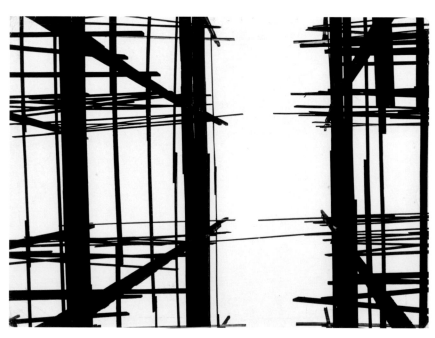

Marcel Giró
Structure (Estrutura). 1955
Gelatin silver print, 15¼ × 11¹¹⁄₁₆ in. (38.7 × 29.7 cm)
The Museum of Modern Art, New York. Committee on
Photography Fund

Marcel Giró
Ascending Lines (Linhas ascendentes). c. 1960
Gelatin silver print, 11⅝ × 15¹¹⁄₁₆ in. (29.6 × 39.9 cm)
The Museum of Modern Art, New York. Committee on
Photography Fund

Marcel Giró
Mathematics (Matemática). c. 1950
Gelatin silver print, 15⅞ × 11¾ in. (39.2 × 29.8 cm)
Collection David Dechman and Michel Mercure

Marcel Giró
Untitled. c. 1950
Gelatin silver print, 12 × 15 ¾ in. (30.5 × 40 cm)
The Museum of Modern Art, New York. Committee on
Photography Fund

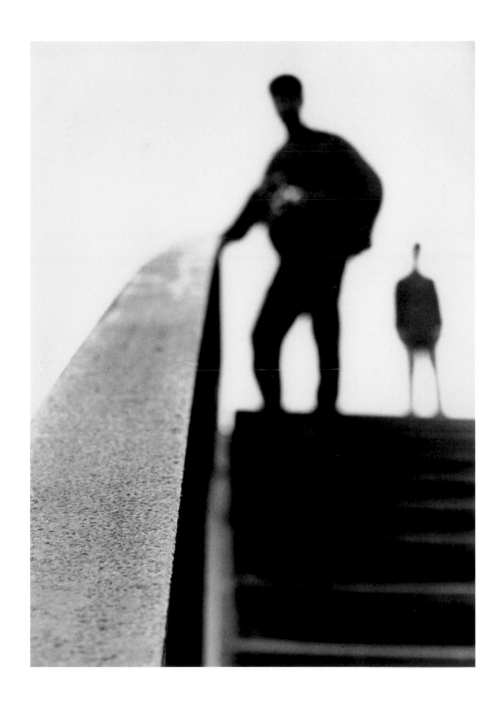

Marcel Giró
Untitled. c. 1950
Gelatin silver print, 15⅟₁₆ × 10¹³⁄₁₆ in. (38.3 × 27.5 cm)
The Museum of Modern Art, New York. Acquired through
the generosity of Thomas and Susan Dunn

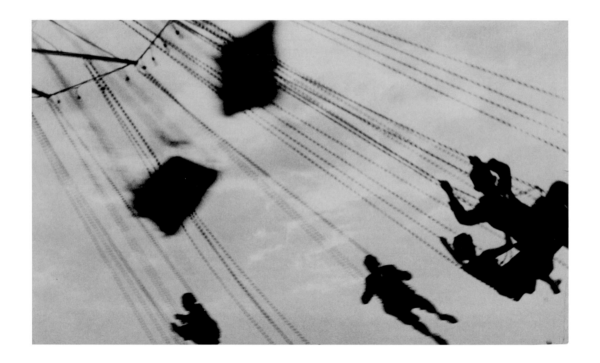

Casimiro Prudente de Mello
Swings (Balanços). 1957
Gelatin silver print, 9 ¹³⁄₁₆ × 15 ³⁄₁₆ in. (25 × 38.5 cm)
Long-term loan MASP FCCB

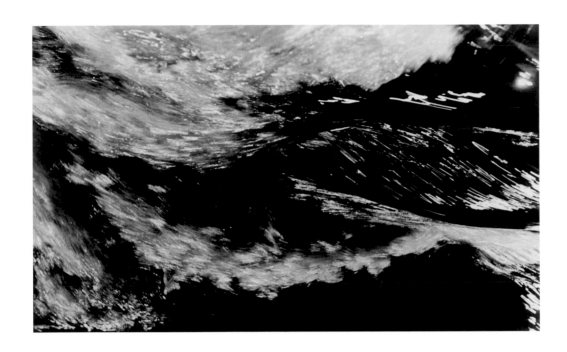

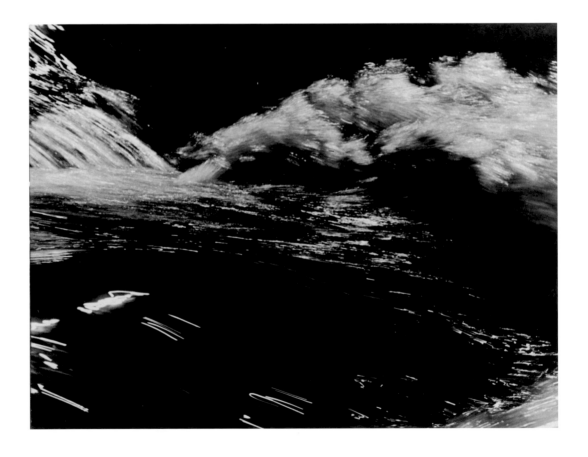

Thomaz Farkas
Rushing Water n° 1. c. 1945
Gelatin silver print, 9 9/16 × 15 9/16 in. (24.3 × 39.5 cm)
The Museum of Modern Art, New York. Gift of the artist

Thomaz Farkas
Rushing Water n° 2. c. 1945
Gelatin silver print, 11 7/8 × 15 3/4 in. (30.2 × 40 cm)
The Museum of Modern Art, New York. Gift of the artist

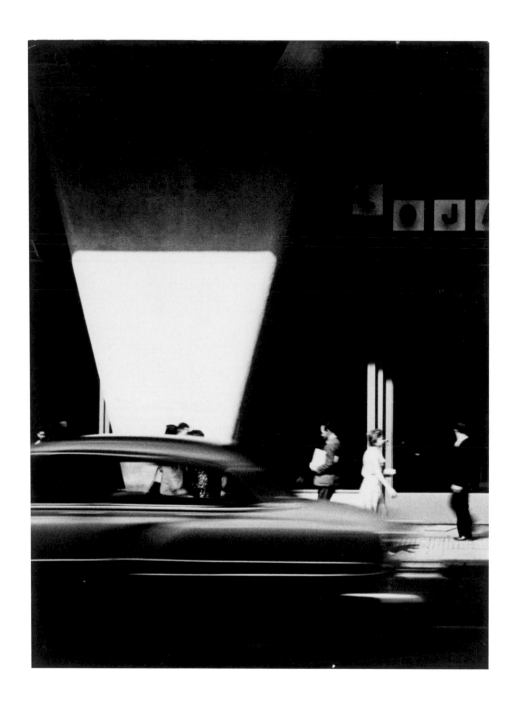

Eduardo Ayrosa
Metropolis n° 1 (*Metrópole n° 1*), from the series Du. c. 1955
Gelatin silver print, 15 ³⁄₁₆ × 11⅛ in. (38.5 × 28.3 cm)
Collection Fernanda Feitosa and Heitor Martins

Aldo Augusto de Souza Lima
Vertigo (Vertigem). 1949
Gelatin silver print, 11 × 14¾ in. (28 × 37.5 cm)
The Museum of Modern Art, New York. Acquired through the generosity of
James and Ysabella Gara in honor of Donald H. Elliott

BOLETIM FOTO-CINE

AN ANNOTATED AND ILLUSTRATED CHRONOLOGY

Liz Donato

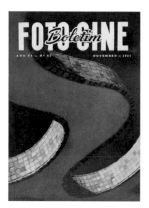

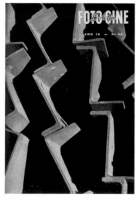
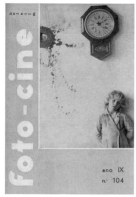
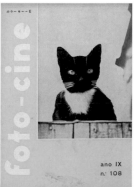
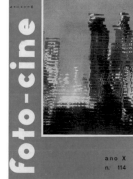

1939

April 29: The Foto Clube Bandeirante (FCB; later, Foto-Cine Clube Bandeirante, or FCCB) is founded in the Martinelli Building, Brazil's first skyscraper, located in downtown São Paulo on rua São Bento. The street is home to several photographic supply shops, where the "idealists and enthusiasts" of the amateur photography scene informally gather. The club occupies two rooms on the twenty-second floor until relocating to rua Avanhandava in mid-1949.

Thomaz Farkas is identified on his membership card as *fundador*, or founding member, no. 61. (At least eighty-six members are given this distinction—all those recorded as having joined before 1940.) The date of his enrollment—handwritten rather than typed—corresponds to the date of the club's founding. Farkas would have been just fourteen years old.

1942

October 3: The FCB organizes the first annual Salão Paulista de Arte Fotográfica (São Paulo Photographic Art Salon) at Galeria Prestes Maia. See "The FCCB Salons" (right).

1943

January 1: Eduardo Salvatore (*fundador* no. 86) assumes presidency of the FCB. He will remain president until 1990.

1945

October 29: Brazilian president Gétulio Vargas is deposed by the military, ending his fifteen-year rule and the Estado Novo regime, which had been established in 1937 when Vargas, who had been president since 1930, staged a coup d'état, disbanded the Brazilian congress, and imposed an authoritarian constitution. Democracy is restored with the adoption of a new constitution in 1946.

1946

January: A club circular announces two new departments: the Secção Feminina (Women's Section) and the Departmento Cinematográfico (Department of Cinema)—the latter precipitating the renaming of the club, now the Foto-Cine Clube Bandeirante.

May (*Boletim* 1): The club begins publishing an informational bulletin, the *Boletim* (later titled *Boletim foto-cine* and, finally, just *Foto-cine*), producing more than 140 issues between 1946 and 1964. (Beginning in 1952 it is no longer consistently published on a monthly basis.) See "*Boletim foto-cine*" (right).

1947

February: Brazil's first major commercial photography magazine, *Íris: Revista brasileira de foto-cinema e artes gráficas*, puts out its first issue. In response *Boletim* 10 notes, "At last, the eagerly awaited IRIS is out. It is the first Brazilian magazine dedicated to photography and film. This quality publication boasts a wide range of contributors and is expected to be an important influence on the progress of photographic art in Brazil."

July 2–18: *Creative Photography/ Fotografia artística*, organized by The Museum of Modern Art, New York, is on view at the Biblioteca Municipal de São Paulo. See "*Creative Photography*" (page 166).

The FCCB Salons

The first Salão Paulista de Arte Fotográfica opened on October 3, 1942, at Galeria Prestes Maia, the municipal exhibition space founded by São Paulo mayor Francisco Prestes Maia. It would be held there annually for the next forty-seven years. The inaugural salon was intended to take place in 1940, but the club's precarious finances caused the event to be delayed two years. Of all the club's activities, the annual salon was by far the most significant event in terms of investment of club resources and energy. The salons boosted the visibility of individual club members and of the organization as a whole, on both local and international levels. By its fifth iteration, the salon had become an international event, and its title was amended to the Salão Internacional de Arte Fotográfica São Paulo. In November 1946 the newly renamed FCCB announced it would adopt salon rules of the Photographic Society of America (PSA), and in the March 1951 *Boletim*, in anticipation of the Tenth Salon, the club announced that it would also follow the recommendations of the Fédération Internationale de l'Art Photographique (FIAP), thereby aligning the protocols of the club's salons with international norms. The rules for submissions shifted over the years, but there were general restrictions on the number of prints that could be submitted and on their dimensions. In accord with much of the club's hierarchical structure, salon submissions were classified as the work of a novice, junior, or senior, and acceptance into the salons was highly competitive. An official stamp was applied to the verso of accepted prints, which became a record of the photograph's circulation on the international amateur photography circuit and a marker of a print's status: the more stamps, the greater the prestige. Prizes were given for best photographs in each classification, as well as for best club and best club publication. Every year after 1946 the FCCB's in-house bulletin devoted ample coverage to preparations and press leading up to the salon, followed by reports on its success. The *Boletim* frequently reprinted reviews of the event that had appeared in prominent Brazilian publications (e.g., *Habitat*, *Íris*, *Anhembi*, *Folha da Manhã*, and *O Tempo*), to highlight the club's prominence on the national arts scene.

Boletim foto-cine

The first issue of the *Boletim* was published in May 1946. Members of the club received complimentary copies, but the publication was also available for purchase in photography-supply stores. From the start the FCCB was explicit about its desire to publish not just an informative bulletin but a veritable magazine of art photography, with the ambition of garnering broader critical standing for the medium in Brazil. The first "A nota do mês" ("Note of the Month"), the magazine's editor's letter, articulated the objective: "It tries its best to serve members by disseminating current photographic art, explaining its problems, answering questions, and advising and guiding beginners in the difficult art pioneered by Daguerre." The first issue (above, left) begins with an introduction by the club's president, Eduardo Salvatore, about the recent 4º Salão Paulista de Arte Fotográfica and its success in challenging the "unjustifiable indifference" to artistic photography on the part of the São Paulo press, accompanied by an installation view of the salon. Comprising only eight pages, the first issue includes many of the features and columns that would appear regularly: "Note of the Month," "O 'Bandeirante' no exterior" ("The 'Bandeirante' Abroad"), technical articles, announcements of new members, upcoming salons, and internal contests, among other items. On page three, "Um pouco de história…" ("A Little Bit of History…") provides a celebratory narrative of the club's founding—an origin story that would be told again and again in the pages of the *Boletim*.

August: José Oiticica Filho (father of the artist Hélio Oiticica and an FCCB member since May 1946) arrives in Washington, DC, after receiving a Guggenheim Foundation Fellowship in Biology for 1947–48 (and renewed the following year). He contributes a number of "Cartas de Washington" ("Letters from Washington") to the *Boletim*, which provide technical information, commentary on the organization of North American photo clubs, and observations on the quantity of photographic materials in the US. In one letter, published in *Boletim* 43 (November 1949), he writes, "Two things have impressed me deeply here, my friends: not just the abundance of photographic material but of material of every nature; also, the tremendous highway network. Both these things are impressive and serve to increase my respect for the way the folks at the Bandeirante are always having to contend with material shortage. You are producing work that is all the more admirable if . . . contemplated from afar, as I am doing now. I keep thinking what the Bandeirante could do with all the resources that are available here."

October: The Museu de Arte de São Paulo (MASP), founded by the businessman Assis Chateaubriand, opens to the public. He invites the Italian art dealer and critic Pietro Maria Bardi to be the first director, and the architect and designer Lina Bo Bardi to adapt the former office building's interior to the needs of a museum and to take charge of the exhibition design. Bo Bardi will later design the iconic modernist building that MASP has called home since 1968.

1948

November (*Boletim* 31): Farkas travels to the United States, where he meets Edward Weston in California and Edward Steichen in New York, visiting the latter at The Museum of Modern Art in late fall. This issue mentions "Farkinhas"'s travels in North America in "Instantaneos" ("Snapshots"), noting a postcard he affectionately addressed to his dear Bandeirante friends and colleagues, promising news and updates.

December (*Boletim* 32): The club announces that it has received a bust of Hércules Florence, a French-born artist and inventor who, while living in Brazil, pioneered an early form of photography that preceded by several years Louis Daguerre's better-known invention of 1839. The bust was a gift from Florence's son, Paulo, who presented it to the FCCB to inaugurate the annual salon. Displayed in front of the Brazilian flag, Florence's image becomes a symbol of national identity and pride for Brazilian photographers.

1949

January 25: The Museu de Arte Moderna de São Paulo (MAM) opens to the public.

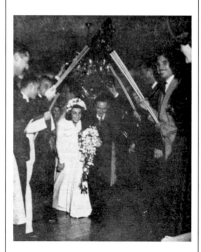

March (*Boletim* 35): Farkas's wedding announcement appears in the *Boletim*'s "Social" section, underscoring the extent to which the club cultivated personal relationships among its members. The caption to the accompanying photo notes that after the ceremony Farkas and his wife, Melanie Rechulski, passed beneath an arch formed by the tripods and cameras of their fellow Bandeirantes.

Creative Photography

From July 2 through July 18, 1947, the Biblioteca Municipal de São Paulo (São Paulo Municipal Library) presented the portable didactic exhibition *Fotografia artística*, organized by the Department of Circulating Exhibitions at The Museum of Modern Art, New York, where it was originally titled *Creative Photography*. The director of the library, Sérgio Milliet (also a prominent art critic), encouraged such initiatives to educate the public about modern art in the years before any major museum of modern art was established in São Paulo. The FCCB sponsored the exhibition, along with the Secretaria Municipal de Cultura de São Paulo (São Paulo Department of Culture), the União Cultural Brasil-Estados Unidos (Cultural Union Brazil-United States), the Clube de Cinema de São Paulo, and the newly founded magazine *Íris*. The display consisted of twelve panels that contained forty-seven photographic reproductions of works by US and European photographers, including Helen Levitt, Ansel Adams, Charles Sheeler, Andreas Feininger, Edward Weston, Henri Cartier-Bresson, Walker Evans, Berenice Abbott, and Paul Strand. A series of lectures accompanied the exhibition, and among the speakers were several prominent FCCB members, such as Jacob Polacow and Valencio de Barros, whose talks were subsequently reprinted in the *Boletim*. Polacow's lecture "Pictorialismo em arte fotográfica" ("Pictorialism in Art Photography") and de Barros's "A fotografia é arte?" ("Is Photography Art?") reveal the club's founding members' commitment to Pictorialism. A notable gap existed between the content of the lectures, which privileged photography's painterly affinities (for instance, the art critic Lourival Gomes Machado's "Relações entre o cinema e a pintura" ["Relationships between Film and Painting"]), and the modernist tendencies on view. An editorial in *Boletim* 15 (July 1947) critiques the overly didactic framing of the work in the exhibition and the "illustrative" quality of the images, even calling Abbott's work boring. The text bemoans the comparatively generous coverage devoted to the library exhibition in the local press as opposed to that typically afforded the FCCB's annual salon. This instance of cross-cultural exchange captures not only a moment of transition in Brazilian art, and in the culture of São Paulo in particular, where the opening of major modern art institutions was imminent, but also a shifting of aesthetic sensibilities within the club itself: the FCCB would increasingly develop its modernist orientation as more members embraced experimental approaches.

Excursions

Group photos of smiling Bandeirantes gathered outdoors, or "in action," appear throughout the history of the *Boletim*. Such images document the FCCB's excursions, one of the club's primary membership benefits,

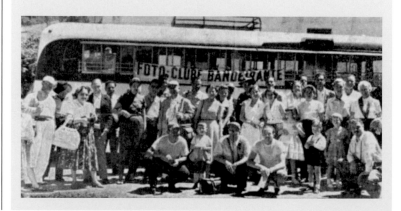

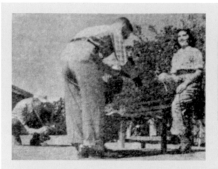

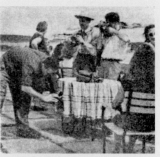

Two of many excursions documented in the pages of the *Boletim*. In the November 1948 issue (above, left), an image of two members "exploring" a "beautiful model" appears near one in which Thomaz Farkas is "caught" in a characteristic pose (above, right). In the November/December 1952 issue (opposite, bottom), a group of smiling Bandeirantes stand before their club banner.

and accompany full-length articles on these outings. In one of the field trips depicted here, the *excursionistas* pose in front of a bus (the primary mode of transport for these trips) festooned with a banner bearing the club's name. Unlike the highly competitive internal contests and seminars, the excursions were primarily a social activity, intended to encourage member participation and to develop the amateur's skills in a range of environments. Submissions for internal contests and salons were often photographs taken during these outings, as multiple images of the same building or site reproduced in the *Boletim* suggest. Organized by the club's social department, the excursions were well documented in reports that detailed the trip's itinerary and included images of club members photographing the landscape or simply enjoying the conviviality of the occasion. The number of excursions varied from year to year, transpiring roughly every other month; trips generally lasted from one to three days. The geographic distribution of the excursions was concentrated in southeastern Brazil, with the majority in São Paulo state or in the city proper. However, a number of field trips ventured further afield into neighboring states such as Rio de Janeiro and Minas Gerais. The furthest documented excursion took members to Sergipe, in northeastern Brazil. Some destinations were selected to give members the opportunity to visit other amateur photo clubs; others were prompted by invitations from local tourism councils. Certain sites, such as the coastal city of Santos and the forests of Morro Grande, were no doubt chosen for the landscape views, whereas others, such the spa city of São Bernardo do Campo, for the recreational possibilities they afforded. Several excursions provided an opportunity to document the rapidly industrializing landscapes of midcentury Brazil. In the mid-to late 1950s, the club toured various factories of Light S.A., the Brazilian electric utility, which resulted in related exhibitions and contests.

Internal Contests

"Improve your photographic art by participating in the internal contests of the Club," reads a recurring footer in the *Boletim*. The *concursos internos* were monthly competitions devoted to a specific subject, formal motif, or special process (e.g., "architecture and monuments," "a cup of coffee," "atmosphere," "movement," and "photograms"). A typical annual schedule consisted of ten contests (two months were reserved for the annual salon, during which contests were not held) devoted to an assigned theme one month and an "open theme" (*tema livre*) the next. These competitions were fundamental to the club's commitment to educating the amateur, encouraging participation, and

"Adquirida a séde própria!" ("We Got Our Own Place!"): The FCCB's new building, illustrated in *Boletim* 37 (May 1949)

July: The FCCB completes its move to a new permanent headquarters at rua Avanhandava 316 and inaugurates the new facilities on July 12. The club leadership announces an internal voluntary lending initiative to fund the new building. Members who provide financial support will be reimbursed over the course of three years. Aldo Augusto de Souza Lima, Salvatore, Gaspar Gasparian, and Gaspar Gasparian Filho all lend the club money. In addition, the general assembly approves an extra monthly tax of ten cruzeiros (roughly eight US dollars; optional for members outside São Paulo) that will go toward repayment of loans for a fixed period. The shift in architectural setting is significant: founded in a provisional location in a skyscraper, the club relocates to a smaller-scale building intended to host exhibitions and social and educational activities for the FCCB's expanding membership. The editorial and administration offices remain at rua São Bento 357.

July 21: Farkas's solo show *Estudos fotográficos* (*Photographic Studies*) opens in the Salão Pequeno at MAM; it is the first exhibition devoted to photog-

raphy as a fine art in a Brazilian museum. (See Meister, pages 14–15.) The exhibition design marked a radical departure from the typical *fotoclubista* salon. A collaboration with the architects Jacob Ruchti and Miguel Forte, the display mounted sixty of Farkas's prints, unframed, on varying architectonic supports: a minimalist scaffold inclined on the wall; three-dimensional structures suspended by wires in the center of the gallery; and panels that evidenced Farkas's and the architects' awareness of exhibition design in US institutions, including recent displays at MoMA. Despite the break from the club's traditional salon-style displays, the FCCB praised Farkas's accomplishment in a short text about the exhibition in *Boletim* 39 (July), noting that he "never conformed to convention."

August 6: The first Seminário de Arte Fotográfica (Seminar on Art Photography), designed to provide a more structured framework to critique submissions to internal club contests, takes place at the FCCB. See "FCCB Seminars" (page 169).

In November 1949 the *Boletim* participated in the PSA's International Club Bulletin Competition and won a special award for editorial content (*Boletim* 43). The *Boletim* was awarded the prize again in November 1951.

1950

May: The Fédération Internationale de l'Art Photographique (FIAP) invites the FCCB to become a founding member. Established that year by Maurice Van de Wyer in Belgium, the organization promotes the international exchange of art photography. Oiticica Filho serves as the Brazilian representative.

September (*Boletim* 53): The *Boletim* undergoes a redesign, acquiring a new logo and now appearing as the *Boletim foto-cine*. For the first time, the bulletin lists single-issue and subscription rates for non-members both in Brazil and abroad. The publication remains free of charge for members. The newly added table of contents lists recurring columns—"Atividades fotográficas no país" ("Photography Events Around the Country"); "The 'Bandeirante' Abroad"; Social Activities; Contests; Salons—that highlight club perks.

December: The 1ª Convenção Brasileira de Fotografia (First Brazilian Photography Convention) unites all of the photography clubs in Brazil at a convocation in São Paulo. The Confederação Brasileira de Fotografia (Confederation of Brazilian Photography) is formed; among other activities, the organization is tasked with representing Brazil at FIAP.

1951

January 2–18: Geraldo de Barros's exhibition *Fotoforma* is mounted in a small gallery at MASP. (See Meister, pages 15–16.) Although it is the first exhibition devoted to photography at the institution, the event barely registers, save for a fleeting reference in the February 1951 issue: "Brazilian artists must hold their own solo exhibitions, following the leads of Thomaz Farkas and Geraldo de Barros.... When will we have exhibtions by José Yalenti, Francisco Albuquerque, José Oiticica Filho, Angelo Nuti, Gaspar Gasparian, German Lorca, and many others?"

The absence of a review of the exhibition in the *Boletim* underscores the vexed relationship between the vanguard artist and the more conservative FCCB leadership. *Fotoforma* evinces de Barros's interest in constructivism and, as did Farkas's exhibition at MAM, experimental museography. With some *fotoformas*, de Barros relies on formal and technical manipulations, cropping and scratching the negative. FCCB

A typical *Boletim* issue juxtaposes the more competitive activities of the club, as seen in the club rankings (left), and images of family-friendly social events (right), such as the recurring Natal Bandeirante (Bandeirante Christmas). *Boletim* 57 (January 1951)

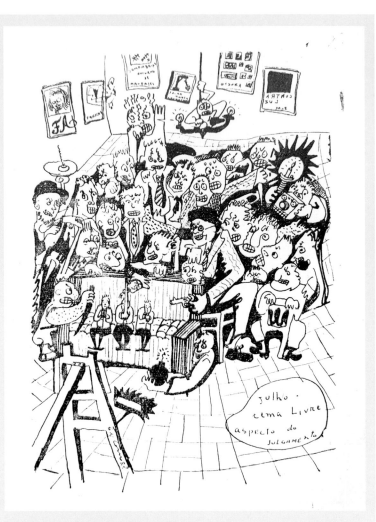

Satirical cartoon of the *concursos internos* by Geraldo de Barros from *Boletim* 41 (September 1949). Betraying the anxiety of those whose work is being judged, three diminutive members, one waving a white flag, are menaced by other members wielding a gun, a bomb, and a knife.

fostering dialogue. Submissions were ranked according to membership classification (seniors, juniors, novices, and, later, "aspiring") and assigned points based on specific aesthetic and technical criteria. A jury ranked the allegedly anonymous submissions (photographs were identified by assigned numbers rather than by contestants' names) in a public forum in the presence of participants and other interested parties so that everyone could hear the jury's critiques. (Despite procedures for protecting the anonymity of submissions, many of the club's more influential figures, including, notably, its president, consistently received top marks.) According to a description of the contests in November 1947, the jury assessed photographs according to originality and interest, technical execution, and artistic value. At the end of each year, the total points earned by participants in the internal contests were tallied—the primary mechanism by which members won promotion to a higher classification. In an article in September 1954, "Promoção de classe no FCCB" (Promotion of Class in the FCCB), Armando Moraes Barros expresses frustration over the process and the difficulty of ascending ranks in the FCCB. He notes that members are often stuck at a level despite earning additional points, and he

suggests increasing the number of points awarded, to facilitate promotion. The director of the Photography Department (a rotating position, at the time occupied by Francisco Albuquerque) was responsible for selecting the monthly themes that enabled amateurs to gain fluency in different photographic genres and techniques. The first internal contest to accept submissions in color took place in April 1949. Other special contests were designed specifically for beginners, which the FCCB cosponsored with local photo shops; Laboratório Próprio (Your Own Photo Lab) solicited submissions developed in home photo labs rather than commercial ones.

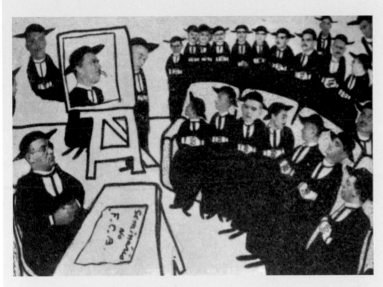

"O nosso seminário de arte fotográfica numa 'visão' de Geraldo" ("Our Photographic Art Seminar in a 'Vision' of Geraldo [de Barros]"). *Boletim* 50 (June 1950)

FCCB Seminars

In June 1949 the *Boletim* editors announced a new initiative, the Seminário de Arte Fotográfica (Photographic Art Seminar), which offered members the opportunity to participate in organized critiques of works submitted to the monthly internal contests. Although the seminars were open for all members to attend, only the moderator (frequently Salvatore), members of the jury, and the artist could participate in the discussions. Generally, more advanced members participated in the seminars. *Boletim* 40 (August 1949) included a summary of the first seminar's conversations: Salvatore introduced the session; artists provided technical information about their work—such as the type of camera, film, and paper they used—and explained their working processes. Subsequent seminars appeared in the *Boletim* in greater detail. Transcripts of the discussions were published beginning with the second seminar, in *Boletim* 41 (September 1949), which also featured a photograph of the event. It was not until the third seminar that several of the works under discussion were reproduced—in *Boletim* 42 (October 1949)—to accompany the transcript of the debate. *Boletim* 45 (January 1950) reproduced all of the works in a seminar for the first time; some issues presented images as separate plates rather than as part of the seminar coverage. The seminars occurred regularly (roughly monthly) from 1949 through 1952 and then with less frequency when printing costs skyrocketed, at which point the *Boletim* could no longer afford to reproduce full transcripts with corresponding images.

leaders reject these "artificial" interventions, which they believe taint the purity of the medium. It will not be until 1954 that one of de Barros's *fotoformas* is reproduced in the *Boletim*, alongside a multiple exposure by Ademar Manarini (see page 171), accompanying his review of the Sala de Fotografia at the Second São Paulo Bienal.

January 31: Vargas returns to power in Brazil, this time as the elected president.

February: De Barros leaves for Paris on a grant from the French government. His name appears in the *Boletim* masthead as a foreign correspondent in Paris from February through November. While in Europe, he travels extensively.

February (*Boletim* 58): The FCCB has established a strong relationship with Argentine photo clubs via Alejandro C. Del Conte, founder of the Buenos Aires–based biweekly *Correo fotográfico sudamericano*. The *Boletim* frequently reprints articles from the *Correo* and dedicates a contest to Del Conte after his death in 1952.

Pietro Bardi and Lina Bo Bardi visit the FCCB headquarters.

Photograph by German Lorca of Annemarie Heinrich surrounded by FCCB members José Yalenti, José Oiticica Filho, and Aldo de Souza Lima. *Boletim* 59 (March 1951)

Cover of *Boletim* 59 (March 1951). Photograph by Annemarie Heinrich

March: The FCCB organizes a solo exhibition of the work of the German-born Argentine photographer Annemarie Heinrich at MASP. Jacob Polacow refers to her as a "militant collaborator" and notes her versatility: "From landscape to portraiture, from still life to fantastic and subjective works, from the delicate nude to dramatic portraits and genre scenes, nothing eludes Annemarie's achievement." Heinrich is a frequent presence in the *Boletim*. She is featured in interviews (May 1951), and her texts and photographs appear in specially commissioned articles such as "Fotos de 'ballet'" (July 1951) and "Incentivar a expressão creadora na fotografia" ("Encourage Creative Expression in Photography"; October 1951). Heinrich's collaborations with the FCCB will continue via her role in the Buenos Aires–based Carpeta de los Diez (Portfolio of the Ten, or Group of Ten) which forms in 1953, and her second solo exhibition in São Paulo, this time at FCCB headquarters. She is one of the few non-Brazilian photographers whose work appears consistently in the publication.

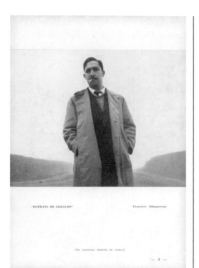

Francisco Albuquerque submitted his 1950 portrait of Geraldo de Barros (*Retrato de Geraldo*) to the March 1951 *concurso interno*. When the photograph was published that May, de Barros was still in Europe on a grant. *Boletim* 61 (May 1951)

May 1–July 4: Farkas's photograph *Rushing Water n° 2* (see page 161), which he had sent to Steichen in early 1949, is included in the MoMA exhibition *Abstraction in Photography*.

October–December: The 1ª Bienal de São Paulo takes place in a temporary pavilion on avenida Paulista (the future site of Lina Bo Bardi's renowned building for MASP). MAM will be responsible for organizing the Bienal between 1951 and 1961.

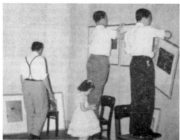

The Tenth Salon was such a significant event in the club's history that even the deinstallation was considered worthy of being documented. *Boletim* 68 (December 1951)

1952

June: MAM presents *35 foto-grafias*, a solo exhibition of German Lorca's photographs. Visitors can observe the evolution of Lorca's career just before he leaves the club to establish his own com-mercial studio. The June *Boletim*

Corte, Interpretação e Princípios de Composição

ANTONIO DA SILVA VICTOR

The article "Corte, interpretação e princípios de composição" ("Cropping, Inter-pretation, and the Principles of Composition") exemplifies a regular feature of the publication: technical articles that provide the amateur with an array of didactic content. This particular text, written by Antonio da Silva Victor, then the director of the cinema department, provides illustrations of the same image with alternative croppings by FCCB members. The article argues for the importance of "personal, affective" vision in organizing a composition. *Boletim* 63 (June/July 1951)

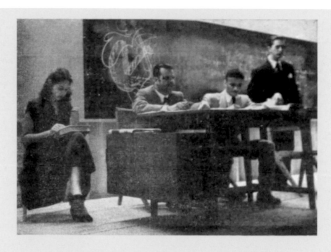

Dulce Carneiro and colleagues at the 1º Congreso Brasileiro de Clubes de Cinema, São Paulo. *Boletim* 52 (August 1950)

Film at the FCCB

By the end of 1945 the club declared its intention to form a new cinema department, which formally launched the following year, on the club's seventh anniversary, with a screening of amateur films. By the late 1940s and early 1950s the FCCB was increasingly known for modernist exper-imentation in photography, but the status of cinema in the club was more precarious, owing in part to a lack of film stock and specialized laboratories for film processing. Early articles in the *Boletim* reflect the complex material realities of producing amateur film in Brazil (e.g., in July 1948, Benedito Junqueira Duarte's "Cinema em 16mm, a censura, a alfândega e outras pragas" ["Cinema in 16mm, Censorship, Customs, and Other Plagues"]), while emphasizing the importance of developing proper technique with available resources. The first column devoted to amateur cinema, "A página do cine-amador" ("The Amateur Cinema Page"), edited by Antonio da Silva Victor, the first director of the cinema department, appeared in December 1946. Jean Lecocq would be the other long-serving director of the department; his tenure began in 1953. Amateur filmmaking provided opportunities for the exploration of diverse formats and genres (scientific, educational, experimental, and documentary) outside of the emerging national commercial industry, which privileged imported Hollywood productions and feature-length fiction films. However, amateur filmmaking proved less of an experi-mental enterprise than photography during the FCCB's heyday, with the exception of the moving-image work of Thomaz Farkas, who helped integrate cinema into the club's activities. Farkas's first experimental film, *Estudos* (*Studies*, 1949), was cocreated with Luis Andreatini. Now considered lost, this short work of "pure cinema" was submitted to a variety of contests and festivals sponsored by the FCCB, including the 1º Concurso Cinematográfica Nacional para Amadores (First National Amateur Film Contest), held on January 20, 1950, in the headquarters of *A Gazeta* newspaper. 1950 was a significant year for cinema at the club: the FCCB established partnerships with national and interna-tional clubs, including the Union Internationale du Cinéma d'Amateur (UNICA), leading to the 1º Festival Internacional de Cinema Amador held on October 13 and 14 at MASP, which had recently inaugurated its Sala de Projeções. Because few amateur films made in Brazil during this era have been preserved, the cinema pages in the *Boletim* remain one of the primary records of this early history of noncommercial filmmaking in São Paulo.

Humor in the *Boletim*

The social life of the FCCB is manifested in the *Boletim* in a variety of ways, and humor played an important role in animating the club's many activities and some of its larger personalities. Several recurring columns appear under titles containing puns or other word play, such as "Flash...adas" (punning on the Portuguese word for "arrow," *flecha*, and the English "flash") and "Perguntas 'foto-cretinas'" ("Stupid Photo Questions"), or dark humor—for instance, "Pílulas cianídricas" ("Cynanide Pills"). Geraldo de Barros contributed satirical illustrations to accompany a couple of these columns, which lampooned both the amateur photographer and club decorum (see e.g., the illustrations on pages 168 [top, right] and 169 [top, left]). De Barros himself was the target of some of this wry humor: one entry in June 1950 sardonically references the artist's participation in a photography "seminar" held at a well-known psychiatric hospital in Rio de Janeiro, riffing on the unintelligibility of his work to (presumably) sane fellow members. Other entries were less caustic and captured the playful camaraderie of the club. A "Flash...adas" entry from October 1950 includes a droll shot (above) in which José Oiticica Filho ("one of the most remarkable figures in Brazilian art photography") is seen anointing a recently promoted novice member, Frederico Soares de Camargo, in a mock-ceremonial rite. The caption notes that Oiticica is ably "assisted by the indefatigable [Fernando] Palmério, under the attentive gaze of Ciro Cardoso, C. Pugliesi, and F. Albuquerque."

The Tenth Salon

The Tenth Salon opened on September 11, 1951, and its commemorative significance was underscored both by its scale and by the *Boletim*'s sustained efforts to highlight the event. Photographers from forty countries participated, evidencing the club's expanding international reach. The Tenth Salon was also the first to accept submissions in color. Of 3,166 submissions, 507 works (105 for the color section) were accepted. The salon drew record crowds: according to the *Boletim*, close to 150,000 visitors passed through the displays at Galeria Prestes Maia. The Tenth Salon also coincided with the emergence of the term Escola Paulista (Paulista School) to characterize the formal experimentation of the FCCB (in contradistinction to the lingering Pictorialist tendencies of some amateur circles). *Boletim* 66's "Note of the Month" reports that "in light of their impressions of the [Tenth Salon], some of the most authoritative critics have clearly expressed their enthusiasm, stating categorically that São Paulo artists' personalities and boldness were leading them to

announces his imminent departure: "A longtime member of the FCCB, where he acquired and perfected his knowledge, he has moved on from amateur status to become one of the most competent professionals in São Paulo." The article reproduces an excerpt of de Barros's essay in the exhibition brochure, noting a shift in Lorca's work: "He moves away from the subject of society in order to concentrate on purely formal values. His interest in subject matter and literary tastes disappear, to be replaced by rhythms and compositions in black and white that stem from his understanding of the formal problems of placement and surface." Clearly, Lorca is already adept at promoting his professional work: below the article, an advertisement for Lorca Foto Studio highlights its full range of services, from "technical, industrial, and commercial" photography to reportage in general as well as baby and wedding albums.

Although Lorca intends to abandon the world of *fotoclubismo*, he will resume his affiliation later in the decade while maintaining his commercial practice.

December: De Barros exhibits his paintings in the inaugural exhibition of Grupo Ruptura at MAM. The *Manifesto ruptura* declares its signatories stand against mimetic representation and naturalism, defending an objective art closely aligned with industry.

1953

December: The 2ª International Bienal de São Paulo opens in the new Oscar Niemeyer-designed pavilions in Ibirapuera Park, and includes two galleries featuring photographs by FCCB members. The Bienal remains on view through February 1954. See Meister, pages 17–18, and "Photography at the Second São Paulo Bienal" (pages 172–73).

1954

February: The FCCB mounts an exhibition of forty photographs by Oiticica Filho at the club. It is covered extensively in the April issue of the *Boletim*.

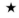

Several of the photographs featured in the Second Bienal were also reproduced in the *Boletim*. Geraldo de Barros's *Fotoforma* nº 12 appears opposite a work by Ademar Manarini (see page 4).

April (*Boletim* 88): An unsigned item notes the call for submissions to MoMA's forthcoming international touring exhibition *The Family of Man* ("O Museu de Arte Moderna de New York comemorará o seu 25.° aniversário com uma exposição de fotografias!" ["The Museum of Modern Art in New York Will Commemorate Its 25th Anniversary with an Exhibition of Photographs!"]). The FCCB laments that it received the call too close to the deadline to enable the club to submit works to this "important exhibition." The text includes a translated excerpt of *The Family of Man*'s press release that encapsulates curator (and, at the time, director of the Museum's Department of Photography) Steichen's vision for an exhibition that would include, when it opened at MoMA in January 1955, some five hundred photographs organized around "universal" human themes. In the article FCCB clearly aligns its mission with that of MoMA and the recent Sala de Fotografia at the Second São Paulo Bienal, seeing each as a step in the advancement of art photography.

★

May: The FCCB holds a retrospective exhibition of the work of José Yalenti at its headquarters, coinciding with the club's fifteenth anniversary celebrations.

In Rio de Janeiro, Ivan Serpa founds Grupo Frente, a group of avantgarde artists that includes many of his former pupils. Early members include Aluísio Carvão, Lygia Clark, and Lygia Pape, who would later be joined by Abraham Palatnik and Hélio Oiticica, among others.

May 15: The so-called Salão Preto e Branco (Black and White Salon), officially known as the 3° Salão Nacional de Arte Moderna, opens in Rio de Janeiro. Participating artists (including Carvão, Clark, Pape, and Serpa) submit only black-and-white paintings to protest Brazil's new tariffs on imported paints and other art supplies, now deemed luxury goods. More than six hundred artists sign a manifesto, addressed to the minister of education, denouncing the prohibitive costs of artistic materials. The high price of quality photographic paper and the increased cost of printing affects photographers and jeopardizes the regular production of the *Boletim*.

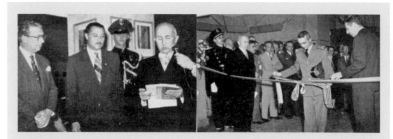

The FCCB's Tenth International Salon was abundantly illustrated in the *Boletim*. Maurice Van de Wyer, President of FIAP, was the official speaker at the opening ceremony (seen here with Yalenti and Salvatore, the club's vice president and president, respectively), the exhibition symbolically inaugurated by a representative of Brazil's Ministry of Education. *Boletim* 65 (September 1951)

become pioneers of a new school of photographic art." Several *Boletim* issues featured reprints of reviews of the salon written by some of São Paulo's, and Brazil's, most prominent arts and culture publications, such as *Anhembi*, *Habitat*, *Íris*, and *Paulistana*. *Boletim* 67 notes that the arts and architecture magazine *Habitat* (then edited by Lina Bo Bardi and Pietro Maria Bardi) dedicated two full pages to the salon and reproduced photos by Abilio M. Castro Filho, André Carneiro, Gasparian, Lorca, Polacow, and Salvatore and cites the magazine's laudatory introduction: "The Tenth Salon is one of the most remarkable exhibitions of artistic photography ever held on this continent. In the work of the F. C. Bandeirante, Brazil achieves truly prominent stature as one of the most advanced centers [in the world] for practitioners of photographic art." A review in *Anhembi* (reprinted in its entirety in *Boletim* 68) asserts that the FCCB has accomplished "the 'double victory' . . . of having made São Paulo one of the most important centers for contemporary photography and of having decisively contributed to the making of a Paulista 'school' of photography." The review notes the distinctiveness of the São Paulo amateurs and the uniqueness of encountering such innovative production in a traditional photo-club structure.

Photography at the Second São Paulo Bienal

Although de Barros's engagement with photography waned after 1951, he collaborated with several prominent members in the organization of the Sala de Fotografia at the 2ª Bienal de São Paulo. In de Barros's extended article "A sala de fotografia" ("The Photography Gallery") in *Boletim* 87 (February/March 1954), he recounts the circumstances that led to the club's participation. The spatial distribution of galleries shifted after the Haitian and Nicaraguan representations withdrew from the exhibition days before the official opening. De Barros, among others, advocated for a gallery devoted to photography. Although they expected resistance, the organizing committee accepted the proposal. De Barros writes, "We contacted Salvatore, who responded immediately and showed us a collection of photographs by club members." De Barros, Salvatore, Yalenti, and Manarini were responsible for the selection. Given the lack of time, they had to work with the best of what was immediately available: "We concluded that the unity of the gallery was the most important thing. And we believe we have achieved that. Considering that, for lack of time, a general invitation or a competition was completely out of the question, it was decided that the photographs would be selected from members' preexisting work stored in the club's drawers. This would simplify our problem even as it encouraged members to keep their drawers well-stocked with work for occasions such as

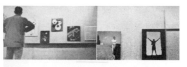

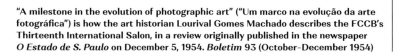

"A milestone in the evolution of photographic art" ("Um marco na evolução da arte fotográfica") is how the art historian Lourival Gomes Machado describes the FCCB's Thirteenth International Salon, in a review originally published in the newspaper *O Estado de S. Paulo* on December 5, 1954. *Boletim* 93 (October–December 1954)

this one." The FCCB-organized Sala de Fotografia gave the medium a significant presence at a high-profile international event, suggesting an integration of photography within circles much broader than the amateur photography scene. De Barros proudly noted the positive reception of the photography gallery among important Brazilian critics at the time, such as Mário Pedrosa, Geraldo Ferraz, José Geraldo Viera, Maria Eugênia Franco, and Sérgio Milliet, and among international figures such as Max Bill, Jorge Romero Brest, Walter Gropius, and Bernard Dorival, although the scholar Adele Nelson has concluded that these commentaries appear to have been oral. De Barros refuted some critics' belief that the club received the commission based solely on its reputation, insisting that it was for the quality of the members' work. His essay also demonstrates his continued engagement with the club—despite his complicated relationship to it and his gradual abandonment of a photographic practice—at a moment when it was more receptive to the experimentation he had embraced since the late 1940s.

A Banner Year

The "Note of the Month" in the February/March 1954 *Boletim* boldly pronounced that "1954, the year of [São Paulo's] Fourth Centenary, will surely go down in the annals of the FCCB as a year of great accomplishments." The FCCB played an active role in the commemorations of the four hundredth anniversary of São Paulo's founding, celebrating the city's role in the industrialization and modernization of Brazil. The *Boletim*'s June/July "Note of the Month" added to the propagandistic fervor: "A cosmopolitan city par excellence, a kinship in which all races, all peoples have together erected this monumental metropolis, 'the world's fastest growing city.' There could be no art better than photography—the universal language of which requires no words—to translate the spirit of universal brotherhood that characterizes São Paulo." Building on the quadricentennial's momentum, the club organized a series of exhibitions at its headquarters, most of which were solo exhibitions of prominent members (Oiticica Filho, Yalenti, Roberto Yoshida), but there were also group shows of organizations from abroad (such as Groupe des XV of France and C. S. [Combined Society] of England) and, at MAM, Manarini's exhibition, co-sponsored by the FCCB. The events organized in conjunction with the centenary also prompted important critical reflections in various São Paulo publications, several of which the FCCB reprinted in the pages of the *Boletim*.

Bandeirantes

The Bandeirante Trophy was considered the highest honor for Paulista photographers. In 1955 (its inaugural year) it was awarded to Salvatore and Marcel Giró. *Boletim* 100 (June/July 1956) reproduces an image of the trophy, a bronze statuette of the bandeirante, a quasi-mythical figure deeply embedded in Brazilian, and especially Paulista, identity—part colonial frontiersman, part slave raider. Both the bandeirante's violent history and mixed racial identity were whitewashed in early-twentieth-century appropriations of the figure. Contrary to the historical reality, the bandeirante became a symbol of white, Europeanized Paulista identity and served to glorify the region's role in nation building. Such sentiments were frequently echoed in the *Boletim*: "One of the most characteristic features of the 'bandeirantes' was their tenacity—a stubbornness in pursuing their aims. They were unstoppable. They reorganized themselves after temporary defeat, assembling new forces and returning as often as necessary to vanquish whatever obstacle befell

July 7: An exhibition of forty photographs by Manarini opens at MAM. The *Boletim* reviews and publishes several works from this solo display, organized in collaboration with the FCCB. Walter Zanini, a critic and curator (and future director of the Museu de Arte Contemporânea da Universidade de São Paulo [MAC-USP]), praises Manarini's formal innovation in "Fotografia, arte?" ("Photography, Art?"), an article in the newspaper *O Tempo*, which the *Boletim* reprints in its September issue.

July 15: The artist Waldemar Cordeiro delivers a well-attended lecture at FCCB headquarters on the "Possibilidades históricas do concretismo" ("Historical Possibilities of Concrete Art").

August 23: The FCCB opens a solo show of Roberto Yoshida's work at club headquarters; Yoshida's "table-top" photographs are singled out for praise in the *Boletim*.

August 24: Brazilian president Vargas commits suicide. His vice president, João Café Filho, assumes the presidency through the 1955 elections.

1955

January–March (*Boletim* 94): A Marcel Giró solo exhibition is held at the FCCB. Reviews of the event identify his work as exemplary of "Paulista style": "Giró is undoubtedly one of the most authentic representatives of this photography that has taken on special interest for its bold angles and compositions, its play of lines, light, and shadow (one of Giró's favorite subjects), and that critics call 'the Paulista School.'"

The "Report from the Directors" for 1953–54 addresses the national economic situation: "We are not unaware that mistakes were made; things didn't always work out as they might have, particularly because of our nation's hard times, and because of the

high cost of living in general. In the club's case, the scarcity and exorbitant price of photographic materials severely restricted the activity of our members."

April/May (*Boletim* 95): The "Note of the Month" continues to discuss the financial difficulties related to publishing the *Boletim* regularly and cites a lack of support from photography-supply stores. The club contracts the firm Publicidade A–Z to manage advertising for the magazine.

June: The exhibition *Otto Steinert e seus alunos* (*Otto Steinert and His Students*) opens at MAM in collaboration with the FCCB: the club's role in organizing exhibitions was central to its public presence. Like many of the Bandeirantes, Steinert was a self-taught photographer from a white-collar background (he was a doctor) as well as cofounder of the group Fotoform. He organized a series of traveling exhibitions called *Subjektive Fotografie* (in 1951, 1954, and 1958). The exhibition at MAM, while not part of this touring show, presented the work of Steinert alongside that of his students at the Staatliche Schule für Kunst und Kunstgewerbe (State School of Arts and Crafts) in Saarbrücken, Germany.

Boletim 97 (August-October 1955) will devote ample space to Steinert in an article by Rubens Teixeira Scavone titled "Diagnóstico do subjetivo" ("Diagnosis of Subjectivity"). Scavone offers an explanation of Steinert's conceptualization of art photography (rather than a critical review), accompanied by reproductions of works from the show as well as installation views. Citing Steinert, Scavone defines the movement's approach as a "humanized, individualized photography," which manifests the subjective vision of the photographer and an exploration of the human psyche rather than an indexical reflection of "objective" representations of the visible, external world. Steinert

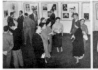

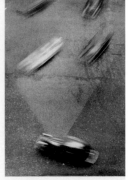

Scenes from the June 1955 opening of *Otto Steinert and His Students* at MAM, reproduced across from Steinert's *Movimento sôbre extrutura* (*Movement Across Structure*). *Boletim* 97 (August–October 1955)

encouraged formal interventions and experimental processes, hence Scavone's references to figures such as Man Ray, László Moholy-Nagy, and Paul Klee. These references suggest a shift in the club's discourse, which had by now fully assimilated avant-garde principles, making the club's regular collaborations with São Paulo's major institutions of modern art a natural fit.

1956

January 31: Juscelino Kubitschek is inaugurated president of Brazil. After campaigning on a platform that promised "fifty years of progress in five," Kubitschek announces the relocation of the nation's capital (then in Rio de Janeiro) to the remote Brazilian highlands, where he will build a new modern city to be named Brasília. Construction begins in 1957.

April 26: An exhibition of photographs by Maria Helena Valente da Cruz and drawings by Henrique Valente da Cruz opens at the FCCB headquarters. The display is mentioned twice, briefly, in *Boletim* 99 (May 1956).

May 24: An exhibition of photographs by Eduardo Ayrosa and José Mauro Pontes opens at FCCB headquarters. Originally shown at Teatro Maria Della Costa, the exhibition was reviewed by Lourival Gomes Machado in the May 1956 *Boletim*.

June/July (*Boletim* 100): A text by Giró, "Literatura? Nããão! Fotografia!" ("Literature? Nooo! Photography!"), originally published in the bulletin of an amateur photo club in his native Catalonia (which he had recently visited), is reprinted in *Boletim* 100. In his article, Giró criticizes the *Boletim*'s editors for their decision to publish so many technical articles that interest only a minority of readers rather than translating articles from quality foreign publications and sharing the insights of great photographers, whom he identifies as Man Ray, José Ortiz-Echagüe, Steinert, Ansel Adams, and Steichen. "I am not interested in learning about how a certain lens is made," he writes, "and much less in knowing the chemical composition of the materials that made it possible." Instead, he calls for soliciting articles from "qualified individuals" and rejecting any article that does not deal with "more 'contemporary'

them. And so, they broke through and expanded the frontiers of our nation. The 'bandeirantes' of photography have apparently inherited those qualities from their ancestors. Our bulletin started out as a modest publication for circulation within the FCCB and then grew to become a magazine" ("Note of the Month," *Boletim* 104 [December 1958]).

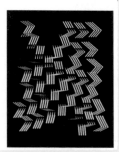

"Photography as an Artistic Form"

The February 1959 issue of *Boletim* included an article by the art critic Frederico Morais titled "A fotografia como forma artística." Morais identifies two divergent currents in contemporary photography: photo-reportage (encompassing humanism) and formalism (encompassing Concrete and other abstract tendencies). He illustrates his text with an image from Oiticica Filho's recent *Recriações* series (1958–64), which the artist produced during a fertile period of contact with the burgeoning Neo-Concrete movement in Rio de Janeiro, a movement in which his son Hélio was a key figure. The elder Oiticica also began to paint during this period, expanding the possibilities of his photographic experimentation by subjecting the negative to cutting, painting, and collage. For

this reason, Morais refers to Oiticica's process as "almost exclusively a task of the laboratory." He recognizes Oiticica's innovation, noting that he "attempted to blaze new trails with his 'recriações,' re-creations that sought not only to solve problems inherent to art photography but to the visual arts in general, since the photographic negative contains [citing Oiticica Filho] 'a potential world of new combinations that were not merely visual but also visual-aesthetic.'" Morais is critical of Oiticica's narrow definition of artistic photography, writing that "his position is bold and rather debatable . . . primarily because he will not consider any other form to be photography." He challenges Oiticica's dismissal of photo-reportage, which the photographer claimed "may be of interest yet is not [artistic] creation." For Morais, this work also requires "a creative mode of seeing that implies a critical artistic stance." The catholic tastes supported by the club's leadership resonated with Morais's broad definition of what constituted artistic photography.

"Art and Photography"

Over the years, many esteemed critics wrote reviews of the salons and FCCB-sponsored exhibitions for the *Boletim* or local newspapers. In 1962, after abandoning "militant criticism" to take up the position of director of the Museu de Arte Moderna de São Paulo, Mário Pedrosa contributed a short review titled "Arte e fotografia" to *Boletim* 132 on the occasion of a solo exhibition of Ivo Ferreira da Silva's work at the FCCB. Pedrosa celebrates the "spontaneity of [Ferreira da Silva's] shots, which are unaltered by photographic process or trickery or by anything beyond their intrinsic expressive means." Ferreira da Silva belonged to the generation of FCCB photographers who built upon the abstract formal legacy of the earlier Escola Paulista, but the body of work highlighted by Pedrosa exhibits what the critic calls a "neorealist tendency." Here Pedrosa privileges the direct, spontaneous, and personal vision in Ferreira da Silva's photographs, writing that the photographer "wants to make prints of the external reality he discovers, camera in hand, during his poetic meanderings—a personal interpretation that marks his sympathy for the things and beings photographed." This short review was one of Pedrosa's few forays into writing on photography; it is consistent with his criticism's emphasis on the social function of art.

problems." He concludes: "We amateurs want and love photography as art. Leave technicians and industry to pursue their own fields while we create the real photographs that are and that should be our purpose."

In the same issue, Scavone's "Foto-livros" ("Photo Books") offers a review of Cartier-Bresson's *Les Européens* and Beaumont Newhall's *History of Photography* (the latter published by MoMA). Scavone is particularly critical of Newhall's book, calling it "nothing more than a quasi report on the history of photography. . . . Its documentary component is of greater interest. . . . The work is almost exclusively restricted to the US and Europe, ignoring the progress of photography in other parts of the world, which is plainly a failure in terms of [providing] a general history."

1957

June: An exhibition of Dulce Carneiro and Maria Helena Valente da Cruz's work is on view at Boutique Etoile on rua Augusta in São Paulo and is briefly but warmly reviewed in *Boletim* 103 (June–November 1957).

The FCCB publishes its first (and only) *Anuário brasileiro de fotografia* (Brazilian Photography Annual) in late 1957. In June/July 1956 the "Note of the Month" states, "The time has come to collect the most valuable work by Brazilian artists in a more ambitious format. Beyond offering an overview of Brazilian photography and its position with regard to other countries, [the *Anuário*] will also serve to record this moment of the medium's evolution [in Brazil]. . . . Undoubtedly an ambitious project, but one much needed and as surely successful as the [club's] other enterprises. The *Anuário*'s core will consist of reproductions of all work accepted for the next salon (the fifteenth)—in itself a safeguard of the book's value and importance." In the next issue (*Boletim* 101

[August–November 1956]) the editors report that they have encountered difficulties that will impact the printing of the *Anuário*: "After we published the Fifteenth Salon's catalogue, we were informed that we could not have any more paper this year [1956] because our per annum import quota had been exhausted. Not only the *Boletim* took a hit: the *Anuário*'s publication was also threatened." It will be a full year before these issues are resolved, during which time the club publishes only two issues of the *Boletim*.

1958

November 26: Farkas's photograph *Rushing Water n° 2* (see page 161) is displayed for the second time at MoMA in the exhibition *Photographs from the Museum Collection* (on view through January 18, 1959).

December (*Boletim* 104): Only one issue of the *Boletim* is published in all of 1958; it introduces major changes to the cover (new design with color and new logo). The number of issues has been declining as a consequence of mounting production costs, material shortages, and the redirection of resources to the *Anuário*, a major undertaking that the editors refer to as the "first of its kind" in Brazil.

1959

February (*Boletim* 106): The financial and supply issues abate sufficiently for the *Boletim* to resume monthly publication in the first half of 1959; planning begins for a twentieth-anniversary retrospective exhibition featuring work made by members from 1939 to 1959.

April: (*Boletim* 108): This issue is devoted to the twentieth anniversary of the club. In honor of that milestone the FCCB organizes a retrospective exhibition that traces the evolution of individual members' work. Salvatore contributes an expanded "A Little Bit of History . . ." (the original chronicle having appeared in the *Boletim*'s first issue), in which he rehearses

the story of the club's founding and situates the FCCB in a broader history of photography in Brazil, focusing on Hércules Florence and *fotoclubismo*. Salvatore also includes a timeline of important events in the club's history. His reflection is notable for its consolidation of a narrative of the club's evolution, which culminates in the achievements of the Paulista School. After citing important benchmarks, he claims that "if these were the FCCB's most outstanding accomplishments, the artistic progress of its members stood out even more, marking the emergence of what critics called the 'Escola Paulista,' admired for the air of renewal it breathed into 'pictorial' styles of old."

In the *Boletim*'s previous issue the "Note of the Month" singled out figures aligned with the Escola Paulista in describing the forthcoming twentieth-anniversary show: "This retrospective exhibition will allow us a new opportunity to observe Yalenti's efforts in violent backlighting, Farkas's geometric compositions, Salvatore's concentration on form, and Geraldo de Barros and Manarini's abstract photography, efforts that forged the Paulista School." The *Boletim*'s editors celebrate the club's status and unparalleled influence in Brazilian photographic culture: "The history of photography in Brazil may be divided into two perfectly distinct periods: before and after the FCCB." This grandiose statement appears in *Boletim* 107's "Note of the Month," which Salvatore will cite in *Boletim* 108, attributing the pronouncement to an unidentified "esteemed critic."

June 16–July 13: The 1ª Exposição Latino-Americana de Fotografia Moderna (First Latin American Exhibition of Modern Photography) takes place at Galería de Artes Plásticas in Mexico City. This initiative of the Mexican group La Ventana, in collaboration with the FCCB, aims to bring together the work of Latin American photographers and includes photographs

by Gertrudes Altschul, Dulce Carneiro, Farkas, Giró, Ferreira da Silva, Heinrich, Oiticica Filho, Salvatore, and other Brazilians, as well as by photographers from across Mexico and South America. The exhibition subsequently travels to the FCCB headquarters and other venues in Argentina, Chile, and Uruguay.

1960

January/February (*Boletim* 115): Cartier-Bresson's essay "A Reportagem" ("Reportage"), which originally appeared in the French journal *Jeune Photographie*, is published in translation in the *Boletim*. Since the *Boletim*'s early days, the FCCB frequently ran translations of important texts from international photography magazines and journals that were otherwise inaccessible to the amateur photography community in Brazil. This practice reveals the club's ambition to position itself within an international discourse on photographic theory and practice.

April 21: Brasília is inaugurated, although its official dedication will not be captured in the *Boletim* until a year later, with a single photograph, Mamede F. Costa's photo *Sentinela* (*Guard*) (no. 124 [July/August 1961]). Farkas, no longer active in the club, made several trips between 1957 and 1959 to photograph the new capital under construction.

1961

November 10: The 1ª Exposição de Fotojornalismo no Brasil (First Exhibition of Photojournalism in Brazil) opens at the Centro Metropolitano in São Paulo. Organized by the Associação Brasileira de Arte Fotográfica (Brazilian Asso-

German Lorca. *Congonhas Airport, São Paulo*. 1961. Gelatin silver print, 10½ × 15 in. (26.7 × 38.1 cm). The Museum of Modern Art, New York. Gift of the artist. Featured in the Eighth São Paulo Bienal and reproduced in *Boletim* 148 (September–November 1965)

Eighth São Paulo Bienal

The FCCB organized the photography section in the Eighth São Paulo Bienal (September–November 1965), hoping to repeat the success of the Sala de Fotografia at the Second Bienal, in 1953. The jury invited submissions from all Brazilian photo clubs and associations, although a cursory scan of the catalogue suggests that the Paulistas (and FCCB members) dominated the representation, with work by FCCB members Dulce Carneiro, Lorca, Ferreira da Silva, Yalenti, Salvatore, and Yoshida included. The catalogue evinces the self-promotional and celebratory rhetoric that characterized FCCB editorials over the years: "For twenty-six years now, the Foto-Cine Clube Bandeirante has fought for photography, committing itself to the development of a Brazilian 'art of light.' It cannot now fail to express its satisfaction or applaud the felicitous and timely deliberation of the Eighth São Paulo Bienal." Yet the Eighth Bienal took place in a markedly different political context than that of 1953–54, when the FCCB had last participated in the organization of the exhibition. The eighth iteration opened to the public a year and a half after the military coup, and the government's heavy hand was felt by those participating: several critics and intellectuals were jailed in the months before the show's opening, prompting artists to deliver a letter to Brazilian president Castelo Branco demanding the release of the prisoners. The FCCB would participate in (but not organize) one further Secção de Fotografia, in the subsequent Bienal, in 1967. However, these appearances at the biennials of the mid-1960s would mark the end of the club's participation in exhibitions affiliated with official art spaces, after which amateur photography in Brazil would never again achieve the same status in the art world at home or abroad. The heyday of artistic experimentation at the FCCB had come to an end.

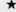

ciation of Art Photography), the exhibition showcases the work of photographers affiliated with the *Jornal do Brasil* in Rio de Janeiro. Salvatore attends the opening as a representative of the Confederação Brasileira de Fotografia e Cinema (Brazilian Confederation of Photography and Cinema), along with Ferreira da Silva, then vice president of the FCCB. Their participation signals the club's growing attentiveness to professional practices.

1962

January/February (*Boletim* 129): An article titled "Edward Steichen: O mestre" ("Edward Steichen: The Master") reports Steichen's retirement from MoMA the previous November and is followed by an article about his career that features examples of his work as a photographer.

May/June (*Boletim* 131): *Foto-cine*, as the *Boletim* was retitled starting in mid-1961, publishes an obituary for Gertrudes Altschul, who died earlier in the year. It is illustrated by her photograph *Filigrana* (*Filigree*) (see cover and page 80)—printed upside down, although when it first appeared in the magazine, in *Boletim* 81 (April-June 1953), it was oriented correctly.

1963

July/August (*Boletim* 138): Fernando Goldgaber's review "Os anos amargos: 1935-1941" ("The Bitter Years: 1935-1941") appears. It critically appraises a recent exhibition at MoMA on American photography during the Great Depression and is accompanied by images by Dorothea Lange, Arthur Rothstein, and Carl Mydans. The article notes that the Itamaraty library in São Paulo received a catalogue of the exhibition.

1964

March 31–April 1: A military coup d'état, backed by the United States, deposes Brazilian president João Goulart. The military regime will rule under a series of general-presidents until 1985.

August–October (*Boletim* 144): This issue is dedicated to the memory of Oiticica Filho. His obituary, published alongside a reproduction of a work from his *Recriações* series, outlines his career as a scientist and artist.

1965

September–November (*Boletim* 148): This issue doubles as a catalogue for the photographs presented in the Eighth São Paulo Bienal. Catalogues for the club's annual salons were published as issues of the *Boletim* beginning in 1959. See "Eighth São Paulo Bienal" (opposite).

FCCB MEMBERS IN *FOTOCLUBISMO*

Little is known about many members of the FCCB, including several of the photographers featured in this book. The information below—including sequentially assigned membership numbers, enrollment dates, and members' professions—relies heavily on the membership cards and applications in the club's archives. Given that one can, to a great degree, gauge members' reputations within the club by their prominence in the *Boletim*, we have listed below every appearance of a member's work on the magazine's cover. Each entry concludes with references to reproductions in this publication, noting if any were also reproduced in the *Boletim* or *Anuário brasileiro de fotografia* (1957).

Julio Agostinelli (Brazilian, b. 1919)
N° 438; joined January 30, 1947
Businessman
Cover: nos. 30 (October 1948) and 45 (January 1950)
Page **103**

Francisco (Chico) Albuquerque (Brazilian, 1917–2000)
N° 465; joined July 24, 1947
Photographer
Cover: nos. 15 (July 1947), 17 (September 1947), 36 (April 1949), 39 (July 1949), 43 (November 1949), 57 (January 1951), 63 (July 1951), 77 (September 1952), and 104 (December 1958)
Pages **87**, **126**

Gertrudes Altschul (Brazilian, b. Germany. 1911–1962)
N° 1008; joined July 9, 1952
No occupation listed
Cover: no. 84 (September/October 1953)
Pages **41** (also cover of *Boletim* 84), **47** (also *Anuário*), **75**, **76**, **77**, **78**, **79**, **80** (also *Boletim* 81 [April–June 1953] and 131 [May/June 1962; upside down]), **81**, **84**, **109**, **142**, **143** (also *Boletim* 98 [April 1956]), **152**

Eduardo Ayrosa (Brazilian, b. 1922)
N° 811; joined November 9, 1950
Civil servant
Cover: no. 67 (November 1951)
Pages **50** (also cover of *Boletim* 67), **162**

Armando Moraes Barros (Brazilian, b. 1923)
N° 797; joined September 28, 1950
Engineer
Cover: no. 90 (June/July 1954)
Pages **85**, **150**

Geraldo de Barros (Brazilian, 1923–1998)
N° 633; joined May 17, 1949
Bank employee
Pages **3**, **90**, **112**, **113**, **114**, **115**, **116**, **117**, **118**, **119**, **120**, **127**

Frederico Soares de Camargo (Brazilian, b. 1916)
N° 469; joined August 27, 1947
Physician
Page **53**

André Carneiro (Brazilian, 1922–2014)
N° 846; joined March 20, 1951
Journalist
Cover: no. 58 (February 1951)
Page **67** (also cover of *Boletim* 58)

Dulce Carneiro (Brazilian, 1929–2018)
N° 850; joined March 20, 1951
Journalist
Pages **64**, **68**, **87** (also *Anuário*)

Maria Helena Valente da Cruz (Portuguese, b. 1927)
N° 963; joined December 27, 1951
No occupation listed
Cover: no. 100 (June/July 1956)
Page **133** (also *Boletim* 76 [August 1952])

Thomaz Farkas (Brazilian, b. Hungary. 1924–2011)
N° 61; founder
No occupation listed
Cover: no. 52 (August 1950)
Pages **6**, **7**, **45**, **49**, **73** (also cover of *Boletim* 52), **83**, **89** (also *Boletim* 39 [July 1949]), **93**, **94**, **95**, **96**, **97**, **98**, **161**

Oswaldo Willy Fehr (Brazilian, b. 1911)
N° 593; joined January 18, 1949
Retail merchant
Page **107**

Antonio Ferreira Filho (Brazilian, b. 1914)
N° 872; joined April 17, 1951
Physician
Page **52**

Gaspar Gasparian (Brazilian, 1899–1966)
N° 170; joined June 30, 1943
Businessman
Cover: nos. 23 (March 1948), 34 (February 1949), 40 (August 1949), and 46 (February 1950)
Pages **4**, **69**, **122**

Marcel Giró (Spanish, 1912–2011)
Nº 734; joined January 26, 1950
Businessman
Cover: nos. 75 (July 1952) and 105
(January 1959)
Pages **5**, **125**, **127**, **131**, **153**, **154**, **155**,
156, **157**, **158**, **159**

Palmira Puig Giró (Spanish,
1912–1978)
Nº 1380; joined January 29, 1957
No occupation listed
Pages **5**, **92**, **145** (also *Anuário*)

Paulo Suzuki Hide (Japanese, b.
1925)
Nº 1165; joined December 9, 1954
Electrician
Cover: no. 101 (August–
November 1956)
Page **106** (also cover of *Boletim*
101 and *Anuário* [rotated
counterclockwise])

Kazuo Kawahara (Japanese,
b. 1905)
Nº 607; joined March 15, 1949
Retail merchant
Cover: no. 81 (April/May 1953)
Page 48 (also *Boletim* 67
[November 1951])

Nelson (Nochum) Kojranski
(Brazilian, b. 1927)
Nº 1160; joined October 26, 1954
Lawyer
Page 86

Carlos Frederico Latorre
(Brazilian, b. 1921)
Nº 316; joined December 5, 1944
Student
Cover: no. 27 (July 1948)
Page **52** (also *Boletim* 37
[May 1949; rotated
counterclockwise])

Lucílio Corrêa Leite Filho
(Brazilian, 1915–1990)
[Membership information unknown]
Page **99**

Aldo Augusto de Souza Lima
(Brazilian, 1920–1971)
Nº 590; joined January 18, 1949
Insurance company managing
director

Cover: nos. 47 (March 1950), 62
(June 1951), and 73 (May 1952)
Pages **151** (also *Boletim* 57 [January
1951]), **163**

German Lorca (Brazilian, b. 1922)
Nº 499; joined January 15, 1948
Accountant
Cover: nos. 50 (June 1950) and 68
(December 1951)
Pages **51**, **54** (also *Boletim* 66
[October 1951]), **91** (also *Boletim*
45 [January 1950]), **105**, **132**, **134**
(also *Boletim* 51 [July 1950]), **135**,
136 (also cover of *Boletim* 68), **137**,
138, **139** (also *Boletim* 61 [May
1951]), **140** (also *Boletim* 69/70
[January/February 1952])

Ademar Manarini (Brazilian,
1920–1989)
Nº 886; joined May 15, 1951
Businessman
Cover: *Boletim* 91 (August 1954)
Pages **4** (also *Boletim* 87 [February/
March 1954]), **70**, **71**, **73**, **82**, **133**

Casimiro Prudente de Mello
(Brazilian, b. 1916)
Nº 1037; joined October 22, 1952
Businessman
Page **160**

Barbara Mors (Brazilian, b. 1925)
Nº 563; joined August 26, 1948
Biologist
Cover: no. 48 (April 1950)
Pages **3**, **72**

João Bizarro da Nave Filho
(Portuguese, b. 1908)
Nº 1450; joined June 17, 1958
Businessman
Cover: nos. 135 (January/February
1963) and 141 (January–March
1964)
Pages **2**, **49**, **146**

José Oiticica Filho (Brazilian,
1908–1964)
Nº 409; joined May 15, 1946
Engineer
Pages **62**, **63**, **106** (also *Boletim* 112
[October 1959]), **123**, **124**

This spread and following page: Three applications to join São Paulo's Foto-Cine
Clube Bandeirante (Maria Helena Valente da Cruz [1951], Palmira Puig Giró
[1957], and José Yalenti [1947]). Collection Foto Cine Clube Bandeirante

Jacob Polacow (Brazilian, b.
Russia. 1911–1966)
Nº 264; joined November 25, 1943
Agronomist
Page **101**

Astério Rocha (Brazilian, b. 1921)
Nº 350; joined December 21, 1944
Cotton classifier
Cover: no. 35 (March 1949)
Page **141** (also *Boletim* 42 [October
1949])

Eduardo Salvatore (Brazilian,
1914–2006)
Nº 86; founder
Lawyer
Cover: nos. 18 (October 1947),
33 (January 1949), 41 (September
1949), 51 (July 1950), 55 (November
1950), 69/70 (January/February
1952), 74 (June 1952), 78 (October
1952), 95 (April/May 1955), 123
(May/June 1961)
Pages **46**, **65**, **74** (also *Boletim* 131
[May/June 1962]), **110**, **144**

Eijiryo Sato (Japanese, b. 1916)
Nº 647; joined July 26, 1949
Photographer
Cover: nos. 71/72 (March/April 1952)
Page **53**

Rubens Teixeira Scavone
(Brazilian, 1925–2007)
Nº 1081; joined April 8, 1953
Public prosecutor
Cover: nos. 87 (February/March 1954), 99 (May 1956), and 116 (March/April 1960)
Pages **44** (also *Anuário*), **121**, **128** (also cover of *Boletim* 87)

Ivo Ferreira da Silva (Brazilian, 1911–1986)
Nº 437; joined January 30, 1947
Businessman
Cover: nos. 60 (April 1951) and 132 (July–September 1962)
Pages **42**, **129** (also cover of *Boletim* 60), **147**

Paulo Pires da Silva (Brazilian, 1928–2015)
Nº 763; joined April 5, 1950
Teacher
Cover: no. 144 (August–October 1964)
Pages **108**, **111**

Alzira Helena Teixeira (Brazilian, b. 1934)
Nº 1390; joined March 19, 1957
Student
Page **101**

Sergio Trevellin (Brazilian, b. 1922)
Nº 457; joined May 28, 1947
Accountant
Page **102** (also *Boletim* 27 [July 1948])

Antonio da Silva Victor (Brazilian, dates unknown)
Nº 363; joined March 1, 1945
Businessman
Page **91** (also *Boletim* 33 [January 1949] and 60 [April 1951])

José Yalenti (Brazilian, 1895–1967)
Nº 8; founder
Engineer
Cover: nos. 9 (January 1947), 22 (February 1948), 38 (June 1949), and 89 (May 1954)
Pages **43**, **55**, **56** (also *Boletim* 89 [May 1954]), **57** (also *Boletim* 119 [November/December 1960]), **58**, **59** (also *Boletim* 87 [February/March 1954]), **60**, **61**

Roberto Yoshida (Japanese, 1911–1978)
Nº 329; joined December 5, 1944
Retail merchant
Cover: nos. 37 (May 1949), 86 (January 1954), 92 (September 1954), and 114 (December 1959)
Pages **100** (also cover of *Boletim* 114), **149**

PHOTOGRAPH CREDITS

© 2021 Julio Agostinelli: 103. © 2021 Estate of Gertrudes Altschul: 41, 47, 75, 76, 77, 78, 80 (and cover), 81, 84 (top and bottom), 109, 142, 143, 152. © 2021 Arquivo Geraldo de Barros: 3 (top), 17 (fig. 6), 90, 112 (top and bottom), 113, 114, 115, 116 (top and bottom), 117, 118 (top and bottom), 119, 120, 127 (top); courtesy David Dechman, photo Roz Akin: 112 (bottom); courtesy Susana and Ricardo Steinbruch: 116 (top), 119. © 2021 André Carneiro: 67. © 2021 Thomaz Farkas Estate: 45, 89, 93, 95, 161 (top and bottom); courtesy João Farkas and Kiko Farkas: 6, 7, 49 (top), 73 (top), 83, 94, 96 (top and bottom), 97, 98. © 2021 Estate of Gaspar Gasparian: 4 (top), 69 (and back cover), 122. © 2021 Estate Marcel Giró: 5 (bottom), 125, 131, 153, 155, 156 (top and bottom), 158, 159; courtesy David Dechman, photo Roz Akin: 127 (bottom), 154, 157. © 2021 Estate Palmira Puig Giró: 5 (top), 92; courtesy David Dechman, photo Roz Akin: 145. © 2021 Lucílio Corrêa Leite Filho: 99. © 2021 Aldo Augusto de Souza Lima: 151, 163. © 2021 German Lorca: 51, 54, 91 (bottom), 105, 132, 134, 135, 136, 137, 138, 139, 140,

176 (top). © 2021 Estate of Ademar Manarini: 70, 73 (bottom), 82, 133 (bottom); courtesy Itaú Collection, photo Humberto Pimentel: 4 (bottom), 71 (top and bottom). © 2021 João Bizarro da Nave Filho: 2, 49 (bottom), 146. © 2021 Eduardo Salvatore: 46, 65, 74, 110, 144. © 2021 Rubens Teixeira Scavone: 44, 128; courtesy David Dechman, photo Roz Akin: 121. © 2021 Ivo Ferreira da Silva: 42, 129, 147; © 2021 Paulo Pires da Silva: 111; courtesy Itaú Collection, photo Humberto Pimentel: 108. © 2021 José Yalenti: 43, 55, 56, 58, 59, 60, 61 (top and bottom); courtesy Itaú Collection, photo Iara Venanzi: 57.

Courtesy João Farkas and Kiko Farkas: 15 (fig. 2, fig. 3). Courtesy Fernanda Feitosa and Heitor Martins: 2, 3 (top), 40, 43, 48, 54, 55, 56, 58, 62, 74, 82, 87 (top), 100, 104, 116 (bottom), 117, 118 (top and bottom), 120, 125, 126, 128, 129, 130, 132, 133 (bottom), 140, 141, 143, 144, 162. Courtesy Rubens Fernandes Junior: 1. Courtesy Foto Cine Clube Bandeirante: endpapers, 10, 12 (fig. 1), 17 (fig. 7), 20 (fig. 9), 27 (fig. 13), 31 (figs. 15, 16), 164–177. Courtesy Instituto Moreira Salles: 16 (fig. 4, fig. 5), 25 (fig. 10, fig. 11), 26 (fig. 12). Courtesy Itaú Collection, photo Humberto Pimentel: 101 (top); photo Iara Venanzi: 106 (bottom), 124. Courtesy MASP, photo Eduardo Ortega: 42 (C.00130), 44 (C.00238), 47 (C.00111), 49 (bottom, C.00153), 50 (C.00052), 51 (C.00086), 52 (top, C.00021), 52 (bottom, C.00037), 53 (top, C.00051), 53 (bottom, C.00070), 59 (C.00168), 63 (C.00160), 65 (C.00055), 68 (C.00050), 78 (C.00108), 85 (C.00001), 86 (C.00193), 90 (C.00081), 91 (top, C.00023), 92 (C.00199), 96 (top, C.00248), 102 (C.00082), 106 (top, C.00203), 107 (C.00198), 109 (C.00109), 123 (C.00161), 134 (C.00093), 137 (C.00094), 142 (C.00112), 149 (C.00230),

150 (C.00002), 151 (C.00014), 160 (C.00038). Courtesy Sarah Meister: 34 (fig. 18). © 2021 The Museum of Modern Art Archives, New York, photo Soichi Sunami: 32 (fig. 17). © 2021 The Museum of Modern Art, New York, Department of Imaging and Visual Resources: 17 (fig. 7), 18 (fig. 8); Photo Robert Gerhardt: 88, 148; Photo Thomas Griesel: 113, 114; Photo John Wronn: 3 (bottom), 4 (top), 5 (top and bottom), 29 (fig. 14), 41, 45, 46, 60, 61 (top and bottom), 64, 66, 67, 69 (and back cover), 70, 72, 73 (bottom), 75, 76, 77, 79, 80 (and cover), 81, 84 (top and bottom), 87 (bottom), 89, 91 (bottom), 93, 95, 99, 101 (bottom), 103, 105, 110, 111, 112 (top), 115, 122, 127 (top), 131, 133 (top), 135, 136, 139, 146, 147, 152, 153, 155, 156 (top and bottom), 158, 159, 161 (top and bottom), 163, 176 (top).

Uncaptioned Illustrations

Frontispiece:
FCCB members on an excursion to Paquetá Island to visit the Sociedade Fluminense de Fotografia (Fluminense Photographic Society). *Boletim foto-cine* 17 (September 1947): 3. Special thanks to Rubens Fernandes Junior for his help with identifying the individuals in this photograph

Page 2:
João Bizarro da Nave Filho
High Speed (Alta velocidade). 1966
Gelatin silver print, 14³/₁₆ x 10¹³/₁₆ in.
(36 x 27.5 cm)
Collection Fernanda Feitosa and Heitor Martins

Title page, top:
Geraldo de Barros
African Mask (Máscara africana). c. 1949
Gelatin silver print, 14⁹/₁₆ × 10³/₈ in.
(37 × 26.3 cm)
Collection Fernanda Feitosa and Heitor Martins

Title page, bottom:
Barbara Mors
Sunday (Domingo). c. 1953
Gelatin silver print, 11 × 15¹/₂ in.
(27.9 × 39.4 cm)
The Museum of Modern Art, New York.
John Szarkowski Fund

Page 4, top:
Gaspar Gasparian
Untitled [São Paulo]. c. 1944
Gelatin silver print, 15⁹/₁₆ x 11¹¹/₁₆ in.
(39.5 x 29.7 cm)
The Museum of Modern Art, New York.
Acquired through the generosity of José Olympio da Veiga Pereira, and Alfredo Setubal through the Latin American and Caribbean Fund

Page 4, bottom:
Ademar Manarini
Untitled. 1953
Gelatin silver print, 11 x 15³/₈ in.
(28 x 39 cm)
Itaú Collection

Page 5, top:
Palmira Puig Giró
Untitled. c. 1960
Gelatin silver print, 15³/₈ x 11¹¹/₁₆ in.
(39.1 x 28.1 cm)
The Museum of Modern Art, New York.
Agnes Rindge Claflin Fund

Page 5, bottom:
Marcel Giró
Texture 2 (Textura 2). c. 1950
Gelatin silver print, 12¹/₈ × 15³/₄ in.
(30.8 × 40 cm)
The Museum of Modern Art, New York.
Committee on Photography Fund

Page 40: Verso of José Oiticica Filho's *Abstraction 2-57 (Abstração 2-57)*, 1958 (for recto see page 62)

Page 66: Verso of Barbara Mors's *Study with Sun II (Estudo com sol II)*, c. 1953 (for recto see page 72)

Page 88: Verso of Lucílio Corrêa Leite Filho's *Fluorescent Symphony (Sinfonia fluorescente)*, c. 1960, (for recto see page 99)

Page 104: Verso of Ivo Ferreira da Silva's *The Mark of Time (A marca do tempo)*, 1951 (for recto see page 129)

Page 130: Verso of Astério Rocha's *A Leap in Space (Um pulo no espaço)*, c. 1951 (for recto see page 141)

Page 148: Verso of Marcel Giró's *Structure (Estrutura)*, 1955 (for recto see page 156)

Generous support for the exhibition is provided by
David Dechman and Michel Mercure and by the
Consulate General of Brazil in New York.

Additional funding is provided by
Rose and Alfredo Setubal.

Published in conjunction with the exhibition *Fotoclubismo: Brazilian Modernist Photography, 1946–1964* at The Museum of Modern Art, New York, March 21, 2021–June 19, 2021. Organized by Sarah Hermanson Meister, Curator, and Dana Ostrander, Curatorial Assistant, The Robert B. Menschel Department of Photography, The Museum of Modern Art

Generous support for the exhibition is provided by David Dechman and Michel Mercure and by the Consulate General of Brazil in New York.

Additional funding is provided by Rose and Alfredo Setubal.

Produced by the Department of Publications, The Museum of Modern Art, New York

Hannah Kim, Business and Marketing Director
Don McMahon, Editorial Director
Marc Sapir, Production Director
Curtis R. Scott, Associate Publisher

Edited by Don McMahon
Designed by Amanda Washburn
Production by Marc Sapir
Proofread by Emily Hall
Printed and bound by Trifolio, Verona, Italy

This book is typeset in Alethia Pro and Excelsior. The paper is 150 gsm Condat Matt Périgord.

Library of Congress Control Number: 2020951909

ISBN: 978-1-63345-084-4

Published by The Museum of Modern Art
11 West 53 Street
New York, New York 10019-5497
www.moma.org

Distributed in the United States and
Canada by Artbook | D.A.P.
75 Broad Street, Suite 630
New York, New York 10004
www.artbook.com

Distributed outside the United States and
Canada by Thames & Hudson Ltd
181A High Holborn
London WC1V 7QX
www.thamesandhudson.com

Printed in Italy

Endpapers:
FCCB membership cards.
Collection Foto Cine Clube Bandeirante

Front Cover:
Gertrudes Altschul
***Filigree (Filigrana)*. 1953**
(See page 80.)

Back Cover:
Gaspar Gasparian
***Divergent (Divergente)*. 1949**
(See page 69.)